The *Watercolorist's*
COMPLETE GUIDE TO COLOR

The *Watercolorist's*
COMPLETE GUIDE TO COLOR

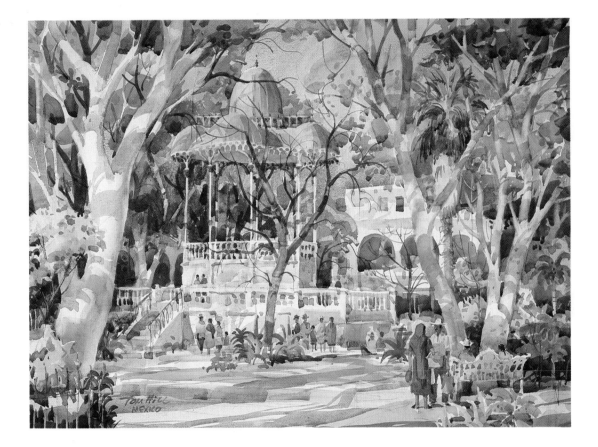

TOM HILL

Cincinnati, Ohio

96 95 94 93 92 5 4 3 2

Library of Congress Cataloging-in-Publication Data

Hill, Tom.
 The watercolorist's complete guide to color / Tom Hill. —
1st ed.
 p. cm.
 Includes index.
 ISBN 0-89134-430-6
 1. Watercolor painting—Technique. 2. Color guides.
I. Title.
NC2420.H55 1992
751.42'2—dc20 91-45724
 CIP

Edited by Greg Albert and Rachel Wolf
Designed by Cathleen Norz
Cover by Paul Neff

To Barbara

My thanks to David Lewis, Greg Albert, Rachel
Wolf, Terri Boemker, and all the other talented folks
at North Light Books for their help and interest.

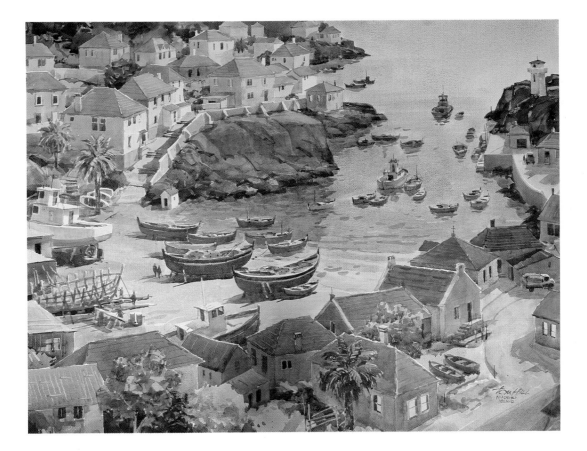

TABLE OF CONTENTS

INTRODUCTION ... 1

Chapter 1
TOOLS, MATERIALS AND EQUIPMENT ... 3
Essentials ... 3
Brushes ... 3
Paper ... 4
Paint ... 5
Palette ... 5
Easel/Drawing Board ... 5
Taboret ... 6
Other Equipment ... 7
Your Studio ... 7

Chapter 3
COLOR ... 23
What Actually Is Color? ... 23
Primary, Secondary and Tertiary Colors ... 25
Color Terms ... 26
Color Wheels ... 27
Hue, Value and Intensity ... 28
Color Temperature ... 29
Local and Atmospheric Color ... 29
Colors That Advance and Retreat ... 29
Tint, Shade and Tone ... 29
Graying a Color ... 29

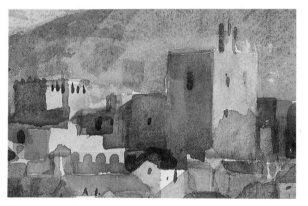

Chapter 2
THE PAINTING PROCESS ... 9
Wash Techniques ... 9
Making Your Brush Perform ... 12
Other Ways to Apply and Remove Paint ... 12
Putting a Painting Together ... 14
Basic Painting Guidelines ... 15
Development of a Painting ... 18

Chapter 4
HOW COLORS IN PAINT BEHAVE ... 33
Comprehensive Color Chart ... 34
Tube Colors on the Color Wheel ... 40
Experiments to Check Color Characteristics ... 42
Transparency/Opacity of Colors ... 42
Staining Strength of Colors ... 47
Tinting Strength of Colors ... 48

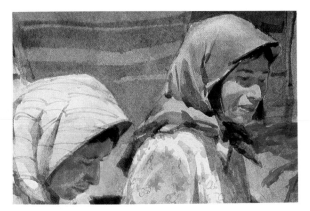

Chapter 5
COLOR MAGIC ... 51
Mixing Two Colors ... 51
Mixing More Than Two Colors ... 51
Mixing Colors While Painting ... 53
Graying Colors ... 55
Intensifying Colors ... 58
Summing Up ... 60

Chapter 7
COLOR IN LIGHT AND SHADOW ... 77
Sunlight's Action ... 77
Creation of Shadows ... 77
Reflected Light ... 77
Black-and-White and Color Settings ... 78
Painting Shadows ... 81

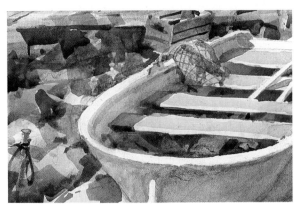

Chapter 6
PALETTES THAT WORK ... 65
1. Monochromatic Palette ... 66
2. Complementary Palette ... 67
3. Analogous Color Palette ... 68
4. Analogous Color Palette With Complement ... 69
5. Low-Key Three Color Palette ... 70
6. High-Key Three Color Palette ... 71
7. Six Color Palette ... 72
Mixtures From Various Palettes ... 73
Full-Color Palette ... 74

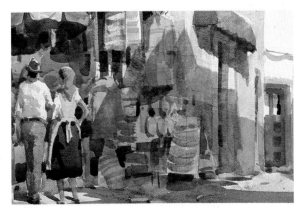

Chapter 8
COLOR IN ACTION: TEN DEMONSTRATIONS
1. Color in Shadows and Cast Shadows ... 83
2. Color in a White Subject ... 88
3. Color in a Colorful Subject ... 94
4. Color in Water ... 98
5. Color in Clouds and Skies ... 104
6. Painting the Greens in Nature ... 108
7. Intensifying a Color's Brilliance ... 114
8. Painting Grays That Aren't Muddy ... 120
9. Using Color to Create Distance ... 124
10. Redesigning Your Subject's Color ... 128

CONCLUSION ... 133

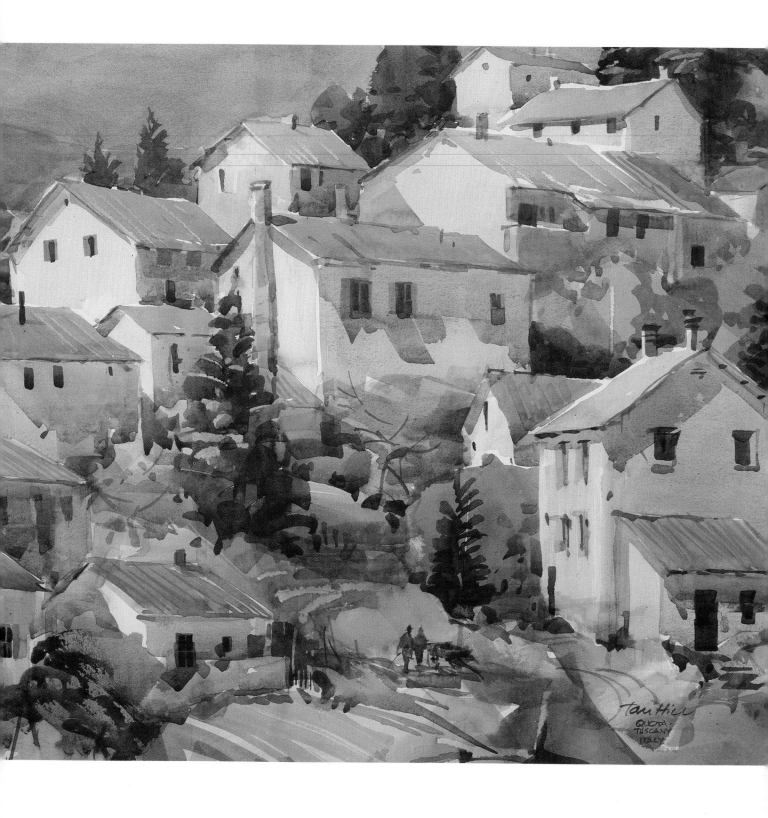

Introduction

If I asked you to tell me what mental images the words "clarity," "purity" and "freshness" bring to your mind, what would you say? Would you be reminded of a drink of pure, cool water? A bath in a pristine mountain stream? An early morning in spring? All would be good similes — but if you asked *me*, I'd add another mental image brought forth by those words: *transparent watercolor!*

Yes, transparent watercolor — that wonderful, fluid painting medium carried to its finest end can have qualities of exceptional *clarity*, unadulterated *purity* and a *freshness* that delights the eye!

Watercolor can charm you, the artist, with an exciting and seductive challenge — and then almost invariably test your mettle and patience with its seemingly capricious nature. Yet, when you least expect it, watercolor can reward your efforts and persistence with an occasional glowing success.

This book is about transparent watercolor — especially about the *color* part of watercolor. It's about understanding color: What color is and is not. What colors in watercolor paint are capable of doing. How we can best use color to express ourselves in our paintings with greater skill, knowledge and conviction.

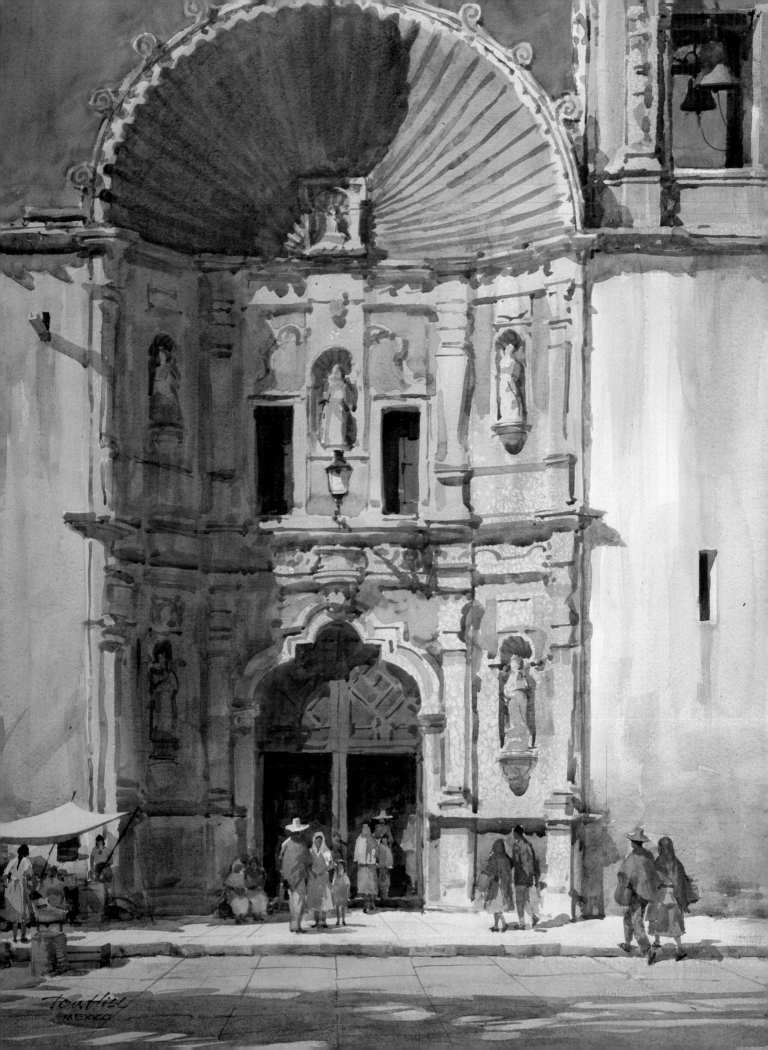

Chapter 1

TOOLS, MATERIALS AND EQUIPMENT

As this book is really about color in watercolor painting, you may wonder why the first chapter starts right off talking about tools, materials and equipment. I realize you've probably done some watercolor painting and already know quite a bit about paint, brushes, paper, etc. What I want to do here is outline what I'm using and why—maybe some of my solutions will prove useful to you.

ESSENTIALS

An endless array of artist's materials is available, and each has its special use or appeal. You could literally fill your studio with the stuff—but you still wouldn't need most of it to paint good watercolors. What do we really *have* to have?

Getting down to the essentials, we must have *brushes, paper, paint* (and a *palette* to put it on). We need a *watercolor board* for our watercolor paper, and something to support it while we paint (an *easel* or *drawing board*). Most artists want someplace to put their palette and painting gear. Indoors this is usually a side table called a *taboret*. Of course, all the *miscellaneous items* like water containers, paint rags, tissues, pencils, sketchbook, etc. are a part of it—as well as having a *place to paint* and *good lighting*.

All these items come in many varieties, so I

recommend that you look them over and use what works best for you. Briefly, here's what works well for me:

BRUSHES

The great variety of brushes offered the artist can be confusing—but you really only need a few good brushes for watercolor painting. Basically, watercolor brushes come in two styles: *flats* and *rounds*. Flat brushes have flat, chisel-shaped ends; round brushes are round with their hairs coming to a point. Both styles come in all sizes, from small to large.

I do almost all my painting with only three brushes. They are:
• A 1½-inch flat—either oxhair or synthetic
• A 1-inch flat—either oxhair or synthetic
• A no. 8 round—the very best red sable I can buy

I occasionally use three other brushes. They are:
• A ½-inch flat—oxhair or synthetic
• A no. 5 round—the best red sable I can buy
• A no. 6 "rigger" or "script"—oxhair or synthetic

You may have other and different brushes that you use in your painting—and if you need them—fine. I've found over the years of painting that I'm better off with only a few good brushes, like those listed above.

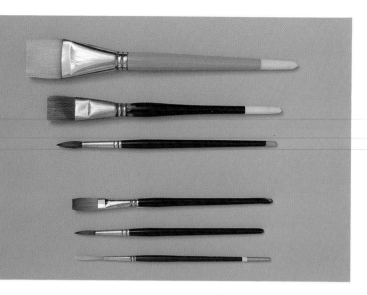

Here are brushes I use in watercolor painting. The three at the top are used the most; the three at the bottom are used less often (mostly for final finishing work).

The brush material in most watercolor brushes is typically made of *sable hair* (the best and most expensive), *oxhair* (almost as good and less expensive), and *synthetic hair* (quite good and least expensive). *Bristle hair* (hog hair) is commonly used in oil painting brushes and isn't suitable for watercolor painting.

PAPER

As in the case with brushes, watercolor papers are offered in a perplexing variety of sizes, weights, textures and prices. There are a number of good brands such as Arches, Whatman, Fabriano, Saunders, etc., and trying them out for yourself is the only way to determine which one suits you best. Currently, I tend to use Arches.

SIZES. Probably the most common size sheet of watercolor paper is referred to as a "full-sheet" (about 22 inches × 30 inches) and can be divided into half and quarter sheets. There are smaller and larger sizes, plus paper in spiral-bound "books" or in "blocks" — there's even watercolor paper in large rolls.

WEIGHT. You may have heard of watercolor paper being referred to as a "140-lb." or "300-lb." sheet.

Obviously the single sheet doesn't weigh that much. It means that a ream (500 sheets) weighs 140 or 300 pounds. Most painters use the 140- and 300-pound paper.

TEXTURE. There are three paper textures normally available: "hot-pressed" (smooth), "cold-pressed" (medium texture) and "rough." Painting on the "hot-pressed" is a little more difficult to control. Many painters prefer "cold-pressed" or "rough" surfaces.

PRICE. The heavier the paper, the higher the cost. A sheet of 140-lb. paper is about one-half the cost of a sheet of 300-lb. paper. Some savings can be realized in buying paper by the 25-sheet package, referred to as a "quire."

STRETCHING PAPER. When watercolor paper gets wet, it tends to expand, creating buckles and wrinkles that can make the painting process even more complicated. Who needs this added problem? Some folks put their paper on a nearly-the-same-size board, holding it around the edges with paper clamps. If the paper buckles, they simply release the clamps, pull the paper tight, re-clamp, and continue painting. My

Stretching paper. The wet, expanded paper is smoothed and gently pulled as it's being stapled, starting from the center of each side, then the corners and finally, in between. When dry, it will be smooth and taut.

preference is to "stretch" my paper, which simply means that I soak the paper with water for a few minutes, allowing it to absorb some of the water and expand a little. While it is expanded, I securely fasten it to a ½-inch thick plywood board, either by taping the edges with brown kraft tape (the kind you need to moisten) or by using a small staple gun that takes ¼-inch long staples. I space these staples about 3 inches apart and ½ inch in from the paper's edges. ("Swingline" and "Arrow" are two brands of such a staple gun.) I find this works even better than using kraft tape.

As the paper dries, it attempts to return to its former size, but can't. So, it remains smooth and taut—a most delightful and cooperative surface on which to paint in watercolor!

PAINT

Quality watercolor paint is essential, of course, and again, we have many choices: paint in pans or in tubes, several sizes and quality lines, and a number of manufacturers, each claiming their paint to be best! Manufacturers like Winsor & Newton, Holbein, Talens, Liquitex and Weber are only a few of the firms offering professional-class paint. This can be less confusing if you keep three things in mind: *quality, size* and *color selection*. I buy only the top-of-the-line watercolor paint, preferring the moist tube colors to the drier pan colors.

I avoid "student" colors because they just don't produce the same results, especially in the area of color. If I have a choice, I opt for the larger tubes — more pigment for the money and less time spent buying more *little* tubes! With the greater choice of color hues available from the top manufacturers, I can come closer to just what I want for my palette. In chapters 4, 5 and 6 we'll really get into exactly which colors to select.

PALETTE

A palette can be as simple as a white china dinner plate — you can put the colors around the perimeter and mix in the center. This works well, but I like a larger mixing area than most plates offer. An enameled steel "butcher's tray" was my first palette — again, colors around the edge, mixing area in the center. Trouble was, being flat, the wet washes I mixed tended to run back into the gobs of pigment, spoiling the wash's color and dirtying the pigments! Both of these palettes allow your pigment to dry out when not being used, which isn't good. My favorite palette — after trying most all of them — is a white plastic palette that has large wells for the paint (allowing that 1½-inch flat brush to dip into them), a good-sized mixing area in the center, and a lid to cover it and keep the paint moist for the next painting session.

This "John Pike" palette is very good. There are several others that are similar, though probably not as rugged as the Pike. The lid serves as an extra mixing area and helps to protect and keep the paint moist between painting sessions — especially if there's a wet rag or sponge left inside.

EASEL/DRAWING BOARD

If you are painting indoors, you could just use a table as a support for your watercolor board, propping one end up to the slant you want. In my studio, I use a large drawing board that quickly and easily tilts from horizontal to vertical (or in between), has a top nearly 3 × 4 feet, and is very steady. It raises or lowers easily, too, so I can work standing or seated on an adjustable

draftsman chair. Styles and sizes of these tables abound, and you can look them over at larger art and drafting supply stores.

Out-of-doors, the very simplest solution would be to paint, seated on the ground, or a low stool, with your board on the ground in front of you, propped up to an angle that you like.

If you stand to paint, you could use a folding card table as your easel. The next step would be to use any one of a number of folding, adjustable, outdoor painting easels, from the very simplest to the top-of-the-line "French" easel, which is like an easel/paintbox on folding adjustable legs. My personal solution is to use an ordinary photographer's tripod to which I screw my watercolor board. It's lightweight and easily adjustable to any angle or terrain.

TABORET

Originally a French word that means a stool or a small portable stand, taboret has come to mean the table or stand that sits alongside the artist's easel and holds all the painting paraphernalia. Depending on whether you sit or stand to paint—which will determine the height needed, and how big an area you require for your gear—you could start off with something as mundane as a folding TV tray, a card table or an old chest of drawers. You could buy a ready-made taboret from the art store or catalog or even have one custom-made for your needs only! I made mine so I could have a number of shallow drawers for storage and easy access to items like pencils, erasers, brushes and tubes of paint.

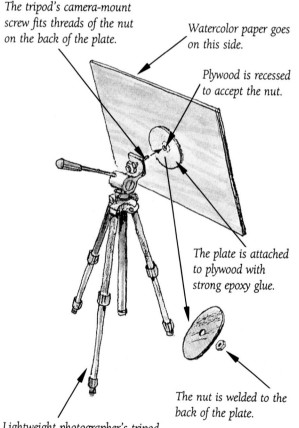

The tripod's camera-mount screw fits threads of the nut on the back of the plate.

Watercolor paper goes on this side.

Plywood is recessed to accept the nut.

The plate is attached to plywood with strong epoxy glue.

The nut is welded to the back of the plate.

Lightweight photographer's tripod.

(Above.) *This is my outdoor painting easel. The plywood is attached by screwing the tripod's camera-mount screw into the nut that's on the back of the plate. The plate (an electrical junction box cover) has a hole in its center, and the nut is centered on this hole and then welded. It fits into a recess, drilled partway through the plywood.*

(Below.) *I designed and built this taboret to fit my needs. It's about 27 inches high, 18 inches deep and 40 inches long. Large, easy-rolling castors make it simple to move and some of the drawers are shallow so that I can more easily locate and pick up smaller items like pencils, brushes, etc.*

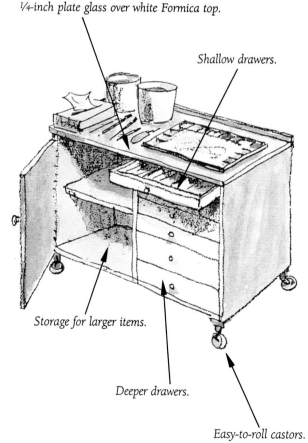

¼-inch plate glass over white Formica top.

Shallow drawers.

Storage for larger items.

Deeper drawers.

Easy-to-roll castors.

Other Equipment

What is actually included in this category of painting gear varies greatly and depends on the individual artist's needs and preferences. The following items are ones that I find useful in watercolor painting.

WATER CONTAINERS. I use one container for clean and another for dirty water. Coffee cans, plastic ice cream containers, etc., work well in this capacity.

CELLULOSE SPONGE. The rectangular "kitchen" variety. Useful for controlling water content in my brush and for cleaning my palette.

COSMETIC SPONGE (NATURAL). Useful for wetting paper, picking up wet color from a wash, etc.

SPRAY BOTTLE. Useful for wetting paper and colors on the palette that are getting a little too dry.

FACIAL TISSUE. More absorbent than most paper towels and great for lifting out wet color, quickly picking up accidental drops or spills.

KNIFE. A pocket knife or mat knife—sharpens pencils and can be used to scrape, scratch, even "squeegee" watercolor washes.

SKETCHBOOK. For sketching, making notes, doing composition and value studies for paintings. I use a smooth bond paper—the pencil goes on much more easily!

PENCILS. I use soft lead (2B through 6B) primarily—both for the sketchbook and for lightly laying in my drawing on the watercolor paper.

ERASERS. I'm partial to the one called Pink Pearl—though I use, or have used, all the others. A kneaded eraser is useful, too.

FLAT, ½-INCH BRISTLE BRUSH. For softening dried washes and scrubbing out small areas.

TOOTHBRUSH. Useful, now and then, for scrubbing out larger areas, or spattering.

SALTSHAKER. A once-in-a-while item for sprinkling salt on wet washes for texture.

Your Studio

If you're painting on location, the out-of-doors is your studio and your concerns, after you've set up your easel and painting gear, are keeping pace with the changing light, avoiding glare on your painting, etc. Painting indoors requires that you at least have a drawing board or table to put your watercolor on as you paint, a handy place to put your palette and other gear, decent lighting and something to sit on (if you don't want to stand all the time).

This could be anything from a corner of a family room or bedroom to a "dream" studio built expressly for your needs. As with materials and equipment, though, it doesn't take *a lot* to be able to paint a good watercolor!

Here are the principal elements in my studio:
- The large *drawing board* described earlier.
- The *taboret* shown on the facing page.
- A *skylight*, surrounded by four 48-inch *fluorescent fixtures*, each having four color-corrected tubes. (I like lots of light!)
- An easily adjustable *draftsman's chair*, which goes from low to high.
- A *filing cabinet* for storing reference material and records.
- A set of large flat *architect's files* for storing paper, sketches, etc.
- A large *side table* for cutting and wrapping.
- *Bookshelves*.

EVITA AND PANCHO, 10½″ × 11½″. Collection of the artist.

Chapter 2

THE PAINTING PROCESS

S omehow, between your idea for a painting and the finished painting, watercolor *paint* must meet watercolor *paper* and the two combine success-fully. *How* to get that paint on the paper has frustrated many an artist and would-be watercolorist!

If you're going to paint in watercolor—really paint just the way you want and say in that painting the things you feel—then you have to be in control of the medium.

Control means that you have a good under-standing of transparent watercolor's physical nature and at least a fair mastery of the techniques necessary to make the darn stuff behave!

Other authors have written a great deal about watercolor technique, so the following is just a short review of the principal ways to put paint on paper.

Paint can be stroked onto paper with brushes (as in oil painting) or, in a way almost exclusive to watercolor, applied as a flowing, liquid-color passage, aptly called a *wash*.

WASH TECHNIQUES

There are three kinds of washes:
1. The "flat" wash, where the color is evenly ap-plied;
2. The "graded" wash, where the color goes from light to dark or vice versa in the same wash;
3. The floated or "wet-in-wet" wash, where color is applied to already wet paper or paint.

These washes plus the various brushstrokes possible with flat and round brushes make up the backbone of watercolor technique.

FLAT WASH. The application of liquid watercolor to dry paper in such a way that the result is about the same value overall is called a *flat wash*.

To practice this wash, tilt the top of your board up about 10 or 15 degrees. (Mix a sufficient amount of paint on your palette so you won't run out midway through the exercise.) With a 1-inch flat brush, make a horizontal stroke across the top of the area planned for the wash. Come back quickly with another brushload, making a second stroke below the first and overlapping it just a little.

You will notice a little puddle, or bead, of paint-water forming along the bottom of each stroke, then running down and re-forming at the bottom of the next stroke. The trick is to keep the amount of paint the same as you make each stroke, but not let that bead get too heavy and run down the sheet to the bottom!

When the flat wash has gone as far as you want it to, quickly wipe out your brush, leaving it damp,

and mop up the remaining bead with it. As you can see, the brush can take color *off* the paper, as well as apply it.

Of course, all flat washes will not be as simple as this and many will have more complicated shapes. As usual, practice is the answer!

A flat wash, *where a color of the same value throughout is applied evenly on the (usually) dry paper.*

GRADED WASH. Usually applied to dry paper—though there may be occasions where you might use damp paper—a graded wash is one that proceeds from light to dark or from dark to light. You simply use proportionally more and more, or less and less pigment-to-water with each successive stroke to create the desired gradation.

Try making a graded wash that goes from dark at the top to light at the bottom, using a darker pigment, such as ultramarine or alizarin crimson. After mixing a sufficient quantity of a rich wash mixture on your palette, load your brush and make a full stroke across the top of the painting area, exactly as you did in starting the flat wash. However, on your second stroke, add a little more water to the brushload, thereby lightening the value. On your third stroke, add still more water to the mixture, the amount depending on how rapidly you want the wash to gradate. With practice, you should be able to end with pure water and a perfect gradation. Reverse the procedure for a graded wash that goes from light to dark.

A graded wash, *where the color goes from dark to light in value; often on dry paper.*

WET-IN-WET WASH. As its name implies, this wash is the application of the liquid color to an already wet surface. There are many variables. The paper surface can be wet with clean water or wet from a previous wash. The amount of moisture on the paper and the proportion of water-to-pigment in your brush, as well as how *loaded* the brush is, are all factors that can make a big difference in the results. The wash can be *very* wet into *very* wet, or *not*-so-wet into *not*-so-wet, or *not*-so-wet into *very* wet, and so forth. Timing, wetness and brushload are critical in this wash—as is the experience of having done lots of practice sheets so you know what to expect!

The heavy 300-lb. paper, well soaked, is certainly going to remain wet much longer than the lighter-weight papers—or even the same 300-lb. paper that has been only lightly moistened on the sur-

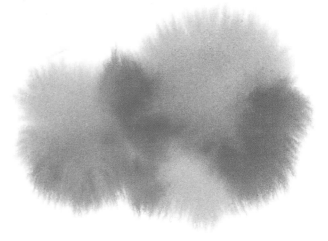

A wet-in-wet wash, *where color is applied to wet paper and can spread in a somewhat unpredictable way.*

face. The rougher papers are going to slow down the paint, and their little pits or depressions will tend to catch any sedimentary pigment, giving a different look than smooth paper.

Try the following experiment in wet-in-wet:

First, get your paint ready on your palette. Then, with your little cosmetic sponge or a clean brush, wet two areas about the same size on your practice sheet. Make one area so wet it glistens, and the other just very damp. Working quickly, drop some color into your first area. Notice that the color runs almost like it had a mind of its own. If you tilt the board while the surface is this wet, the color will run across the area in streaks. If you tilt the board back, you can stop that streaking and even start it going in the other direction!

Now, try putting paint on the second area. Since it's not wet, just *damp*, the color shouldn't run nearly as much and should just form soft-edged shapes that stay pretty much where you put them. The paint will travel from your brush onto the paper—or be sucked back up into the brush—it all depends on which is wetter!

While we're talking about wet-in-wet, let's mention wet blending, or "charging" one wet color into another. This could be just an accent or color note that you want to inject into another area and still have soft edges and blending. Or it could be a diffusion effect you need, like a warm reflected light into a cool shadow. Keep in mind that charging a color is still wet-in-wet technique. The first two illustrations on this page, and the bottom illustration on the facing page, show you typical wet-in-wet effects.

GLAZING. The object of "glazing"—or washing-over-wash—is to achieve dual color and textural effects that are impossible in a single-color wash. You can wash a warm color over a cool, a sedimentary color over a staining one, or apply a wash over several colors, pulling them all together. The method is to paint a first wash, and when it's dry apply a second wash partially or wholly over the first. This produces a "see-through" effect that's altogether different from the fusion and direct blending of wet-in-wet. Glazing is sometimes referred to as the "indirect" or "layered" method, since you must wait for each wash to dry before proceeding to the next.

A wet-into-damp *wash, where the color spreads less but maintains soft edges.*

Wet-in-wet blending *or* charging, *where a wet color is "charged" into a part of a still-wet wash, mingling with the first color.*

A glaze wash (also called "indirect" or "layered" wash), *where a second wash is applied over a dried one, modifying them both.*

If properly executed, the top wash won't soften or take up the bottom wash; rather, it will veil it and make possible a wide range of useful effects. Keep in mind that this glazing business works best if you paint pigmented colors *over* staining colors. As an example—yellow ochre, a pigmented color, goes beautifully over a staining color like alizarin crimson, imparting a nice little optical "haze," which can be very atmospheric. If you reverse the sequence, though, and paint the staining color on top of the pigmented color, chances are the results will be much muddier, without the see-through quality you want in a glaze. The chart on page 43 demonstrates the effects of different pigments both over and under each other.

MAKING YOUR BRUSH PERFORM

I mentioned earlier that the brush can *stroke* on color as well as be the carrier of paint for the wash. The brush is a most versatile tool—and brushstrokes in watercolor seem endless in their variety. Indeed, brushwork can become a very individual thing and can reveal the painter's personality and identify his or her work.

With our basic round and flat brushes, we can make about any brushstroke needed.

ROUND BRUSH. Your round brush is capable of many effects—as you'll see when you do the exercises illustrated on the facing page.

Using your round red sable—say a no. 8 or no. 10—try making the finest hairline you can, with just the tip hairs touching the surface. Next, press down just a little more and the hairline will be thicker. Apply still more pressure, and the line will widen further. Practice this until you have a feeling for just how much pressure will produce what width line, and also how much paint is necessary in the brush.

Now try making the lines turn, curve, double back. Apply different degrees of pressure to achieve different widths.

Many different shapes can be achieved, simply by the way in which the brush is put to the paper surface. Try starting with the tip and then laying the brush hairs flat to the side. Then reverse the proce-

dure. Interesting "tear" or "leaf" shapes can result. Patting or "sweeping" the brush from side to side creates still more possibilities—as does applying a brush that has pigment, but less water than usual, which can produce a variety of wispy or "dry-brush" effects.

FLAT BRUSH. Now let's explore a few of the possibilities that go with the 1-inch flat brush.

Taking advantage of its nice broad coverage in one stroke, hold the brush, rather fully loaded, in a nearly vertical position and make a brush width straight line, as shown at the top right of the facing page. Turning the brush with each successive stroke will produce even *narrower* lines—even hairlines—by using the very tip hairs of the flat brush. As with the round brush, a great diversity of shapes can be produced, as shown, simply by the way the brush is held, how it's applied to the paper, how much or how little paint mixture it contains, etc. Experiment and practice—you'll be able to add all of this to your painting "arsenal"!

When practicing your brushstrokes, always keep in mind the following points:

1. Don't hold your brush down at the ferrule; instead, hold it halfway up the handle—or farther!
2. In nearly every case, avoid resting your hand on the paper when making brushstrokes. Better to have a little less security and a lot more freedom.
3. Whether you're standing or sitting to paint, try to keep a feeling of freedom in your whole body, so you can easily swing the largest stroke, or delicately apply the smallest dab, and never feel cramped.

OTHER WAYS TO APPLY AND REMOVE PAINT

Aside from using brushes, there are other ways to put paint onto paper—or to take it off. Paint can be stamped on with sponges or painted pieces of cardboard. It can be spattered with a toothbrush or applied with crumbled paper or plastic wrap.

Blotting areas of a wet wash with tissue or blot-

ROUND BRUSH

The way the round brush is held, plus its angle to the paper, can easily produce lines from thin to thick.

Up-then-down motions, plus more-then-less pressure give a variety of lines.

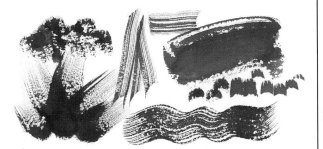

Pressing, lifting, curving and dabbing—each motion offers new shapes.

Dry-brush effects are achieved by various movements and the amount of water-to-pigment in the brush.

FLAT BRUSH

You can make thick to thin lines with the flat brush by turning its angle to the paper.

Flat brush lines depend on the angle held, the amount of tip used, pressure, etc.

Use the flat brush to make angular and box shapes easily, even curved and leaf shapes, by turning and lifting.

Many dry-brush effects are possible depending on the amount of paint, angle and brush movement.

Scraping and squeegeeing effects made with knife and razor on a damp wash.

"Lift-outs" from a dried wash. Left: wet with brush, then blotted with sponge. Right: scrubbed with wet bristle brush, then blotted with tissue.

Wiped out with damp, cosmetic sponge.

Lift-outs from a damp wash. Left: tissue. Right: blotter.

ter paper is a good way to take *out* paint and give you back light areas, or "reverses." However, if you're trying to get a soft edge and you blot while the wash is quite wet, there's a good chance that the remaining wet wash will still run partway back into the blotted area. You'll end up with hard, crinkly edges, rather than the hoped-for soft ones! Of course, if you wait *too* long to blot the wash, you probably won't get out as much of the color as you wanted. As always, timing and practice will tell you how and when.

Taking out wet paint with a clean, squeezed-out brush also works well. Or you can soften an already dry area with clean water and then take out most of the paint. A bristle brush will scrub out even more. An ink eraser will take paint off a dry area. With these last two methods, remember that scrubbing will alter the paper surface, making any paint you apply later go on differently and darker. Try all

these techniques and get them down to where they become easy and natural for you—in effect, second nature!

PUTTING A PAINTING TOGETHER

Before you can really paint a subject, you must understand it. That's just common sense! Two good ways of learning about your subject are: careful and thoughtful *observation* (learning to "see" even better), followed by *drawing*, the purpose of which is to further inform and reinforce memory. I even carry a sketch/notebook with me when painting on location—and observe, draw, and *then* plan my painting's design, its *composition*, before I begin to paint.

The camera is a quick way of recording a lot of information—but it can become a crutch. Be sure

Salt sprinkled on a damp wash, brushed off when dry.

Left: *water drops on wet wash.* Right: *spatter on partially dried wash.*

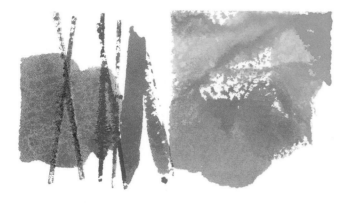

Stampings. Left: *with painted edge of cardboard.* Right: *with painted face of cardboard.*

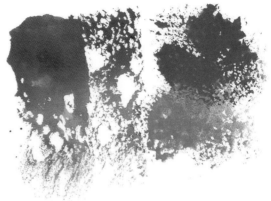

Stampings. Left: *rectangular, cellulose "kitchen" sponge.* Right: *small, natural "cosmetic" sponge.*

that you can paint *without* the camera; then just keep it as a way to supplement your memory.

No question about it—the composition can have a lot to do with the success or failure of the painting. An artist is also a designer and editor who, armed with subject matter, puts all the ingredients together in the best possible way.

On the following two pages are pairs of typical rectangular picture shapes. Each pair has similar, though different, compositional elements. Test your reactions and pick your preference from each pair. These little skeletal "plans" may suggest ideas or ways of thinking about composing paintings.

BASIC PAINTING GUIDELINES

1. Why do I want to paint this painting? What's my reason?
2. What is the absolute *essence* of what I want to convey?
3. Do I understand my subject (or this essence) well enough to be able to interpret it? Or, should I study it more, before I start to paint?
4. What are the *minimal* elements I can incorporate in my painting and still have it convey my meaning?
5. How can I rearrange necessary elements to further improve the painting—to make it say what I want it to say even better?
6. With a plan in mind for drawing, value and composition, how can I use *color* to make my painting work best for me?

Each picture has two horizontal shapes: the left is equally divided, top-to-bottom; the right side is unequal. Any preference?

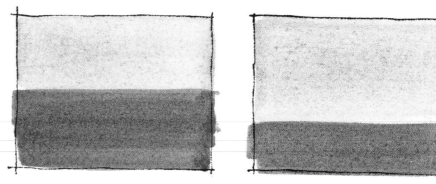

The picture shapes are again divided, this time diagonally. Left is corner-to-corner, the right side is uneven. Any preference?

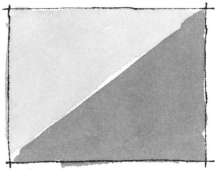

Simple, abstract shapes combine to give a feeling of tranquility on the left side; agitation — even explosiveness — on the right. Would either design work for your next painting?

The picture on the left has most of its elements on one side. A few more elements have been added to the right-hand picture. Which seems more balanced?

On the left, elements are centered, diagonal lines go to each corner. Similar shapes on the right, but arranged in a less centered way. Which is more appealing?

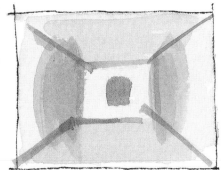

My eye seems to zip right out of the top corner of the composition on the left. On the right, additional shapes stop my eye, leaving it free to look at the rest of the picture. What does your eye do?

 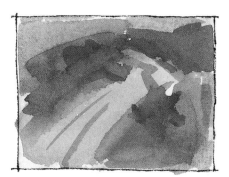

The same trees are in each picture, but they're arranged differently. Which picture seems to hold and challenge your eye the most?

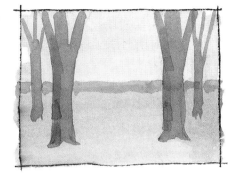 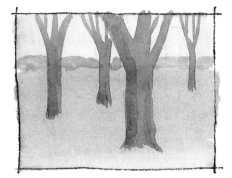

I've put the same elements in each of these little plans. Which is more interesting? Why?

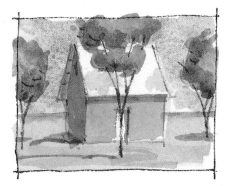 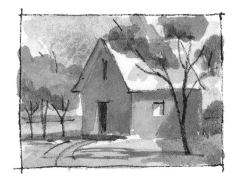

DEVELOPMENT OF A PAINTING. Lisbon, Portugal, is a charming old town and has a lot of subject matter that appeals greatly to me. Recently, while exploring parts of Lisbon on foot, I came upon an area of the town where little streets rose steeply before me and were flanked by wonderful, old tile-topped buildings. Flower-laden balconies, colorful awnings, busy shops and bright afternoon sunshine created an appealing impression that I wanted to record as painting material. My painting gear was far away at the hotel, and

time would change the whole scene considerably. So, I took several photos with my small camera and made some sketches and notes in my book, which you see reproduced on these pages.

I made the painting a bit later, armed with my vivid first impression of the moment-in-time and supplemented with the drawings and the photos. As you can see, I arranged the actual reality of the place quite a bit—all in favor of trying to capture that essence that intrigued me in the first place.

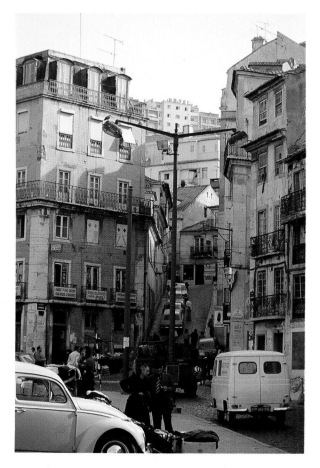

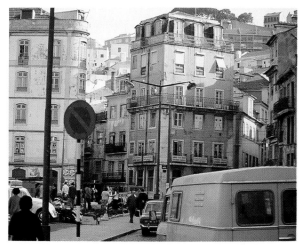

The truck to the right in this shot drove into view just as I was snapping the picture. I noticed later that it hid some of the shops and balconies I was photographing. Fortunately, I had good sketches.

This photo gives you a good idea of the steepness and congestion of some of the streets, plus a feeling of all the hustle and bustle of the place.

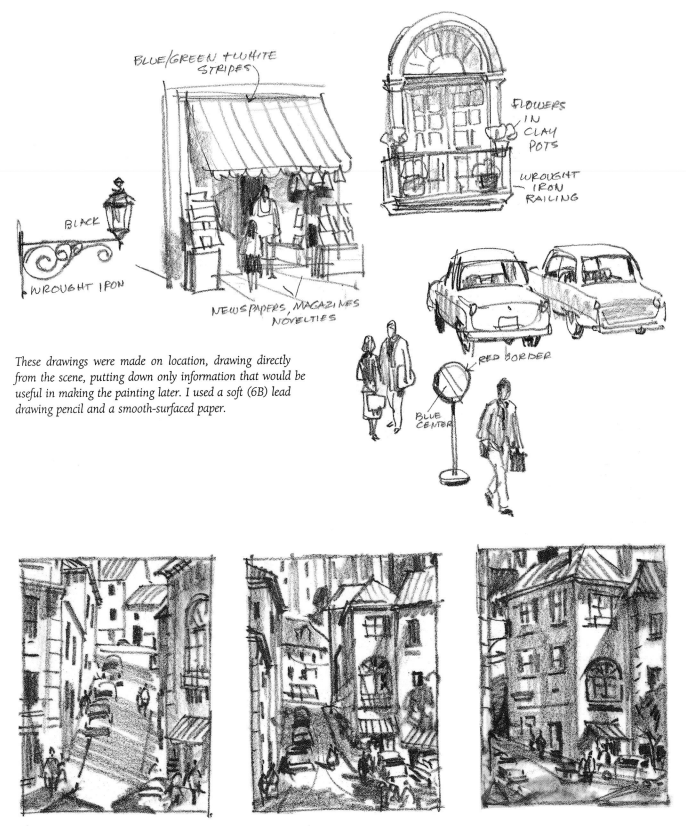

BLUE/GREEN +WHITE STRIPES

FLOWERS IN CLAY POTS

WROUGHT IRON RAILING

BLACK

WROUGHT IRON

NEWSPAPERS, MAGAZINES NOVELTIES

RED BORDER

BLUE CENTER

These drawings were made on location, drawing directly from the scene, putting down only information that would be useful in making the painting later. I used a soft (6B) lead drawing pencil and a smooth-surfaced paper.

I used these little (3½ × 2½-inch) pencil thumbnail studies to explore several compositional possibilities—the important part of planning the arrangement of the painting's principal elements. I decided to use the one in the middle as my painting's basic design.

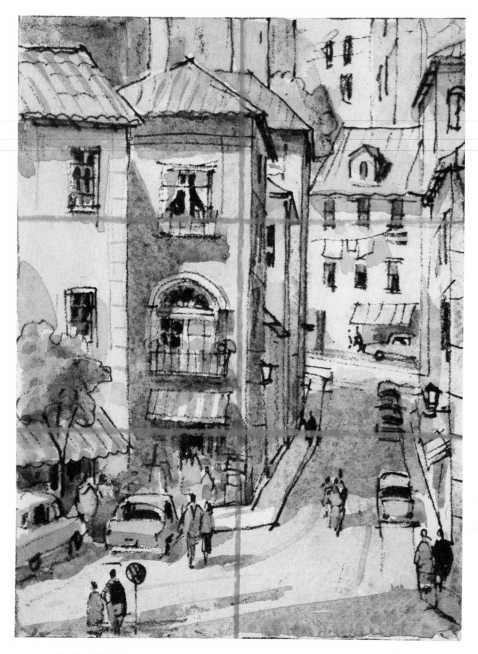

To transfer this final design onto my watercolor paper, I used a simple old technique. I made a few horizontal and vertical divisions on the color thumbnail (orange lines). Then I made the same divisions on the watercolor sheet, which is the same proportion as the study, only larger. I used these lines and divisions as guides in transferring the little design, enlarging it to painting size.

LISBON STREET, 13″ × 10″

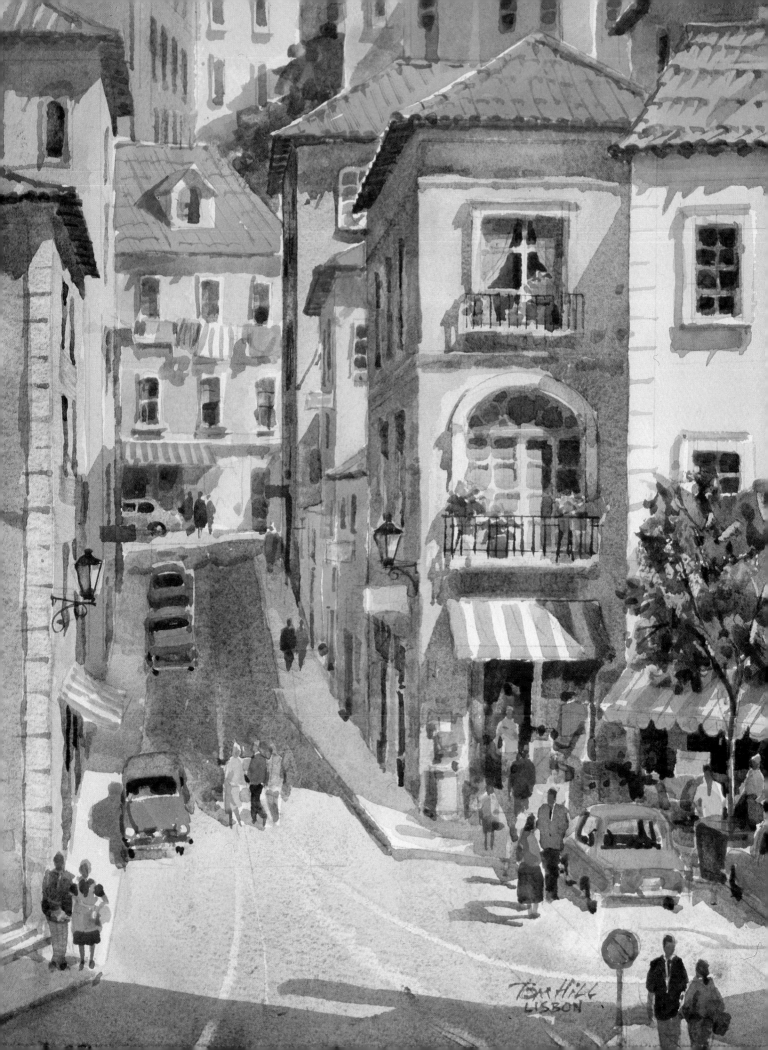

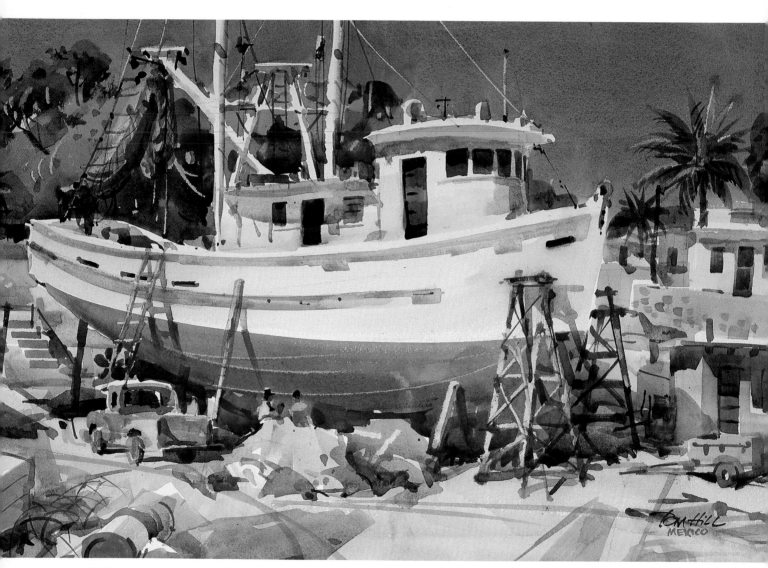

ROCKY POINT DRYDOCK, 13½″ × 21″. Collection of the artist.

This half-sheet watercolor was painted on location and entirely in one session. Because of the quickly changing sunlight, I was forced to work rapidly and broadly, which, for me, can result in a looser, fresher feeling—and an unlabored application of paint. All the colors here were the result of very simple color mixtures—usually only one or two tube pigments—helping to achieve un-muddied results.

Chapter 3

COLOR

Color, the word and the fact, is so common in our daily lives that many of us don't give it more than a passing thought. Yet every once in a while I hear about some blind person who, never having seen at all, is given vision through modern surgery and suddenly, for the first time in his life, can *see*! His reaction is always one of amazement at the visual world revealed. Usually, he already has a fairly good idea of the shapes and textures of things in his life, but *color*—the beauty and intensity of our colorful world—overwhelms him. In a fresh, new way, he sees what we take for granted.

If we could suddenly see color in a new way, I wonder if we wouldn't want to know more about it, to understand it better? As artists, color is one of our main concerns.

Once, in art school, we were having a discussion about color and one of the students asked, "If you put a red ball in a totally dark room what color would it be?" Right away someone answered: "Red, of course, it's still red!" He was wrong. In the dark, without light, the ball would have *no color at all*!

WHAT ACTUALLY IS COLOR?

Color, says the dictionary, is "the quality of an object or substance with respect to light reflected by the object." *Reflected* is the word to remember!

Within sunlight—which is white light—are all the colors of the spectrum. You've probably seen how sunlight, shining through a prism or into a rainstorm, is broken up into the colors of the rainbow—red, orange, yellow, green, blue and violet, each color blending into its neighbor as they meet. This is the *solar spectrum*—the standard by which each hue

(color) is judged.

Now let's consider that red ball again. If we take it from the dark room and put it in direct sunlight, it will appear red again. Why does it appear *red* when the *white* light of the sun is falling on it? Why not white? The answer is that the ball is reflecting back to our eyes only the *red* rays of the sunlight, while absorbing all the other rays. In the same way, a lemon appears yellow in white light because it's reflecting only the *yellow* rays and absorbing all the others; a blue plate reflects the *blue* rays and absorbs the rest; and so forth.

Then what is black? What is gray? In the sense we're talking about here, black is the *absence* of reflected light, because a black object absorbs *all* white light. Thus, a dull black cloth appears colorless. Gray, depending on its value, *absorbs* a portion and *reflects* a portion of all white light rays.

Of course, if the light isn't sunlight, but some other source such as an ordinary incandescent lamp, a fluorescent light, a colored spotlight, or even a campfire, then the red ball or yellow lemon might appear a slightly different color, because it's reflecting and absorbing a different set of light rays. So, we can think of color in two ways: as a direct light source, whether white or colored, or as the light *reflected* by some surface, such as the pigment of paint.

Although adding more light to a direct light source produces more brilliance, adding more pigment to pigment produces *less* brilliance, because more light rays are absorbed and fewer are reflected! In short, reconverging all the light rays of the spectrum would produce white light again, but mixing all the colors of *pigment* together would give us something awfully close to black.

Probably the most important point to under-

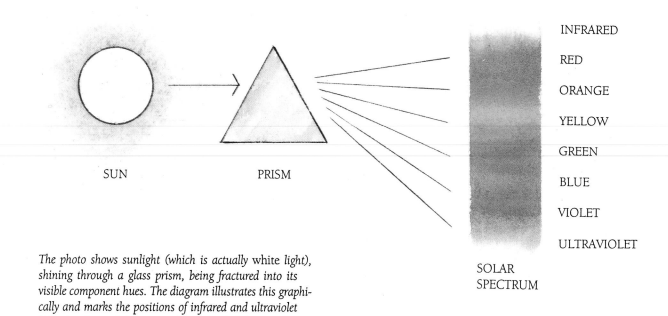

SUN PRISM

INFRARED
RED
ORANGE
YELLOW
GREEN
BLUE
VIOLET
ULTRAVIOLET

SOLAR
SPECTRUM

The photo shows sunlight (which is actually white light), shining through a glass prism, being fractured into its visible component hues. The diagram illustrates this graphically and marks the positions of infrared and ultraviolet light, just beyond the range of our visual abilities.

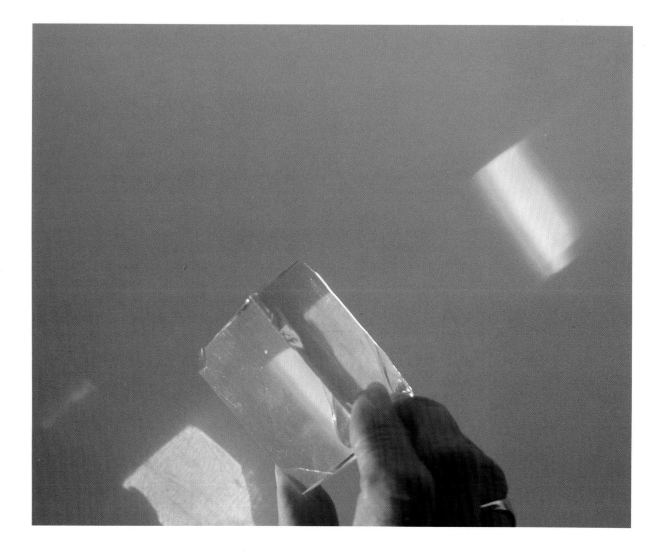

stand about color is that the brightest pigment in our paintbox is still only reflective, and can never rival actual light in brilliance.

PRIMARY, SECONDARY AND TERTIARY COLORS

As long as paint pigments are our chief concern, let's review a little about them. Red, yellow and blue: We know we must at least have these three pigments to paint in full color. Orange can be mixed from red and yellow, green from yellow and blue, and violet from blue and red. But red, yellow and blue can't be mixed from other colors and so are called the *primaries*. Orange, green and violet can be mixed from primaries, and so are called *secondaries*. Colors such as red-orange, yellow-green and blue-violet, which are mixed from a primary and secondary color, are called *tertiary* colors.

COLOR WHEEL

Understanding color relationships in pigment is usually a lot easier for most people if they relate the color spectrum to a gadget called a color wheel—simply the spectrum colors arranged around a circle.

Look at the color wheel at the top of page 27. (A more detailed color wheel appears directly beneath it.) There are a number of things we can learn. Directly across from each color is its "complement" (also called "opposite"). Notice that each primary color is always complemented or "opposed" by a secondary color, never by another primary. Complements are essential in understanding colors; you should try to keep a mental photograph of this little wheel in your head, so you can call on it at will as you paint. Just memorizing the three primaries and their complements will be a big help.

All this discussion about color and the color wheel is, of course, theoretical to a degree, and its purpose is to help set our thinking straight about color relationships in painting. The actual tubes of watercolor that you buy in the art store just don't act in a nice, neat, theoretical manner; they behave with personalities and idiosyncrasies all their own. Instead of lining up on the spectrum or the color wheel like good little soldiers, they fall here and there, missing their idealized places, often by quite a wide mark!

For example, ultramarine blue—that wonderful

The primaries, or principal hues of actual light, are red-orange, green and blue-violet, approximating the secondaries in pigment. When projected or combined, as in the sketch, they produce white. This is called "direct" or "additive" light. Primaries in pigment are red, yellow and blue. When combined, as in the photo of my palette, they produce a neutral that's close to black, which reflects no color. The light by which we see color is called "reflective" or "subtractive" light because it is reflected to our eye; and all but the one color we see is subtracted or absorbed by the pigment.

workhorse of a color—isn't the idealized exact blue that we visualize on the color wheel, but rather leans quite a bit toward violet. Not only that, but one manufacturer's ultramarine may differ slightly from another's. Cadmium orange seems to be the perfect orange when you squeeze it out of the tube at maximum intensity—seems like it would be great for graying its complement, blue. The trouble is, even if you *had* a perfect blue (and you don't), when you add water to cadmium orange, it suddenly veers toward yellow, and any graying of blue you do with it will have a greenish touch!

However, all things considered, the color wheel is *still* the best way I know of to keep color theory and relationships in mind, and will always be a useful tool to us as we get further into color in watercolor!

Color Terms

Contrary to areas where things are precisely measured and defined, color terms in common usage are often confusing. People talk about painting their walls a "shade" of "apricot" and redoing the couch in a "nice, pale fudge" color. I've heard colors referred to as "sweet," "insipid," "lively" and, of course, "nice."

Obviously, your idea and your friend's idea of a particular color could differ dramatically, based on terminology like this!

For our purpose, at least when referring to color in our painting process, let's settle for a *few* words and terms, define and understand them, then stay with them as our standard.

Color has a number of aspects, but the three most important ones to understand are referred to as *hue, value* and *intensity*. On page 28 I've described and illustrated these three aspects—or "dimensions"—and it's very important that you *know* them.

Aside from these three "dimensions" of color, there are some other aspects of color that we should examine and be aware of.

This diagram shows how the color wheel is simply an adaptation of the solar spectrum. By "wrapping" the spectrum into a circle, red meets violet to form purple, a red-violet not found in the spectrum itself. It becomes obvious that the complements are opposite *each other on this now-formed color wheel.*

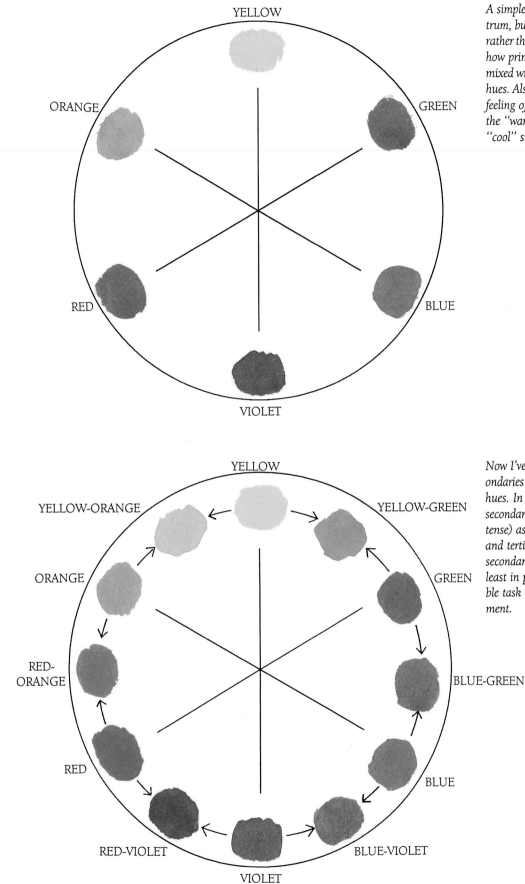

A simple color wheel, following the spectrum, but now based on pigment colors rather than the direct light hues. It shows how primaries red, yellow and blue are mixed with each other to form secondary hues. Also, colors seem to have a natural feeling of temperature—being either on the "warm" side of the wheel or on the "cool" side.

Now I've mixed primary colors with secondaries to make "thirds" or tertiary hues. In the reality of pigment mixing, secondaries aren't quite as brilliant (intense) as the primaries I started with—and tertiaries even less intense than the secondaries! This seems to be due, at least in part, to the apparently impossible task of creating perfect hues in pigment.

THREE DIMENSIONS TO COLOR. *Here, I've painted little still-life illustrations to help demonstrate these three most important aspects — dimensions — of color. Any and every color always possesses all three!*

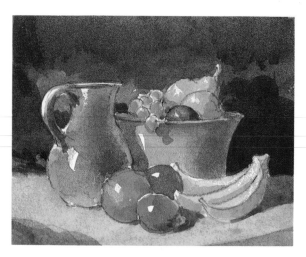

HUE: *Refers to the specific name of a color, as in a blue sky, a yellow flower. In this illustration, I've incorporated all six of the solar spectrum's hues. The spectral hues are shown just below.*

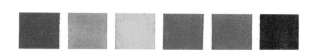

VALUE: *This refers to a color's lightness or darkness, not to a specific hue or to its intensity. Between white (lightest) and black (darkest) there can be an infinite number of grays. The little scale below is plenty for most paintings. A good way to remember what value means is to just think of a black-and-white photograph, and how every hue and intensity of the actual scene is converted into gray, black or white values. The illustration here was done only in values of a neutral gray, with no hues or hue intensities.*

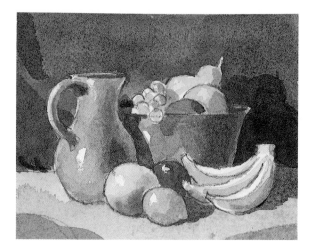

INTENSITY: *Also called "chroma" or "saturation," intensity refers to a color's strength or weakness. The same hue (red, for example) can be of maximum intensity (a very bright red) or of minimum intensity (a rather dull red). I painted the left side of the illustration opposite in intense (bright) hues, and the right side with the hues more neutralized (grayed). Just below, I've painted the three primary hues in three degrees of intensity, from bright to dull, without shifting to another hue.*

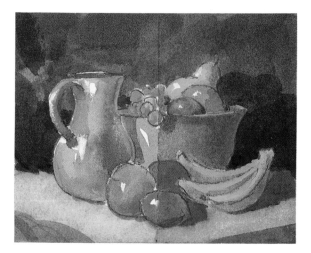

COLOR TEMPERATURE. Colors seem to have a relationship to temperature and are said to be "warm" colors or "cool" colors. There are probably psychological reasons for this, such as associating certain colors with things like fire and ice. Whatever the reasons, if we divided the color wheel vertically down the middle, we'd be splitting yellow at the top and violet at the bottom. Then, everyone would agree that the reds and oranges on the left side of the wheel are warm and the greens and blues on the right are cool. But what about the yellow and violet?

The yellow swatch on the orange side would be a warm yellow, while the yellow swatch on the green side would be a cool yellow. The same idea prevails with violet; it's warmer toward red and cooler toward blue.

There are more possibilities. Even over on the cool side, a blue that's toward violet can seem warmer than a blue that's toward green. On the warm side of the wheel, a red that's toward violet can look cooler than one that leans toward orange. Most people would agree that a red-orange would be the "warmest" hue and that a blue-green would be the "coolest." In actual painting, a lot of what makes a color seem warm or cool depends on which colors are next to it, or around it.

LOCAL COLOR. When artists talk about "local color," they're referring to the actual, true surface color of an object. It's difficult, if not impossible, to really see the pure unadulterated local color because of ever-present surrounding colors and changing light conditions that modify and change the appearance of the local color. These conditions are sometimes called "atmospheric color."

ATMOSPHERIC COLOR. The surrounding atmospheric conditions modify color in many ways. Obviously the color reflected during a dull, cloudy day won't rival the intensity of color reflected on a bright, sunny day. For instance, let's say a friend is wearing a blue shirt; the color of his shirt will appear different indoors, under artificial light, than it does outdoors, in brilliant sunshine. In direct sunlight, the highlights on the shirt look almost white, or bleached out. If he is standing on green grass, the shadows on the shirt could tend toward blue-*green*. If he walks over to a

shiny red car, then the red reflected from the car could modify the blue of his shirt. Later on, at sunset, longer red light waves would dominate the available light, turning that blue shirt into still another color, so that it might possibly not even look blue at all! As night comes and the amount of light is greatly reduced, the shirt would appear nearly colorless, or perhaps as a slightly lighter value than the darkness around it.

COLORS THAT ADVANCE AND RETREAT. Often, in painting, some colors appear to advance toward us while others appear to retreat, without having anything to do with, or getting any help from, scale or perspective. It seems to be the colors themselves that give this illusion. I don't know the reasons, but it appears that warm, dark-value colors come forward, while cool, light-value colors recede. It's useful to know this, and we'll discuss it more in chapter 8.

TINT, SHADE AND TONE. These words are used continuously (and ambiguously) in referring to color. Let's define them for our use and then not worry too much about them. In watercolor you produce a *tint* by adding water to the color (in opaque painting, you would add white paint), so a tint is always lighter than the color you start with. A *shade* is produced by darkening a given color, using black or the color's complement.

Naturally, the intensity of the mixed shade is less brilliant than the color you started with. The term *tone* is really ambiguous, but most often refers to the value of a color.

GRAYING A COLOR. How do you "gray" a color? What exactly is a "grayed" color, anyway? Graying means the same as neutralizing a given hue's intensity—it doesn't mean changing it to another hue. At the bottom of the opposite page, the illustration shows intense (bright) hues on one side, while the same hues are more grayed (neutralized) on the other. There are two ways to gray any color, without changing its hue. One is to mix black with the color, the other is to mix the color with its complement.

In transparent watercolor painting, where so much depends on the reflection of light, I prefer to gray my colors by mixing them with their comple-

Maximum intensity colors, at the rim of the color wheel, become grayer and grayer when mixed with more and more of their opposite, or complementary, color. The center of the wheel represents total grayness, or neutrality. Outside the rim, water added to a color produces a tint of the color — more water results in an even lighter tint.

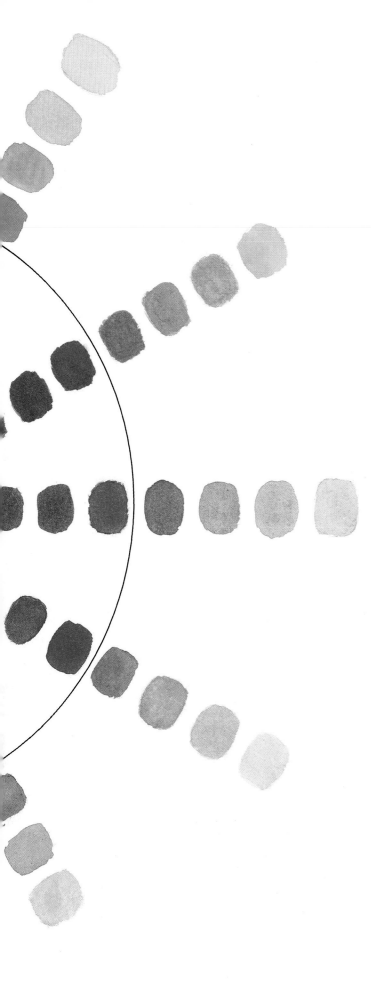

ments. If you use black, it will gray your color very effectively, but because black absorbs all light rays, the results probably won't be as lively and clear as when the complement is used.

Though we know that tube colors are not the exact equivalents of spectral hues, I've painted the large color wheel opposite with the pigments listed at the bottom of page 27, a transparent palette that allows me to come pretty close to achieving "true" color. Starting with the three pigment primaries (red, yellow and blue), I mixed the secondaries from them (orange, green and violet). The tertiaries were then mixed from primaries and secondaries to make yellow-orange, red-orange, blue-violet, blue-green and yellow-green.

The colors at the rim of the wheel are at their maximum intensity, while the center represents totally neutralized — or grayed — color. In theory, any hue can be grayed by adding some of its complement to it. The more complement added, the closer the particular hue gets to a true neutral. This is exactly what I've done here — used the complement, across the color wheel, to achieve the increasingly grayed color swatches, as they move toward the wheel's center.

The swatches of color outside the line of the wheel are tints of each hue — in watercolor, the more water added to the hue, the lighter the value of the tint. Up to this point, we've been talking mostly about color as it behaves in theory, and how paints would work if they were perfect. Of course, they're *not*, and the following chapter deals with the more prosaic realities of what watercolor pigments *actually do* in use — and how to understand all this — and then be "in charge."

Note: There are several color theories or "systems" (Munsell, Ostwald, etc.), which don't agree entirely with each other about every aspect of color. At this writing, scientists still aren't exactly sure how the brain receives and interprets color signals from the eye. Artists and colorists argue about the exactness of this primary and that complement. It can be confusing. However, as watercolor painters, our interest is in making the colors of paint do what we want, and the long-established color approach that I've used in this book has, through a lot of actual painting experience, worked very well for me.

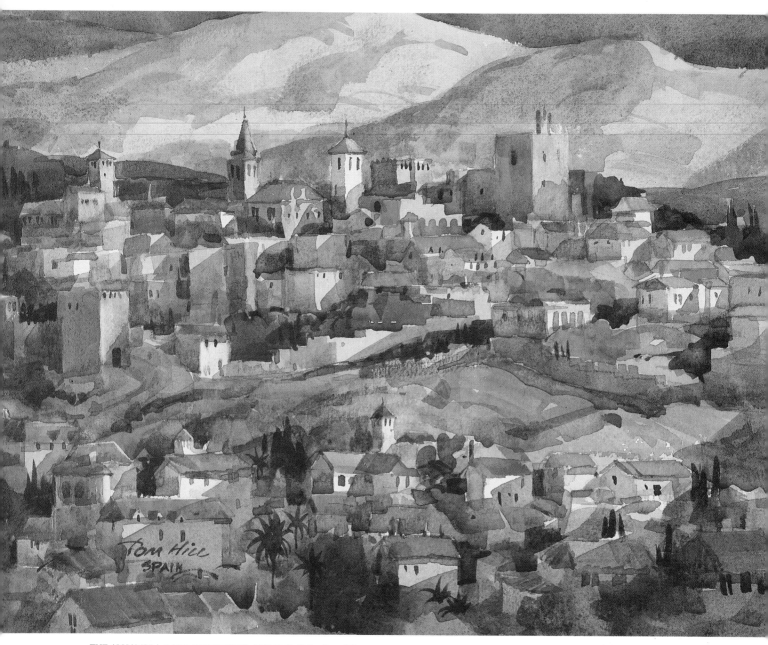

THE ALHAMBRA, LATE AFTERNOON, 10" × 14". Collection of the artist.

I painted this watercolor from the window of our hotel in Granada, looking out at the fabled Alhambra — built by the Moors prior to their being driven out of Spain in the late 1400s. Even though the painting seems complex, I've greatly simplified what I saw before me, striving mainly to capture an impression of lowering afternoon sunlight on wonderful ancient buildings.

Chapter 4

HOW COLORS IN PAINT BEHAVE

Now that we have a practical, workable color theory—and a color wheel to help us understand and keep it all in focus, let's examine the watercolors that are available on the market today. I'll stick to the moist, tube watercolors, as these are my preference over the drier pan colors.

First, let's describe some of the common colors, then I'll outline a few simple tests that you can try to get better acquainted with each tube color's advantages and disadvantages.

The next time you are in an art store or looking through an art supply catalog, notice the array of colors in watercolor that are available today.

On my desk are several manufacturers' watercolor paint charts; you know, the actual paint on cards, listing permanency and price groups. One company offers fifty-five colors, another sixty colors, and a third shows eighty-four transparent watercolor swatches! This last includes fifteen yellows and seventeen reds, not to mention many violets, blues, greens and so forth. Also, the same color may differ slightly from the competition's version, adding to the confusion. Obviously, there's great similarity between many of these colors—even near duplication. Since our color wheel has only *three* primaries and *three* secondaries, it's clear that we don't need *all* the colors shown on the charts!

COLOR CHART

In the chart starting on the next page, I've listed thirty-seven commonly used watercolors, analyzing them in terms of each color's temperature, transpar-

ency or opacity, and each one's staining or sedimentary characteristics. All this information is based on my own painting experiences with these colors. You may want to know about other colors not listed here—the chart, plus the color testing exercises to follow, should make a good guide to your gaining that knowledge. In the chart, the terms "warm" and "cool" (in the temperature column) refer to which side of the color wheel that particular color falls on. As we discussed before, a cool color (such as blue) or a warm color (such as red) can have both warm and cool versions. A color's opacity is also relative, since all these watercolors are transparent, when compared to opaque mediums. A color's staining characteristics mean how much that particular color will stain watercolor paper, and how well it can be washed off that paper. The comments are my own—again, based on my own experience.

A word about the confusion in paint color names: fortunately, most colors have generic names, so that you can look for the same color name, no matter what the brand. However, most manufacturers do put their *own* special names on certain colors, so that the same color can have different names in different brands. For example, phthalocyanine blue (its real name) is made by many manufacturers, but can be known variously as: Winsor blue, thalo blue, phthalo blue, Rembrandt blue, etc.

On the color chart where I've had to use a manufacturer's own color name, I've tried to use the most common name, but have added an asterisk (*) to alert you that this color is available under other names and brands.

Color Group	Name of Color	Temperature	Transparent or Opaque	Staining or Sedimentary	Comments
Yellow	Lemon yellow (Barium)	Cool, toward green	Somewhat opaque	Very little staining, a slight amount of sediment	There are two versions of lemon yellow on the market. This one, made with a Barium base, is very cool, veering toward green, and on most papers can be completely washed off. Weak in tinting strength, it almost disappears in mixture with most other colors. Very permanent.
	Lemon yellow (Hansa)	Cool, toward green	Very transparent	A little staining, not much sediment	This is the other lemon yellow, made with a base of Hansa yellow, which is a bright, pale, yellow synthetic dyestuff. Brighter than the lemon yellow above, it holds its own in mixtures.
	Winsor* yellow	Cool, towards green	Very transparent	Although some staining, no sediment to speak of	Very similar to lemon yellow (Hansa). Its coolness and transparency make fresh, bright greens when mixed with blue.
	Cadmium lemon	Almost center of yellow position on color wheel	Slightly opaque	Some staining, a fair amount of sediment	Close to a true yellow, neither toward green nor orange. It holds its tinting strength well in mixtures (all cadmium yellows seem to) and is a good all-around yellow.
	New gamboge	Warm	Fairly transparent	Somewhat staining	Although it's not as transparent as the original gamboge (which isn't permanent), I love to use this color, especially for mixing the greens of foliage.
	Cadmium yellow: pale, medium, deep	All are warm	All have some opacity	Although all have some sediment, there's a stain left after you wash them off	Good, warm, permanent, workhorse colors. All mix well, adding a little opacity in maximum intensity washes. The deep seems almost an orange, in a rich mix.
	Yellow ochre	Nearly center of yellow as a grayed yellow	Some opacity	No stain, can be almost completely washed off the paper, sedimentary	A real "must" color for most artists. Soft and never dominating, it's still a most useful color that mixes well with all other colors, and adds a subtle glow to passages by itself. Excellent in glazing over more "staining" washes.
	Raw sienna	Nearly center of yellow as a grayed yellow	Fairly transparent	Stains slightly, some sediment	An alternate for yellow ochre, some brands of raw sienna seem cooler than others. A very permanent earth color; a grayed yellow on the color wheel.
	Raw umber	Cool	Transparent	No stain, some sediment	Varies from green to yellow, depending on brand. Think of this old reliable earth color as a grayed yellow that's slightly toward green.

Color Group	Name of Color	Temperature	Transparent or Opaque	Staining or Sedimentary	Comments
Orange	Cadmium orange	Warm	Some opacity	A lot will wash off but a definite yellow-orange stain will remain, some sediment	Looks like the perfect orange—neither warm nor cool—as you squeeze it out of the tube, but it tends toward yellow in mixtures and dilution. The best of the oranges available.
	Burnt sienna	Warm	Transparent	Stains slightly, some sediment	The brightest of the earth colors. A permanent, orange-red, a marvelous mixer—one of the most useful of all the colors.
	Burnt umber	Warm	Fairly transparent	Leaves a little stain after being sponged off, some sediment	A permanent, very grayed red-orange by itself. I find it tends to deaden some other hues—especially if the mix is made of more than two colors.
Red	Cadmium scarlet	Warm	Some opacity	Leaves some orangey pink stain when washed off, some sediment	Sometimes called cadmium vermillion, this is a beautiful red, slightly toward orange, and a brighter and more permanent replacement for the ancient, true vermillion. The brightest of the cadmium reds, and a versatile color.
	Cadmium red: light, medium, deep	All are warm	All are somewhat opaque	Some stain left in paper when washed off, some sediment	Like the cadmium yellows, all the cadmium reds are good, permanent colors, somewhat opaque, especially in maximum intensity. For a bright, light red, I prefer cadmium scarlet, but cadmium red light makes good oranges when mixed with yellow. Cadmium red medium and deep do *not* make *bright*, clear violets, when mixed with any of the blues.
	Scarlet lake	Warm, almost a true red	Very transparent	Staining	A brilliant red, redder than alizarin crimson. Clearer and more transparent than any of the cadmium reds, it mixes well with all colors, holding its own while influencing all mixtures.
	Winsor* or Thalo* red	Warm, slightly toward violet	Very transparent	Very staining, no sediment	Not unlike scarlet lake, but a little cooler—closer to violet. Tends to dominate most mixtures, so use with discretion!
	Alizarin crimson	Warm, on the violet side	Very transparent	Stains the paper with a vengeance, little sediment	Another workhorse color that serves well as an all-around red toward violet, and mixes well but tends to overpower weaker-tint colors. Use with discretion in such cases.
	Permanent rose	Warm, toward violet	Very transparent	Staining, with no sediment	One of the family of new synthetic organic compounds, this is a beautiful, permanent red that was only available in fugitive or impermanent watercolors, just a few years ago.

Color Group	Name of Color	Temperature	Transparent or Opaque	Staining or Sedimentary	Comments
Violet	Cobalt violet	Slightly toward the warm side	Some opacity	Sedimentary, no staining	A gorgeous hue, permanent, and great in passages where it's alone—or nearly so. Easily dominated by most other colors, and tends to disappear in most mixtures. Has a luminous quality and granulates beautifully in big, wet washes. Very permanent, expensive, and said to be poisonous, so don't put your brush in your mouth!
	Winsor* violet	Close to center of violet position on color wheel	Very transparent	Staining, no sediment	Good replacement for mauve, which is listed as fugitive. It is made of the new organic compounds and has excellent brilliance. I generally prefer to mix my violets and purples, however, and don't use this color much.
Blue	Ultramarine or French ultramarine	Cool, but slightly toward violet	Transparent	Practically no staining if carefully lifted off good watercolor paper, some sediment	A wonderful, permanent, indispensible color, long a "must" in every artist's paintbox. Holds its own in most mixtures, never seeming to "seize" or dominate other colors out of proportion to its quantity. Can be combined with the earth colors to produce wonderful sedimentary, granular washes.
	Cobalt blue	Cool, close to center of blue position on color wheel	Somewhat opaque	Practically no staining, as with ultramarine, some sediment	Close to a "true" blue, but not as intense as one should be. Very permanent, but a little weak in tinting strength when combined with stronger colors. Excellent for glazes to produce atmospheric effects.
	Winsor* or Thalo* blue	Cool, slightly toward green	Very transparent	Very staining, no sediment	A powerful blue, edging toward green. Dominates every color it's mixed with unless care is taken: add this blue a little at a time! Replaces older and less permanent blues, such as Prussian and cyanine blue. Actual name: phthalocyanine blue.
	Cerulean blue	Cool, slightly toward green	Quite opaque	Practically no staining, fair amount of sediment	An old, reliable and permanent color, which, like cobalt, is useful in glazing to obtain atmospheric effects. Its name comes from the Latin word *caeruleus*, meaning sky-blue.
	Manganese blue	Cool, toward green	Transparent	No staining, can be washed off completely, some sediment	A relatively new color for artists that is permanent, makes wonderful sedimentary or granulated washes, combines well with most other colors, and holds its tinting strength fairly well in most mixtures.

Color Group	Name of Color	Temperature	Transparent or Opaque	Staining or Sedimentary	Comments
Green	Thalo* or Winsor* green	Cool, nearly on center of green on the color wheel	Very transparent	Very staining, no sediment	Real name is phthalocyanine. Very potent in tinting strength, will dominate and stain every color it's mixed with, so use with caution, a little at a time!
	Viridian green	Cool, slightly toward blue	Transparent	Leaves some stain, some sediment	A permanent, reliable middle green. Doesn't dominate other colors like the new phthalocyanine green listed above. A good, all-around green.
	Hooker's green dark	Cool, but leans a little toward yellow	Transparent	Some staining, very little sediment	A popular color with many watercolorists, especially for painting foliage. I usually prefer to mix my greens from various blues and yellows. Hooker's green light is listed as less permanent.
	Terre verte	Cool	Somewhat opaque	No staining, good sedimentary qualities	A low-key, rather neutral earth color that's weak in all mixtures, but I find it useful for texured washes and atmospheric effects. Very permanent.
Gray	Payne's gray	Cool	Transparent	Slightly staining, a little sediment	A great favorite with beginning watercolorists, it tends to dry a great deal lighter in value than it looked when wet. Equally good, or better, grays can be mixed with complements.
	Davy's gray	Nearly neutral	One of the more opaque watercolors	No stain, lots of sediment	A very neutral gray, sometimes useful in calming down a color scheme that's gotten too brilliant. A very permanent color made of ground slate, it washes off completely.
Black	Lamp black	Toward cool	Somewhat transparent in dilution	Moderate staining	Although I don't use black very often in watercolor painting, it's good to know that even here, warm and cool are evident. Permanent, cool and weaker than ivory black. Made from pure carbon, usually with soot as the source.
	Ivory black	Toward warm	Somewhat transparent in dilution	Very little staining	This is the most-used black among watercolorists. Originally, it was made from burnt ivory, but for many years it's been made from burnt animal bone. Very permanent.

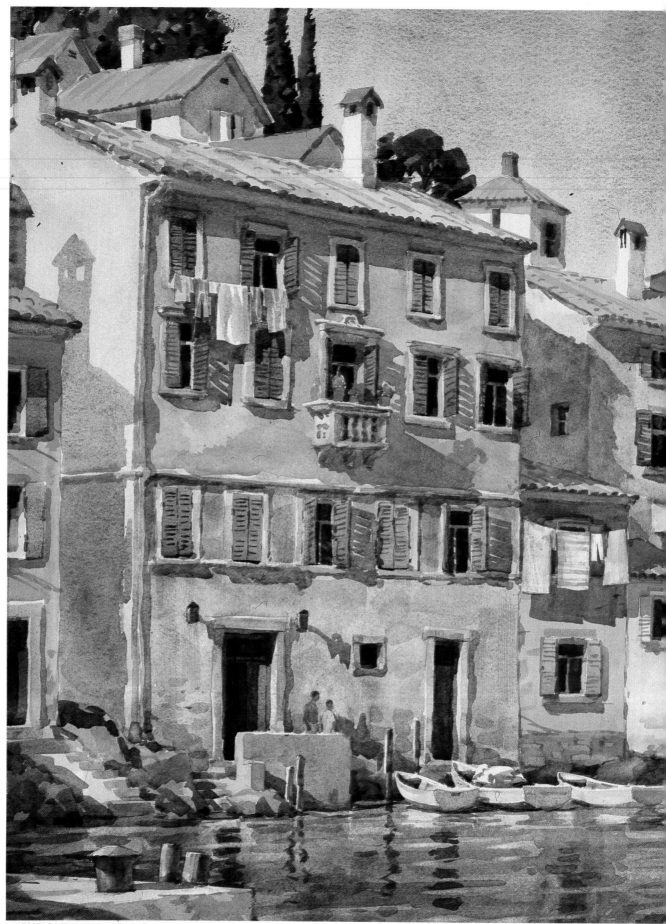

ADRIATIC MORNING, 21″ × 28″. Collection of Phil Schneider.

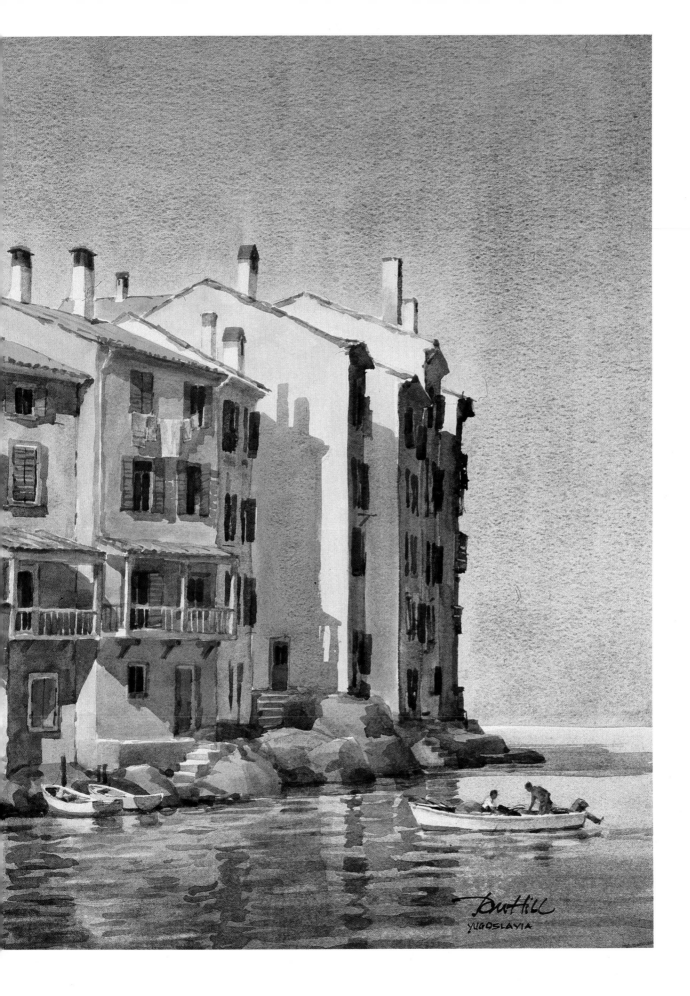

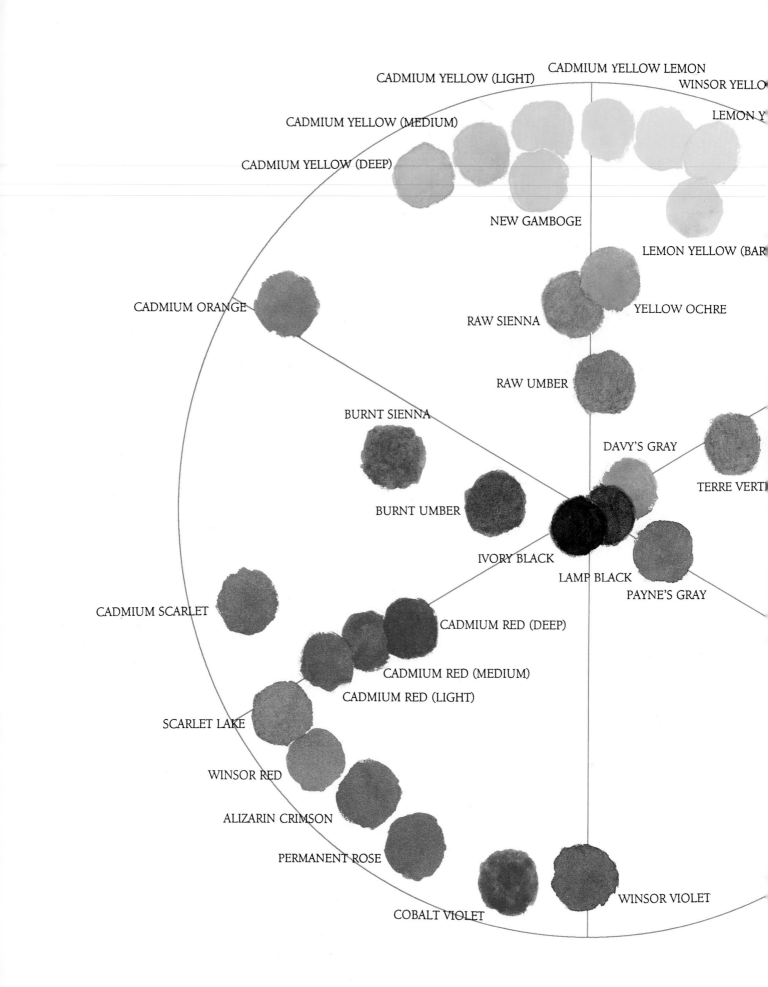

CADMIUM YELLOW LEMON

CADMIUM YELLOW (LIGHT)

WINSOR YELLO

CADMIUM YELLOW (MEDIUM)

LEMON Y

CADMIUM YELLOW (DEEP)

NEW GAMBOGE

LEMON YELLOW (BAR

CADMIUM ORANGE

RAW SIENNA

YELLOW OCHRE

RAW UMBER

BURNT SIENNA

DAVY'S GRAY

BURNT UMBER

TERRE VERT

IVORY BLACK

LAMP BLACK

PAYNE'S GRAY

CADMIUM SCARLET

CADMIUM RED (DEEP)

CADMIUM RED (MEDIUM)

CADMIUM RED (LIGHT)

SCARLET LAKE

WINSOR RED

ALIZARIN CRIMSON

PERMANENT ROSE

WINSOR VIOLET

COBALT VIOLET

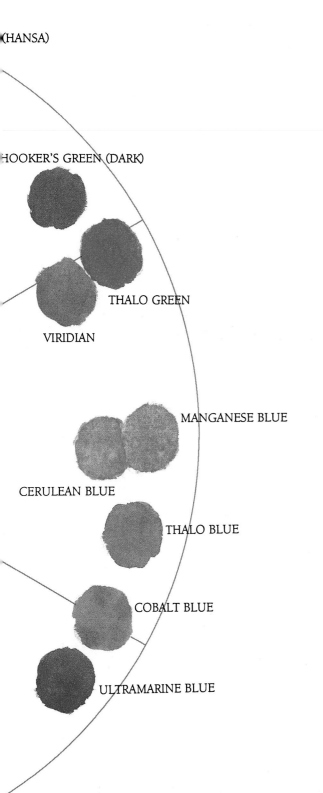

(HANSA)

HOOKER'S GREEN (DARK)

THALO GREEN

VIRIDIAN

MANGANESE BLUE

CERULEAN BLUE

THALO BLUE

COBALT BLUE

ULTRAMARINE BLUE

TUBE COLORS ON THE COLOR WHEEL

The large color wheel on pages 30-31 depicts idealized hues in all their correct positions—and makes an easy way to see their relationships to each other. Now, if you were to place the thirty-seven tube colors from the chart onto a color wheel, where would you put them in regard to each color's hue, temperature and intensity? Keep in mind that most ready-made watercolors don't match up exactly with the idealized "true" colors, either in purity or intensity.

I've painted swatches of the actual paints, just described on the chart, onto another color wheel (left). As you can see, similar hues crowd each other for approximately the same positions and different brands of the same color might require some adjustment—but now we have an idea of where each tube color fits in relation to the idealized primaries and secondaries. The more intense the color, the closer it should be to the wheel's rim; the more grayed the color, the closer it should be to the neutral center. For example, we know that yellow ochre isn't as intense as our ideal maximum-intensity yellow, and therefore should be closer to the totally grayed center of the wheel. And, as I noted in my color chart, yellow ochre is about center of the yellow position on the color wheel.

As another example, alizarin crimson falls on the "warm" side of the wheel and is a "warm" hue compared to blue. However, it's a "cooler" hue than scarlet lake or cadmium scarlet. In the same way, Hooker's green falls on the "cool" side of the wheel, but is "warmer" than thalo green and "cooler" than Winsor yellow.

Here you can see the hues of the thirty-seven colors (from the chart on pages 34 through 37) and approximately where they fall on the color wheel.

Experiments to Check Color Characteristics

Here are some experiments you might like to try to get better acquainted with the capabilities, as well as the idiosyncrasies, of our actual colors.

TRANSPARENCY/OPACITY OF COLORS. Some watercolors are more transparent than others, and it's useful to know which ones, especially when glazing one color over another. The more opaque pigments—like the cadmium colors—tend to bleed up into any wash painted over them, even after they're dry. Here's an easy way to test any color's transparency.

With waterproof black ink (India ink), make a straight line about ½ inch wide and 12 to 14 inches long—or longer, if you want to test more colors. Let the ink dry completely; otherwise, it won't be waterproof. I used the thirty-seven pigments from the color chart and from the tube color pigment color wheel (see pages 44-45). You could test these, or any others you want. Using a rich, full paint mix, paint maximum intensity brushstrokes about 1½ inches long and ½ inch wide across the black line. Lay your brushstrokes on the paper deliberately and completely; don't go back into the paint.

Here again, cleanliness is essential if you're really going to see each color, so wash out your brush between each stroke and use only clean water. After the colors are dry, you'll be able to see the black line completely through some colors, like alizarin crimson and thalo blue, but less completely through more opaque colors like yellow ochre, the cadmium yellows, and cadmium orange.

COLORS WASHED OVER AND UNDER EACH OTHER. This is a good test to find out how each color tested looks—both as a glaze *over* and a wash *under*—every other color! Using the same colors that I did—or those of your own selection—paint vertical bands, about ½ inch wide and fairly close together, of each color to be tested and let them dry completely. Then, make *horizontal* bands of the same size and proportion, in the same order, across the vertical bands. Avoid going back into the painted band with another stroke; just use a fairly full brushload of paint and try painting each band in one deliberate stroke.

After you're finished, you'll be able to tell which colors glaze cleanly over each other (the really transparent ones) and which tend to "muddy up" a little (the more opaque ones).

Notice how a more opaque color glazes better *over* a dry, transparent one—but *not* the other way around! Write the name of each color at the end of each band, for easy reference later.

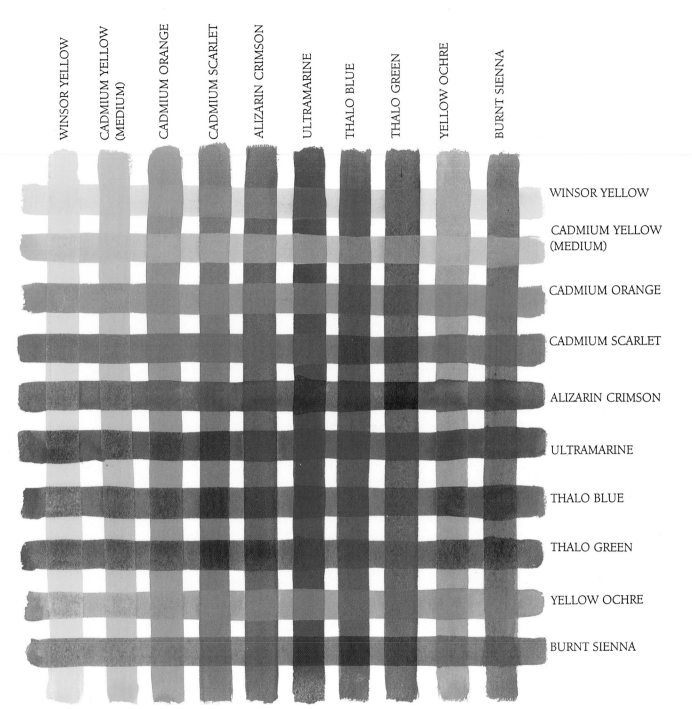

WINSOR YELLOW

CADMIUM YELLOW (MEDIUM)

CADMIUM ORANGE

CADMIUM SCARLET

ALIZARIN CRIMSON

ULTRAMARINE

THALO BLUE

THALO GREEN

YELLOW OCHRE

BURNT SIENNA

This color grid gives you a chance to see each color that you test both over *and* under *every other color! I painted all the colors in one direction and let them dry, then repeated them in the same order going across at right angles. Now, both transparency and opacity, as well as glazing characteristics, can easily be seen.*

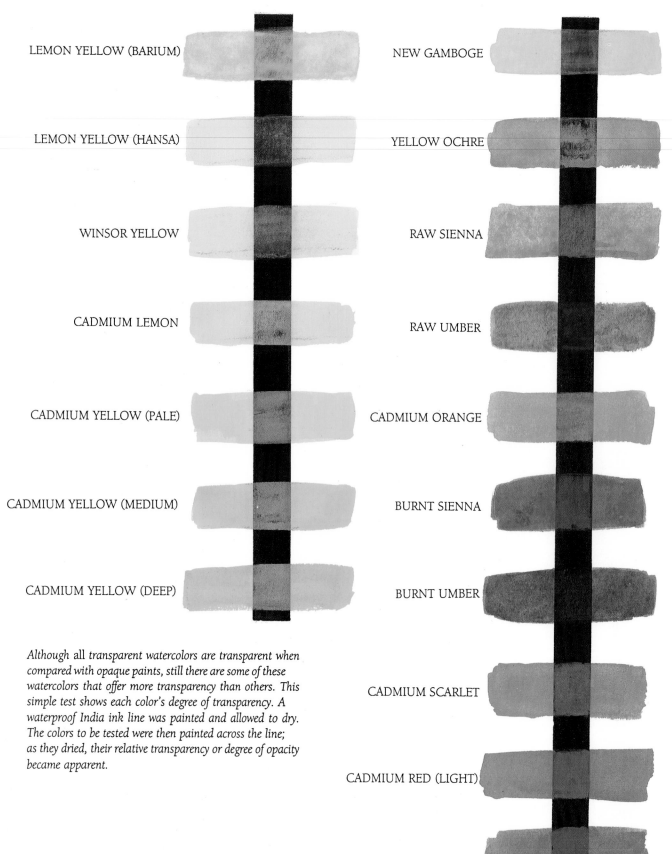

LEMON YELLOW (BARIUM)

NEW GAMBOGE

LEMON YELLOW (HANSA)

YELLOW OCHRE

WINSOR YELLOW

RAW SIENNA

CADMIUM LEMON

RAW UMBER

CADMIUM YELLOW (PALE)

CADMIUM ORANGE

CADMIUM YELLOW (MEDIUM)

BURNT SIENNA

CADMIUM YELLOW (DEEP)

BURNT UMBER

Although all transparent watercolors are transparent when compared with opaque paints, still there are some of these watercolors that offer more transparency than others. This simple test shows each color's degree of transparency. A waterproof India ink line was painted and allowed to dry. The colors to be tested were then painted across the line; as they dried, their relative transparency or degree of opacity became apparent.

CADMIUM SCARLET

CADMIUM RED (LIGHT)

CADMIUM RED (MEDIUM)

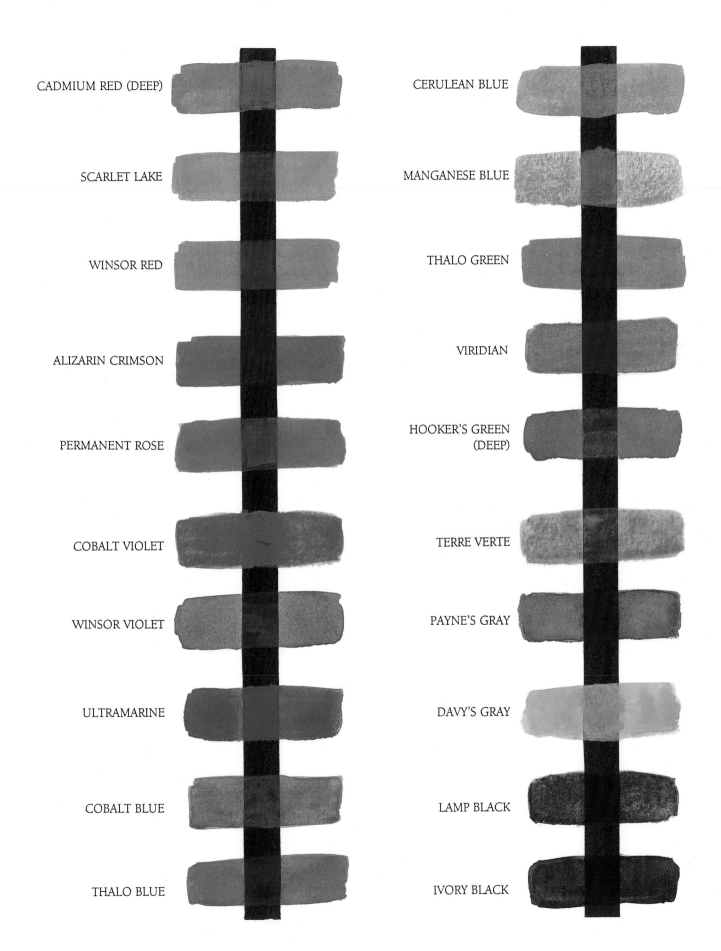

CADMIUM RED (DEEP)

SCARLET LAKE

WINSOR RED

ALIZARIN CRIMSON

PERMANENT ROSE

COBALT VIOLET

WINSOR VIOLET

ULTRAMARINE

COBALT BLUE

THALO BLUE

CERULEAN BLUE

MANGANESE BLUE

THALO GREEN

VIRIDIAN

HOOKER'S GREEN
(DEEP)

TERRE VERTE

PAYNE'S GRAY

DAVY'S GRAY

LAMP BLACK

IVORY BLACK

How Colors in Paint Behave 45

STAINING STRENGTH OF COLORS. Some pigments will wash off the paper almost completely. Others are more staining and grab the paper fibers with a firm grip. It's smart to know in advance what staining power each paint possesses and to anticipate if you'll want to lift off any of these colors later.

Use a sheet of good watercolor paper that can take the scrubbing-out required to get the paint off. I allowed enough area for my paint swatches to be about 1 inch wide and 1½ inches deep. Try testing the colors that I did on the facing page — or any others that interest you. Be sure you use a rich mix of each color. Wash your brush out completely between each color, using only clean water as you mix your color. Take care to keep the whole procedure meticulously clean or the results won't be accurate.

After the color is completely dry, gently wet half of each swatch's color to soften it. Using a bristle brush or small cosmetic sponge, loosen the pigment, then blot it up with a clean tissue. It might be helpful to cover half of each swatch with masking tape, (as I did); it's a little easier to lift part of the color out without disturbing the other half, and it leaves a clean, sharp edge between the areas for better comparison. Now you can easily tell the pigments that stain the most.

TINTING STRENGTH OF COLORS. When we dilute a color with water, we produce a tint of that color; the more water added, the weaker in intensity the tint becomes. Given the *same* dilution, some colors retain their intensity better than others. Also, whereas a color may look like one hue when right out of the tube (at maximum intensity), it's surprising how often it seems to change *hue* a little in dilution. The following test (shown on page 48) shows both these characteristics. Allow a space about 2 inches wide by 2 inches deep for each color tested, leaving enough space between colors. Then dilute each color with water to create little versions of the graded washes we did back in chapter 2 with the maximum intensity at the top, graded down to white paper at the bottom. You can test as many colors as you have space and time for, especially those you paint with a lot.

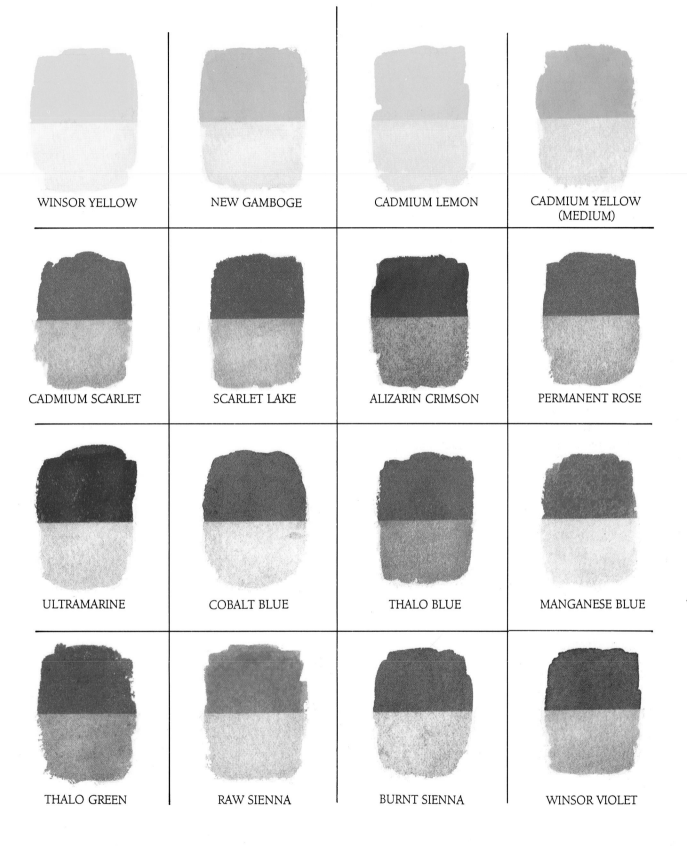

WINSOR YELLOW

NEW GAMBOGE

CADMIUM LEMON

CADMIUM YELLOW
(MEDIUM)

CADMIUM SCARLET

SCARLET LAKE

ALIZARIN CRIMSON

PERMANENT ROSE

ULTRAMARINE

COBALT BLUE

THALO BLUE

MANGANESE BLUE

THALO GREEN

RAW SIENNA

BURNT SIENNA

WINSOR VIOLET

*This test gives an idea of the staining abilities of different
pigments. After the colors were dry, I sponged off part of each
swatch with clean water, revealing what stain was still left.
This can vary from paper to paper.*

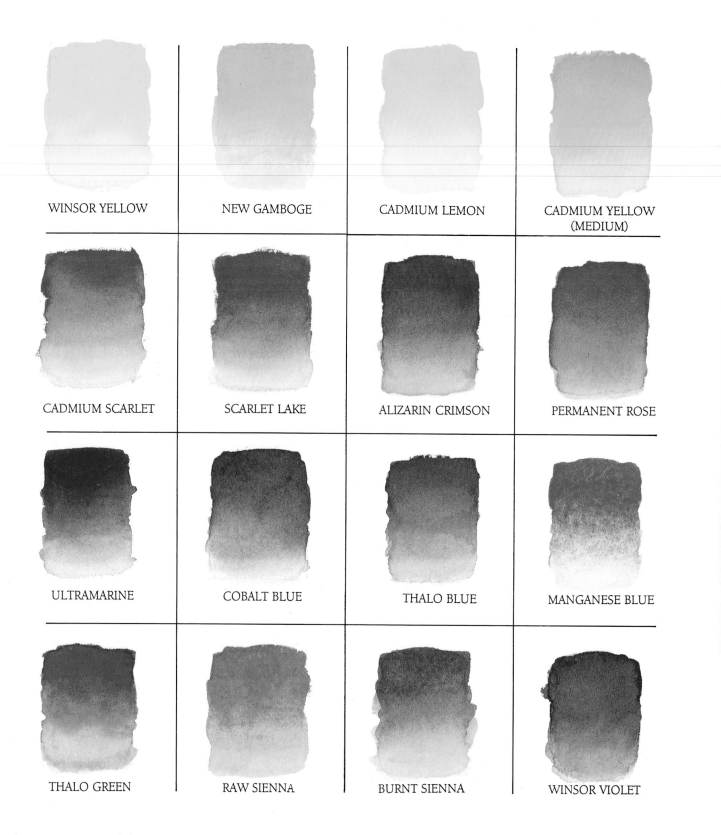

WINSOR YELLOW	NEW GAMBOGE	CADMIUM LEMON	CADMIUM YELLOW (MEDIUM)
CADMIUM SCARLET	SCARLET LAKE	ALIZARIN CRIMSON	PERMANENT ROSE
ULTRAMARINE	COBALT BLUE	THALO BLUE	MANGANESE BLUE
THALO GREEN	RAW SIENNA	BURNT SIENNA	WINSOR VIOLET

When we dilute watercolor paint with water, we get a tint, and as different pigments have different tinting strengths, this test helps show how each color tested looks in equal dilution. Some seem to change their hue a little; some stay stronger, in equal dilution, than others.

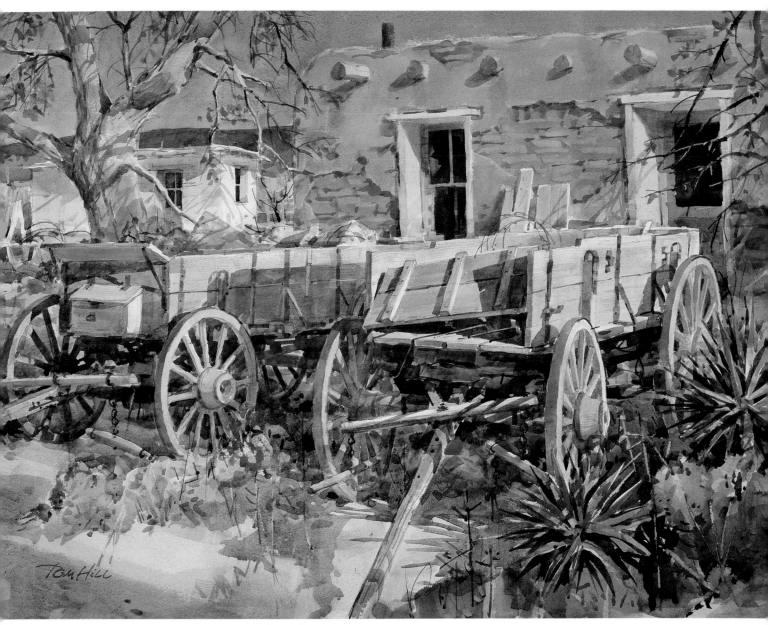

NEARLY FORGOTTEN, ALMOST GONE, 21" × 28½".

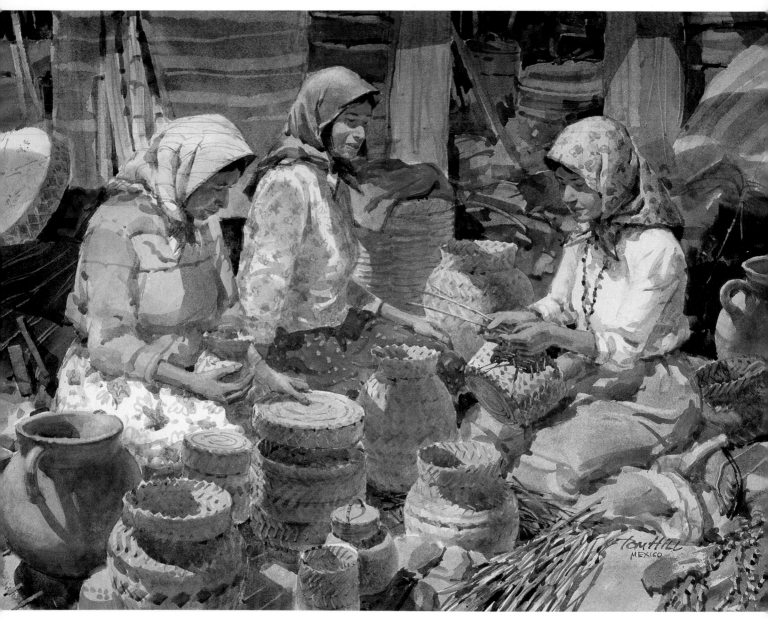

TARAHUMARA BASKET WEAVERS, 21″ × 28½″. Collection of Claudia Mandabach.

The primitive Tarahumara Indian people live in a remote mountainous part of northern Mexico. The men are known for their endurance at running. The women, always colorfully dressed, do many utilitarian handicrafts including the weaving of elegant baskets. I used a full-color palette in my painting of these women and their wares.

COLOR MAGIC

S o far, all our experiments and tests have been with individual tube colors, alone or as a glaze. Let's explore further!

When we *mix* any two colors, we get a third, and depending on several factors, the results of that mix can vary greatly. Such factors include *which* two colors are mixed, in what *proportion* to each other, and in what *dilution* with water.

There wouldn't be enough space in this whole book to mix paint swatches of *each* tube color with *every* other color—informative though that would be. We can learn a lot about color mixtures if we start simply and proceed logically.

On the next few pages are some more color experiments for you to try—all designed to make color mixing more understandable and thus make it easier for you to achieve the colors you want.

MIXING TWO COLORS

On the next page I confined my color choices to the three primaries—red, yellow and blue—using a "warm" and "cool" version of each one. Then I painted cool-and-cool, warm-and-warm and warm-and-cool combinations of each possible color pair to create twelve swatches. I tried for equal intensity of each color, mixing a rich wash of each pair. Of course, if I'd used *unequal* proportions in each pair, the results would have been entirely different!

My choices were: cool yellow: *Winsor yellow*; warm yellow: *new gamboge*; cool red: *alizarin crimson*; warm red: *cadmium scarlet*; cool blue: *thalo (or Win-*

sor) blue; warm blue: *ultramarine*. Mix the same combinations and compare your results with mine.

Try mixing the cool and warm primaries above with the green, orange and earth colors—and any others that you feel you'd like to know more about. The same could be done with varying proportions of one color to another, more water, less water, etc.

In this experiment, it's interesting to note that where the second color is so far around the color wheel as to be a bit nearer the first color's *complement*, the mix will be grayed. For example, in the first swatch, where I mixed cool yellow with cool red, the green tendency in the cool yellow grayed the red a bit, resulting in a less-intense orange than the mix in the sixth swatch, where a warm red and a warm yellow (closer together on the color wheel) yielded a nice bright orange. Notice which colors seem to dominate each mix, which swatches turn out brighter, or more intense, and which seem to be grayed.

I think that now, having done these color experiments, we could decide on a rough rule-of-thumb about our colors: The more a color stains the paper, the more likely it is to stain (dominate) the other color it's mixed with. Further, we might say that the more sedimentary a color is, the weaker its staining power, and the greater the likelihood it will be dominated by a staining color in any "equal" mix.

MIXING MORE THAN TWO COLORS

I feel that the fewer colors you mix to arrive at what you want, the cleaner, truer and less muddy your

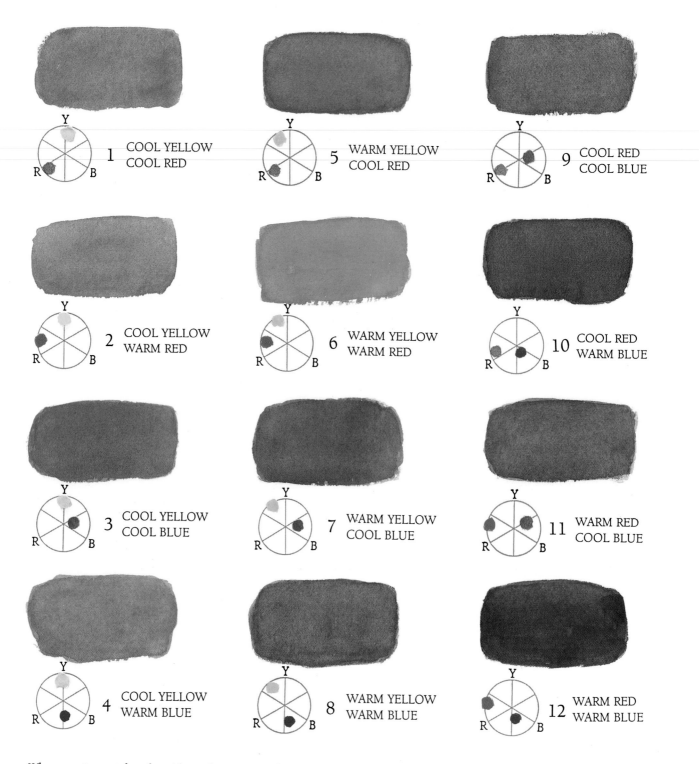

1 COOL YELLOW
COOL RED

5 WARM YELLOW
COOL RED

9 COOL RED
COOL BLUE

2 COOL YELLOW
WARM RED

6 WARM YELLOW
WARM RED

10 COOL RED
WARM BLUE

3 COOL YELLOW
COOL BLUE

7 WARM YELLOW
COOL BLUE

11 WARM RED
COOL BLUE

4 COOL YELLOW
WARM BLUE

8 WARM YELLOW
WARM BLUE

12 WARM RED
WARM BLUE

When we mix one tube color with another, we get a third color — sometimes with unexpected results. For example, color theory tells us that red, mixed with blue, will make violet; but in swatch 11 above, a warm red (cadmium scarlet) mixed with a cool blue (thalo) makes a strange gray. This is because there is some yellow in both the red and blue and as yellow is violet's complement, it acts to gray the mixture, cancelling the violet. The little color wheels·help you see at a glance the warmness or coolness of the pairs of colors used in these mixtures.

results will be, with the best reflection of color from the pigment. Obviously, you can't mix every color, value, etc. that you need, from only *two* pigments every time. But if you think through what you want and how to arrive at it, you'll find you can *come close* almost every time. Just look again at the great variety of swatches achieved on the facing page, and I was only using mixes of equal intensity from the three primaries!

Of course there are times when you will have to add a third color to the mix to achieve your goal. As we discussed in chapter 3, every pigment reflects its identifying color rays and absorbs the rest. The more colors you put together, the more rays absorbed and the fewer reflected, resulting in duller, less-clear color. We know that equal mixing of complements results in near-black and of course, mixing any triad (red, yellow and blue, or orange, green and violet) in equal parts would amount to the same thing.

So, if you want to add a third color, consider what we've been discussing here — intensity, staining strength and complements — and try to make your third color do the job, without turning the mix to mud! As an example of how this might happen, say you want a clear, slightly grayed yellow-green, and you've made a mix of Winsor or lemon (Hansa) yellow with thalo green. You have achieved a yellow-green, but it's *too* brilliant. Adding water would only make a lighter *tint* of the same yellow-green, so you decide to add a little of its complement, red-violet. Not having a red-violet tube color, you mix your red-violet from a red and a blue, probably using alizarin crimson and ultramarine. By this time, you've got *four* colors going, really lessening your chance for a clear, clean final result.

Suppose, instead, that you started with yellow ochre or raw sienna (similar yellows that are already somewhat grayed). Then, by adding thalo green a little at a time (or viridian, which isn't so dominating), you could get your result with only two colors. I could go on with other examples, but there's no need — you get the idea.

Mixing Colors While Painting

In addition to glazing one color over another dry one, and mixing colors together on the palette before applying them to the paper, you can also mix the colors *right on the paper*. You can put a color down on the paper, and while it's wet, charge other colors into it, modifying some or all of it. Referred to as *wet-in-wet* (discussed in chapter 2), this method can add a special "life" or character to a painting passage. One reason is that the colors aren't as thoroughly blended as on the palette and tend, instead, to mingle. This means that there's better reflection of light because each color still has a little of its original identity. Add all the possibilities of sedimentary versus staining color, different values, warm and cool, and you've got a lot of potential color excitement. On the following page I've painted some wet-in-wet, plus "charging" examples that you might want to try — they're fun and exciting to do!

On your palette, prepare rich, full intensity washes of scarlet lake and manganese blue. Wet your paper and then working wet-in-wet, charge a brushload or two of manganese blue into clean, moderately wet paper. Let some areas keep more pigment than others; this is one of those pigments that you can shove around on the paper while things are still wet. Rinse out your brush. Immediately flow some irregular, scattered strokes of scarlet lake right into the manganese wash you just put down. Things will be pretty wild and exciting as the *staining* scarlet lake mingles with the *nonstaining*, granular manganese blue. You'll be able to push the scarlet lake around a *little*, but not much and not for long, because it gets right down between the particles of manganese blue and bites into the paper's fibers fast. Results? A fascinating stain-grain, warm-cool, painted passage that you just couldn't get in any other medium that I know of! The "hot" red stain of the scarlet lake glows through and between the cool, intense granular "settlings" of the manganese blue.

Another wet-in-wet to try: Using ultramarine and burnt sienna, float areas of each color side by side so that they run together loosely in the middle — something like the upper right example on the next page. Notice that it's possible to get beautiful, granulated gray washes, that can be either warm or cool, depending on which pigment dominates your mixture — or, with pigments in equal proportion — make solid darks that don't go "dead." On the lower right-hand side of the next page is another wet-in-wet. This one is also an example of a staining-sedimentary

Putting paint into previously wet areas is called painting wet-in-wet. Adding new wet color to that already wet passage is termed "charging" one color into another. These examples show the technique. Directly above, I painted manganese blue into a fairly wet area of the paper, then quickly added clean scarlet lake. Where the two meet, it's in a random fashion—not really mixed, so the results aren't violet, but more a warm/cool mingling. The example to the right was the same procedure, but done with raw umber and permanent rose. In both cases it's a combination of a staining color and a sedimentary color. Above right is a combination of two sedimentary colors, burnt sienna and ultramarine blue, neither of which stain the paper as much as scarlet lake and permanent rose, and instead stay more on top of the paper, forming lovely warm and cool granulated washes where they mingle.

combination. Use raw umber instead of manganese blue, then charge it with a potent dose of permanent rose. The raw umber can be moved around before it dries—in fact, the permanent rose literally *pushes* it around—creating another stain-grain, warm-cool passage. Try other combinations—the possibilities are endless—and each one (done thoughtfully) will add to your color knowledge.

Graying Colors

Back in chapter 3, we talked about graying a color by mixing it with its complement. Our tests with color mixes in this chapter reveal that tube colors are "characters" with distinct "personalities," and don't always behave according to color theory. It seems the best way to know what tube color most effectively grays another without changing its *hue* is to learn by actually trying the various combinations.

GRAYING REDS (AND GREENS). Although we are going to talk about graying reds, the same thing, of course, will apply in reverse to graying red's complement, green. For the reds that are toward orange, like cadmium scarlet and cadmium red light, try graying them with either viridian, or thalo green—both a little toward blue! As a matter of fact, you can gray cadmium red light or cadmium scarlet fairly well with either manganese blue or cerulean blue, because they both are blues that are somewhat green, and so will do the job.

For graying cadmium red medium or deep, you can still use the two greens, either viridian or thalo.

These two greens also work pretty well to gray alizarin crimson; as a matter of fact, intense mixes of alizarin crimson and thalo green can produce a *very* rich dark the value of black, but not as "dead." If the alizarin, grayed only with thalo green, looks a little too *cool*, then warm it up to the right hue with just a bit of lemon or Winsor yellow. Graying permanent rose (quinacridone) is tricky. I found fair success by mixing it with a green I made from ultramarine and lemon yellow. When permanent rose is mixed with viridian or thalo green, it produces a strange, lovely violet, and the more thalo green added, the more the

mix turns toward a dark purple—very unexpected!

There are many more possibilities for graying the different reds. Try them with different complements and near-complements, and see what you discover.

GRAYING YELLOWS (AND VIOLETS). Yellow is one of the lightest colors in value, whereas violet, its complement, can be quite dark in value. When trying to gray a given yellow, it's a bit difficult to keep it from sliding toward the cool (green) side or warm (orange) side.

For the cool yellows like Winsor or lemon, a mix of alizarin crimson and ultramarine that's a little toward the warm (violet) side, does pretty well. The same is true for the warmer yellows like cadmium pale and cadmium medium, except that you make the violet mix a little toward the cool (blue) side— not too much, however. A little practice with a good light source, clean water and paints will help you learn how far to go to achieve a certain result.

GRAYING BLUES (AND ORANGES). To gray a warm blue (ultramarine), theory tells us to use its complement, orange—but, if we use cadmium orange with ultramarine, instead of behaving like it should in proper color theory, the cadmium orange seems to veer off toward yellow, so our ultramarine looks like a somewhat dirty, grayed *blue-green* (rather than simply a grayed ultramarine).

Now let's try a near complement—burnt sienna—which is really sort of a grayed, or neutralized, *red-orange*. It works beautifully with ultramarine, graying it without changing its hue. Most of the other blues can be successfully grayed with this versatile color, so you ought to try it with them. Burnt sienna neutralizes cobalt as well as it does ultramarine; however, cobalt blue isn't as powerful and it's easy to overdo the burnt sienna and wind up with a grayed burnt sienna, instead of a grayed cobalt blue! Burnt sienna even does a fair job graying thalo blue.

To familiarize yourself with the graying characteristics of any of these complements or near complements that we've been talking about, try the experiments on the following two pages.

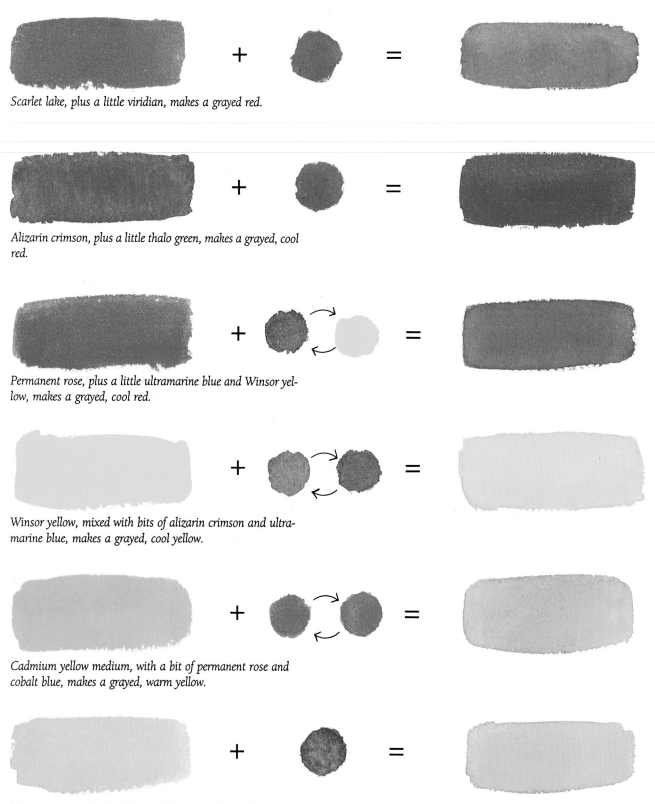

Scarlet lake, plus a little viridian, makes a grayed red.

Alizarin crimson, plus a little thalo green, makes a grayed, cool red.

Permanent rose, plus a little ultramarine blue and Winsor yellow, makes a grayed, cool red.

Winsor yellow, mixed with bits of alizarin crimson and ultramarine blue, makes a grayed, cool yellow.

Cadmium yellow medium, with a bit of permanent rose and cobalt blue, makes a grayed, warm yellow.

New gamboge, mixed with a little Winsor violet, makes a grayed, warm yellow.

The combinations of paint used above and on the facing page show effective ways to successfully gray given hues, without using black, and still largely keep the color the same hue.

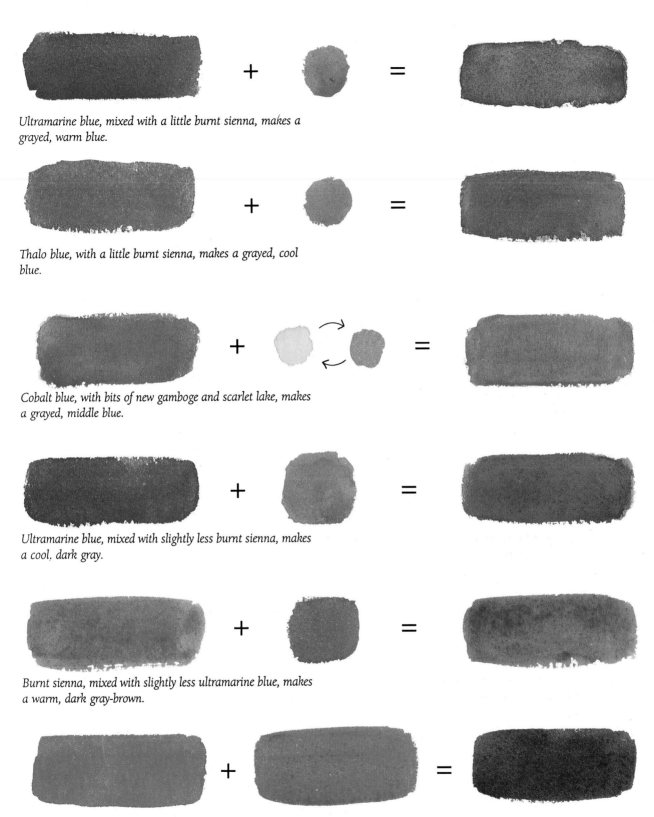

Ultramarine blue, mixed with a little burnt sienna, makes a grayed, warm blue.

Thalo blue, with a little burnt sienna, makes a grayed, cool blue.

Cobalt blue, with bits of new gamboge and scarlet lake, makes a grayed, middle blue.

Ultramarine blue, mixed with slightly less burnt sienna, makes a cool, dark gray.

Burnt sienna, mixed with slightly less ultramarine blue, makes a warm, dark gray-brown.

Alizarin crimson, plus an equal amount (approximately) of thalo green, makes a very dark neutral.

Warm, cool and neutral darks are easily mixed from simple combinations—and can act as lively replacements for black.

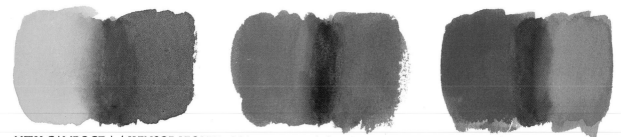

NEW GAMBOGE ◆ ◀ WINSOR VIOLET SCARLET LAKE ◆ ◀ THALO GREEN ULTRAMARINE BLUE ◆ ◀ A MIXED
ORANGE

Color theory says equal parts (approximately) of complements combine to make neutrals — the richer (more saturated) the paint, the darker the value. Above, I've mixed primaries and secondaries — and the theory works pretty well in practice. Try other pigments as well.

GRAYING COMPLEMENTS. Mix a little batch of each in separate areas of your palette. With clean brush and water, make a vertical band about 1 inch wide and 2 inches high of each color, allowing a space between them. Then, while they're still wet, pull the two colors together, in the white center, blending them with your brush as they meet, and making a grayed neutral band in the center. I did several such swatches, which are shown at the top of this page. Try experimenting with other pigment complements or near complements that you want to learn about.

INTENSIFYING COLORS

It's clear that complementary colors gray or neutralize each other when mixed together; we've just proven that with our tests. Now, here's a paradox: The same complements that gray each other in mixtures can be placed side by side — or one surrounding the other — and *not* mixed, and they will *enhance* each other's hue! In other words, complements can *intensify* each other's intensity! Strange as it seems, a maximum-intensity color isn't as intense by itself on white paper, as when directly next to or surrounded by its complement. This is called "color contrast."

Value is another factor influencing the way a color or hue appears to us. Some colors in their brightest or most intense state are dark in value, and others light in value, while still others are somewhere in between. For example, yellow, at its brightest, is still a light value, whereas its complement, violet, is a dark-value color. These two, placed side by side, will contrast both by their color complement *and* their value.

Blue and orange are not as great in value-contrast as yellow and violet, while red and green at full-intensity are about the same value. These last two colors, in equal areas and intensities, and in juxtaposition, can cause some rather strange visual phenomena. Where their edges meet, the colors seem to oscillate or vibrate in a rather disturbing manner.

If the area of red is large and the area of green very small, then the green seems to get *very* active — appearing to almost jump right off the paper! However, if a little red is mixed with the green and a little green with the red, then both red and green calm down and seem compatible — even harmonious! Orange-to-blue and yellow-to-violet don't react with quite this much agitation, but certainly do enhance each other's intensity.

On pages 62 and 63, I did some experiments in influencing, modifying and intensifying given colors by what I painted next to them. Look them over and try them for yourself.

INTENSIFYING GRAYS. Mix a middle-value, neutral gray and paint two identical squares, 1 × 1 inch and about 4 inches apart. Surround the first with a 1-inch band of a *lighter* value of gray and the second with a *darker* value of gray. Paint right up to the dry squares, without leaving any white paper between the band

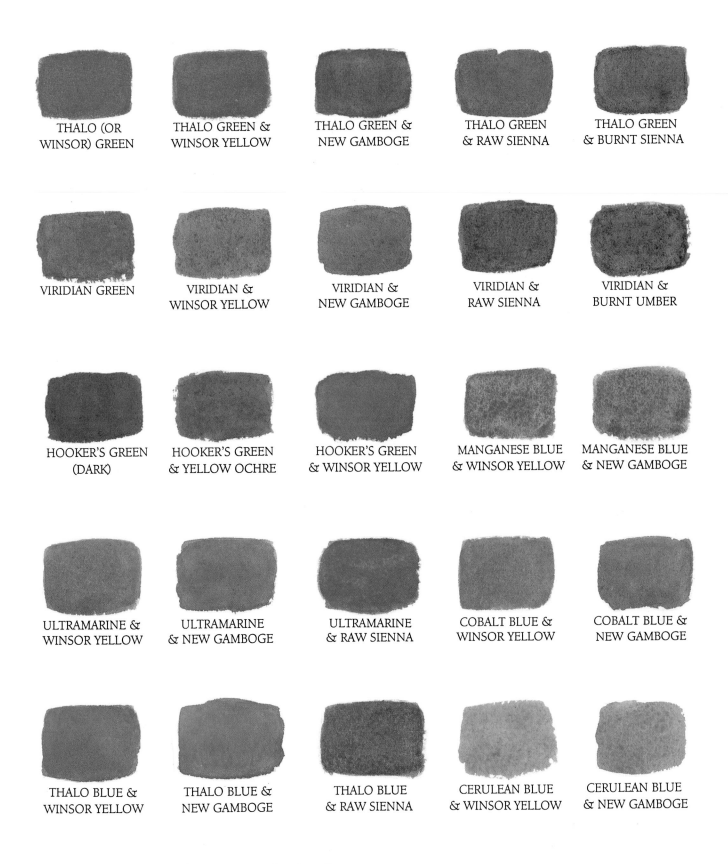

THALO (OR
WINSOR) GREEN

THALO GREEN &
WINSOR YELLOW

THALO GREEN &
NEW GAMBOGE

THALO GREEN
& RAW SIENNA

THALO GREEN
& BURNT SIENNA

VIRIDIAN GREEN

VIRIDIAN &
WINSOR YELLOW

VIRIDIAN &
NEW GAMBOGE

VIRIDIAN &
RAW SIENNA

VIRIDIAN &
BURNT UMBER

HOOKER'S GREEN
(DARK)

HOOKER'S GREEN
& YELLOW OCHRE

HOOKER'S GREEN
& WINSOR YELLOW

MANGANESE BLUE
& WINSOR YELLOW

MANGANESE BLUE
& NEW GAMBOGE

ULTRAMARINE &
WINSOR YELLOW

ULTRAMARINE
& NEW GAMBOGE

ULTRAMARINE
& RAW SIENNA

COBALT BLUE &
WINSOR YELLOW

COBALT BLUE &
NEW GAMBOGE

THALO BLUE &
WINSOR YELLOW

THALO BLUE &
NEW GAMBOGE

THALO BLUE
& RAW SIENNA

CERULEAN BLUE
& WINSOR YELLOW

CERULEAN BLUE
& NEW GAMBOGE

*Although there are a number of greens put up in tubes, I usually
have better results if I mix my greens. Above are a few of the
many possibilities—varying the proportions of the paints used
will produce many more combinations.*

and the square or overlapping the squares. After everything's dry, examine the results. Which of the identical squares now seems the lighter? Which seems the darker?

INTENSIFYING GRAY WITH COLOR. Now paint two identical neutral-gray, middle-value squares, the same as you did before. Surround the first with a full-intensity yellow, the second with a full-intensity violet. Notice that the first square appears faintly *violet*-tinged, while the other square has a definitely yellow cast.

MODIFYING COLOR WITH ITS COMPLEMENT. Paint two 1-inch squares of a slightly-grayed, middle-value green. Make them about 4 inches apart. Surround the first square with an intense red of about the same value, and surround the second with an intense green also of about the same value. What happens? The first square now appears to be a brighter *green* since it's surrounded by its complement, and the second square seems even more grayed, in contrast to the more intense green surrounding it. You'll find it hard to believe that the two green squares are actually identical!

MODIFYING COLOR WITH COLOR. Paint three full-intensity 1-inch squares of cobalt blue (a middle blue) about 4 inches apart. Surround the first with ultramarine blue (a warm blue), the second with thalo blue (a cool blue toward green), and the third with cadmium orange (blue's complement). Notice that the first square appears *cooler* than it did when it was alone on white paper, the second appears to be slightly *warmer*, and the last appears *bluer*.

Summing Up

I think we could safely make the following observations about intensifying, influencing or modifying a given color or value. Complements intensify each other when painted side by side. Light-value colors show up best against dark-value colors and dark-value colors show up best against light-value colors. A grayed color seems even grayer when a more intense version of the same color is put next to it. Any color is influenced by the color next to it, each tinting the other with its own complement. For easy reference I've made a little chart for you.

If you want a color to look:	Paint next to it:
More intense	Its complement
Less intense	A more-intense version of the same color, or a near-hue (its neighbor on the color wheel)
Darker	A lighter value
Lighter	A darker value
Cooler	A warmer color
Warmer	A cooler color

We could sum up the whole idea in Eliot O'Hara's words: "The law for keying a color or value is always the same—an area will vary in a direction opposite to its immediate surroundings."

	RED	ORANGE	YELLOW	GREEN	BLUE	VIOLET

MAXIMUM
SPECTRAL
COLOR

MATCHING
GRAYS

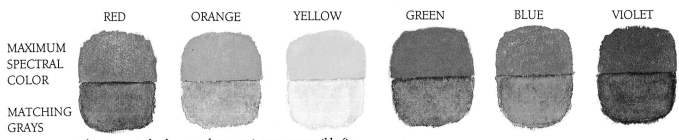

The six spectral colors are shown as intense as possible (in paint) while below them I've tried to match each with its corresponding value in a neutral gray.

MATCHING
COLOR
TINTS

LIGHT
GRAYS (ALL
THE SAME)

Here are six identical light value grays. Above them I've modified the original six spectral hues to match the light value. All except yellow had to be lightened with water. Yellow, though intense, is still a light value.

MATCHING
COLORS

MIDDLE
GRAYS
(ALL THE
SAME)

To match these middle-value grays I've had to alter some of the six hues. Red, green and blue were already close matches for the middle-gray value; violet still had to be lightened a bit; yellow and orange needed to be grayed with their complements a little to get them to a darker value.

MATCHING
COLORS

DARK
GRAYS
(ALL THE
SAME)

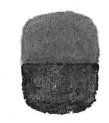
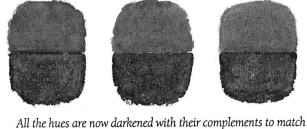
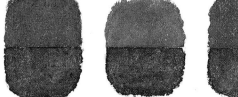
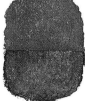

All the hues are now darkened with their complements to match them to the dark values — except violet, which is already a dark value at full intensity.

The examples above attempt to show the difference between the value (dark-to-light) of a color and its intensity (brilliant-to-gray).

Identical middle-value, neutral grays appear to be darker or lighter because of their surroundings.

The same gray squares can acquire an optical "tinge" of color that's the complement of the color surrounding the gray. For example, note the violet cast to the gray square surrounded by yellow.

A grayed, middle-value green can seem brighter or more neutral, thanks to its surrounding hues.

(Below.) Three identical, middle-hue blue squares can appear optically to be greener, more toward violet, or bluer than they were before, being surrounded by other hues. This phenomenon is called "simultaneous contrast."

 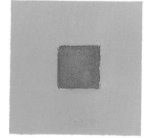

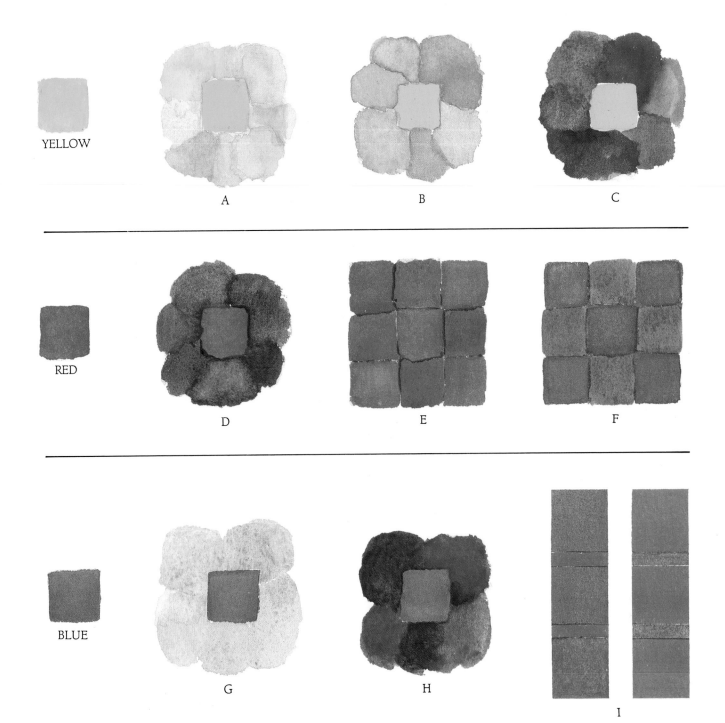

YELLOW

A

B

C

RED

D

E

F

BLUE

G

H

I

The three primaries undergo interesting character changes when their surroundings change. Even though at full intensity, yellow seems weak on a white ground, but (A) seems more intense when surrounded by other hues of the same value; (B) gains more strength with middle values; and (C) glows with brilliance against dark values, especially violet. Red, though intense, is dark appearing on white; (D) glows with intensity against complementary darks; (E) intense red and green can be almost irritating in equal proportions like this, but calm down (F) when intermixed and neutralized. Blue, a dark value against white, isn't as intense as red, and seems almost recessive (G) in close company of lighter value blues and greens. Surrounded by dark value complements (H) the same blue gains a cold yet glowing quality. Blue-green against red-orange (the coolest and warmest hues on the color wheel) (I) help each other's brilliance by proportion and contrast.

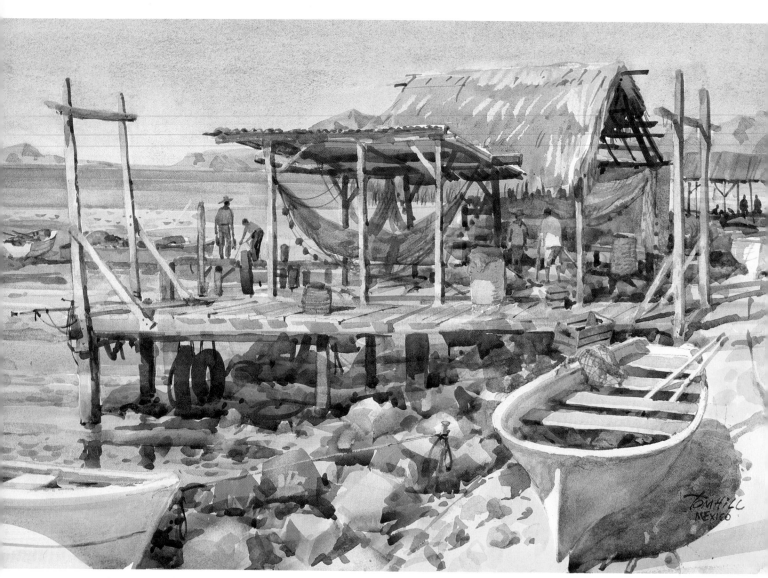

LOW TIDE, EMPALME, 14″ × 21″. Collection of Kerry Griffith.
*This scene of a rural Mexican fishing facility was painted nearly
to completion at the spot, with a few refinements added later
at my studio. Although I'd set out all my usual colors on my
painting palette, I actually used only five to make the painting.
They were: raw sienna, burnt sienna, permanent rose, and man-
ganese and cobalt blues.*

Chapter 6

PALETTES THAT WORK

Strange as it seems, I doubt you'll find two artists who agree totally on what pigments/colors constitute the "ideal" color palette (i.e., the tube colors chosen to actually *paint* with). We narrowed the list from eighty-plus tube colors to thirty-seven and often used only a few of those on all the color charts, experiments and tests we've done. But, these might not seem right to every painter and the business of choosing could still be a problem for you. May I make a suggestion? Don't decide!

At least not "forever." Leave yourself latitude to try different pigments as time goes by. If you'll choose your color palette selection on the basis of how each color will perform for you (its hue, intensity and paint characteristics) you'll probably have more luck in your selections. It all boils down to experience and personal preference.

In the preceding chapters we were working principally with an expanded version of a triad palette: warm and cool versions each of red, yellow and blue (the three primaries) — plus a few greens and earth colors.

Can a successful painting be executed with fewer colors? The answer is definitely *yes*! Indeed, I think most artists are better off working with fewer colors. All the professional painters I've known shun the use of a lot of colors on their palettes at any one time. Though they may vary the palette from painting to painting, they usually paint with a fairly limited number of colors, and this is a good way for *beginning* painters to really learn about their colors and how to get the most out of them. Even if you aren't a beginner, some of the palettes I'm going to talk about might interest you and be useful to you in your development as a *color* watercolorist!

I remember, as a kid, seeing the rotogravure section of the Sunday newspaper. It was printed in a sort of rich dark brown color. It was amazing how much "color" seemed to be there, though there was really only the one ink used to print it. In contrast to the part of the paper that was printed in black ink, this section seemed more alive; the darks weren't as dead and the light values had a warm tint that seemed to be livelier than those printed in black. You've probably seen watercolors or sketches that were done in only one color, such as sepia or burnt umber. These, too, can have a feeling of "color" to them, and are called monochromatic paintings.

The monochromatic palette is the first palette we'll take a look at.

1. MONOCHROMATIC PALETTE

Monochromatic means "single color" and making a painting with a single color is a good way to start your exploration of color palettes. I did the painting below using only a single color, burnt umber, which is a very dark-valued, grayed red-orange — a pigment capable of everything from rich darks to good light-valued tints. Obviously, if I'd used a lighter value pigment, there'd have been no way to get the darks! Color, in the sense of brilliance, isn't possible with burnt umber, of course, but an amazing range of values *are*. These, along with good drawing and composition, make it possible for a monochromatic painting to have a rich and complete feeling.

Try a monochromatic painting yourself. Probably best if you stick to a dark pigment like burnt umber or sepia. It's an excellent way to learn to appreciate that important dimension of color — *value*.

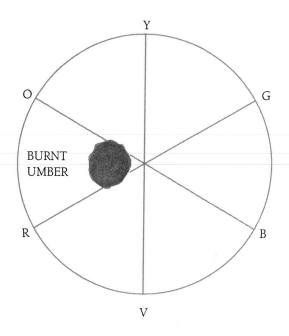

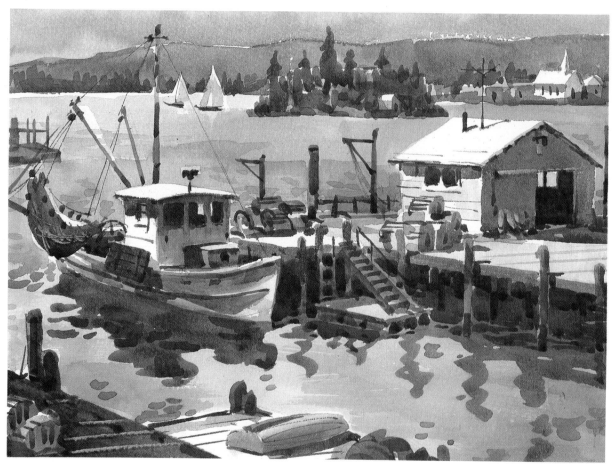

MONOCHROMATIC PALETTE

2. COMPLEMENTARY PALETTE

Add a complement—or near complement—to the monochromatic palette and you have a complementary color palette. Some combinations work better than others—especially if they're not intense primary/secondary pairs. For example, in the painting below, I used only ultramarine and burnt sienna—but ultramarine is a bit toward violet and so has a *little* red; burnt sienna is a grayed red-orange and orange has some *yellow* in it. You see in a subtle way that I'm getting more color "stretch" than if I'd used purer complements like red/green, yellow/violet or blue/orange. My little painting has almost a "full-color" appearance.

Paint a complementary color palette painting. It will increase your ability to get the most out of the two colors and give you more knowledge of each pigment's potential. You could use the colors I did—or try combinations like thalo blue/burnt umber or cobalt blue/burnt sienna.

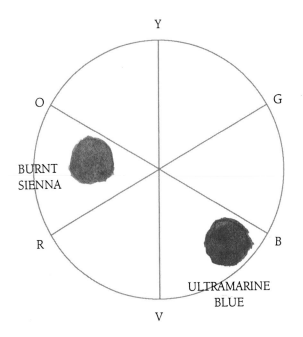

TWO COLOR COMPLEMENTARY PALETTE

3. Analogous Color Palette

Expanding our color palette inquiry further, how about trying an analogous color palette painting like the one shown here? To be analogous means to be "related to" — colors that are close to each other on the color wheel — "near neighbors," so to speak.

For this painting, I used only three analogous colors: violet, at full-intensity; plus red-violet and blue-violet, both of which are grayed about halfway toward neutrality. Obviously, with colors so close together on one little section of the color wheel, color and hue variations were very restricted. Still, I did have the full intensity of the violet, plus the very faint hint of yellow-green and yellow-orange, that I used to gray the red-violet and blue-violet, and which helped me achieve better darks. (Think how lifeless the latter two colors would have been if I'd grayed them with *black*!)

Analogous color combinations are often employed in interior decoration schemes but, for me, are less successful when used as a color palette for paintings. Still, some hues and all values are available and a real painting mood can be established.

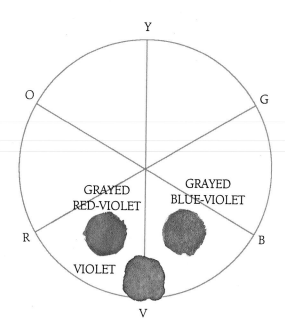

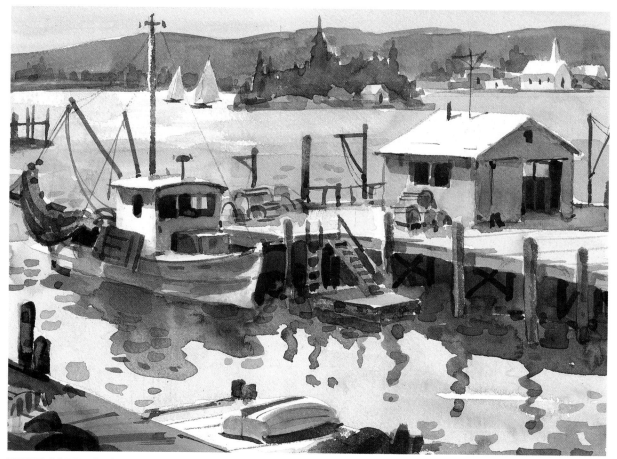

THREE COLOR ANALOGOUS PALETTE

4. ANALOGOUS COLOR PALETTE WITH COMPLEMENT

Using the analogous color palette on the facing page, but adding even a tiny bit of the dominant color's complement — or near complement — puts the whole color scheme into a much more exciting position, as far as I'm concerned. I did just that in the painting example below — used the same full-intensity violet, plus the same two grayed neighbors, red-violet and blue-violet, but this time I added a bit of yellow — violet's complement. That little bit of complementary color pulls the painting into a better feeling of color balance.

If you want to try an analogous color palette, with or without a complement, you could use the hues I did — or pick any others from around the wheel. Some of your hues need to be grayed to help get a greater range of values.

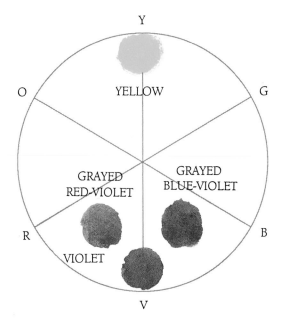

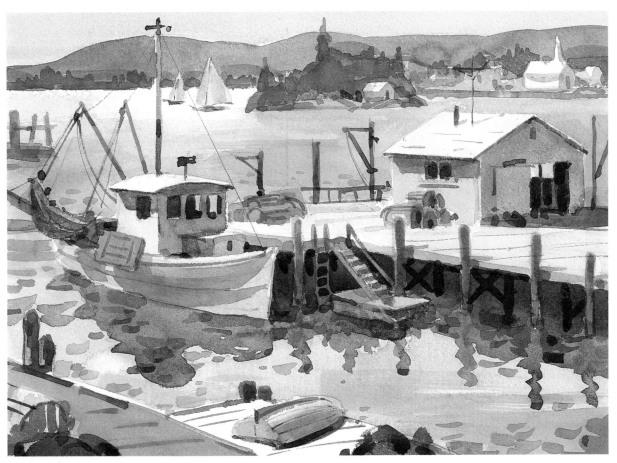

ANALOGOUS COLOR PALETTE WITH COMPLEMENT

5. LOW-KEY THREE COLOR PALETTE

We know we must have red, yellow and blue to paint in full color, but there are no perfect pigment colors to use for these primary positions. So, we've been using warm and cool versions of primaries to compensate for this.

Now, is it possible to paint a full-color painting using only three *imperfect* pigment colors? Sure. The *intensity* of hue will be more grayed, but a good painting is certainly possible. (In fact, many painters like using a rather low-key palette some of the time.) Actually, any triad of already-grayed primaries, or near primaries, will give at least some illusion of full color.

In the painting below, I used *Indian red, raw sienna* and *Payne's gray* for my primaries. I couldn't get a real violet, but did achieve interesting, grayed versions of orange, green, pink and an illusion of blue. Try a low-key triad painting—you'll learn a lot and be amazed at what color effects are possible!

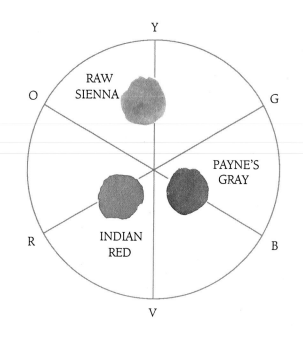

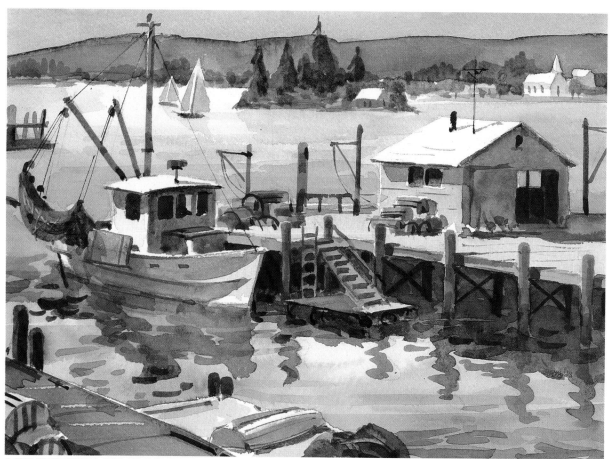

LOW-KEY THREE COLOR PALETTE

6. HIGH-KEY THREE COLOR PALETTE

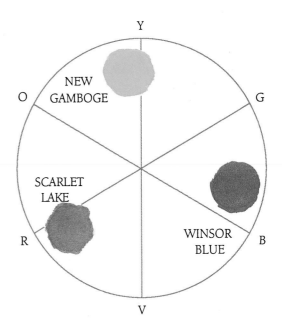

Here's another triad palette painting — only three colors were used. But, this time I used brighter pigments, so I was able to come closer to real full-color effects. I used *scarlet lake, new gamboge* and *thalo (Winsor) blue* as my pigment primaries — and we can see right away that scarlet lake and new gamboge will produce bright oranges, new gamboge and thalo blue will make good greens, but that slightly less-intense violets will come from scarlet lake and thalo blue, because the green cast in this blue will gray the scarlet lake a little bit.

As with almost any triad, good dark values are easily obtained and these primaries also produce beautiful clear tints. Try a painting using this high-key color palette. Or, you could shift your pigment primaries a little and have a palette of *Winsor red* or *permanent rose*; *Winsor yellow* or *cadmium lemon*; *cobalt* or *ultramarine blue*. Any of these will work well and offer different subtleties in mixing secondaries.

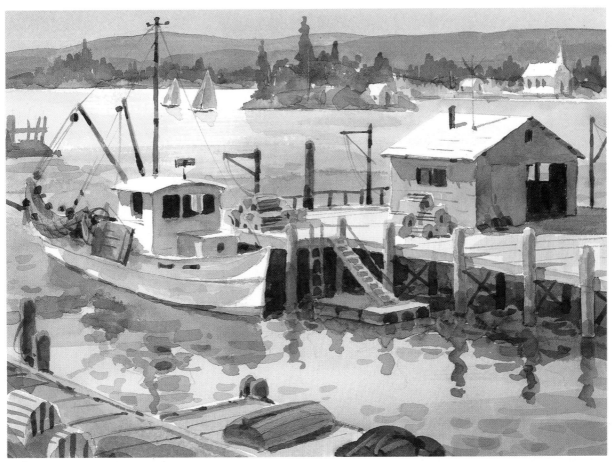

HIGH-KEY THREE COLOR PALETTE

7. SIX COLOR PALETTE

Again, I've painted with three primaries—but have used a "warm" and "cool" version of *each*, which greatly increases my hue-intensity possibilities. My color pigment primaries are—warm red: *scarlet lake*; cool red: *alizarin crimson*; warm yellow: *new gamboge*; cool yellow: *Winsor yellow*; warm blue: *ultramarine*; cool blue: *thalo*.

Now, every secondary color that I mix has a chance for greater hue intensity and cleaner color, because secondary colors can be mixed from pigment primaries already closer to them on the color wheel. For example, clear, bright violets from alizarin crimson and ultramarine, intense oranges from scarlet lake and new gamboge, and wonderful greens, ranging from yellow-green to blue-green, from new gamboge and thalo blue—all were easily obtained. These six pigment primaries make a perfectly adequate full-color palette that will meet almost every hue require-

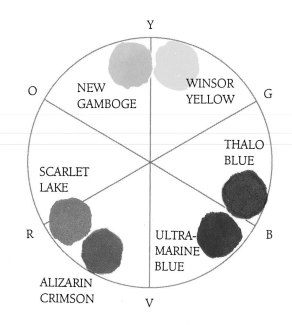

ment. My regular palette is the same except that I've filled it out with a few more pigments, valued for their convenience and paint behavior.

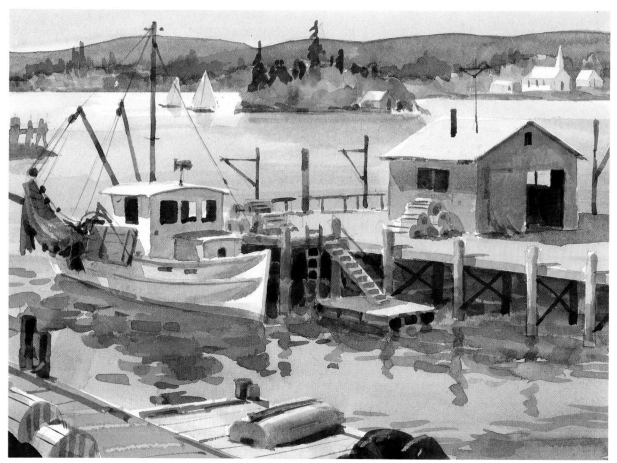

SIX COLOR PALETTE (A WARM AND COOL OF EACH PRIMARY)

MIXTURES FROM THE PRECEDING COLOR PALETTES

1. Monochromatic — a single hue offers only value changes.

2. Complementary — complements have value changes, plus potential for graying and intensifying each other.

3. Analogous hues make for an "unfinished" look.

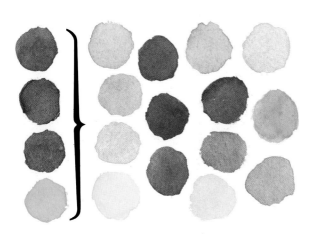

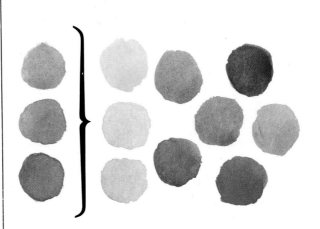

4. Analogous hues plus a complement are much more satisfying.

5. Low-key primaries offer many possibilities, but lack intensity.

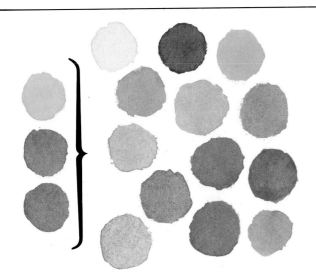

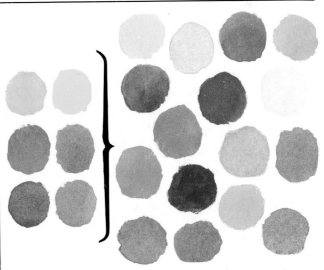

6. High-key primaries greatly widen color mix range.

7. High-key warm and cool primaries come close to providing complete color options.

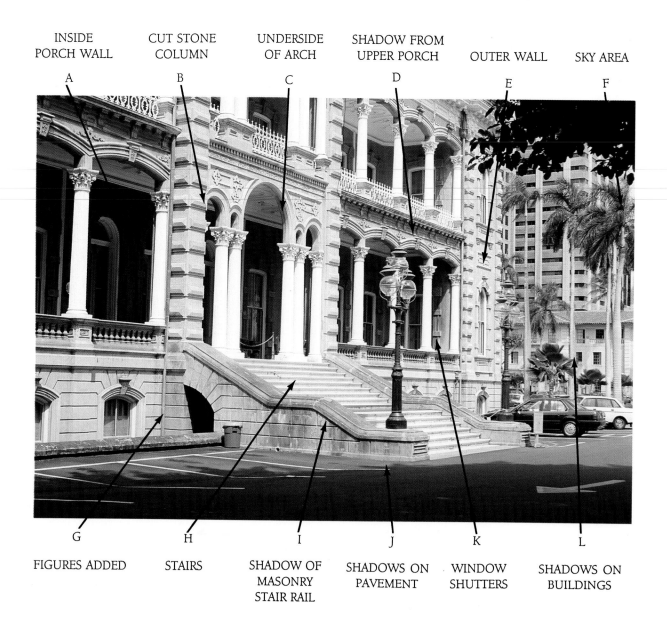

INSIDE PORCH WALL — A

CUT STONE COLUMN — B

UNDERSIDE OF ARCH — C

SHADOW FROM UPPER PORCH — D

OUTER WALL — E

SKY AREA — F

G — FIGURES ADDED

H — STAIRS

I — SHADOW OF MASONRY STAIR RAIL

J — SHADOWS ON PAVEMENT

K — WINDOW SHUTTERS

L — SHADOWS ON BUILDINGS

FULL-COLOR PALETTE

Though I'm always open to changes, my usual full-color palette is: Winsor yellow, new gamboge; scarlet lake, alizarin crimson, permanent rose; ultramarine, cobalt, manganese and thalo blues; thalo green; raw sienna or yellow ochre; and burnt sienna.

The painting reproduced here, of the Iolani Palace in Honolulu, was done as a class demonstration, painted entirely on the spot and finished in about an hour. The old Victorian structure is a museum now, and local ladies in colorful costumes escort tours through it. I used some of them to add color accents and give a feeling of scale to the building. My wife took a color photo of the scene from about the same spot, and though most photos lack in their ability to show the subtleties and clarity of color that our eyes can discern, I thought it would be interesting to compare the photo to the painting. So, I marked the same areas on the photo and on the reproduction of the painting. I painted little swatches of the colors I used in various washes (the size of the swatch approximates the amount of paint used from each pigment color) so you will get an idea of how I arrived at the final results.

The old structure's colors are rather subdued, so I took license and brightened some of them up, and increased the amount of reflected light (which hardly shows at *all* in the photo). I always "vote" in favor of the painting, and you should too! My palette was simple — only seven pigments. They were — reds: *scarlet lake* and *permanent rose*; yellow: *raw sienna*; blues: *cobalt*, *ultramarine* and *manganese*. In addition, I used a bit of *burnt sienna*.

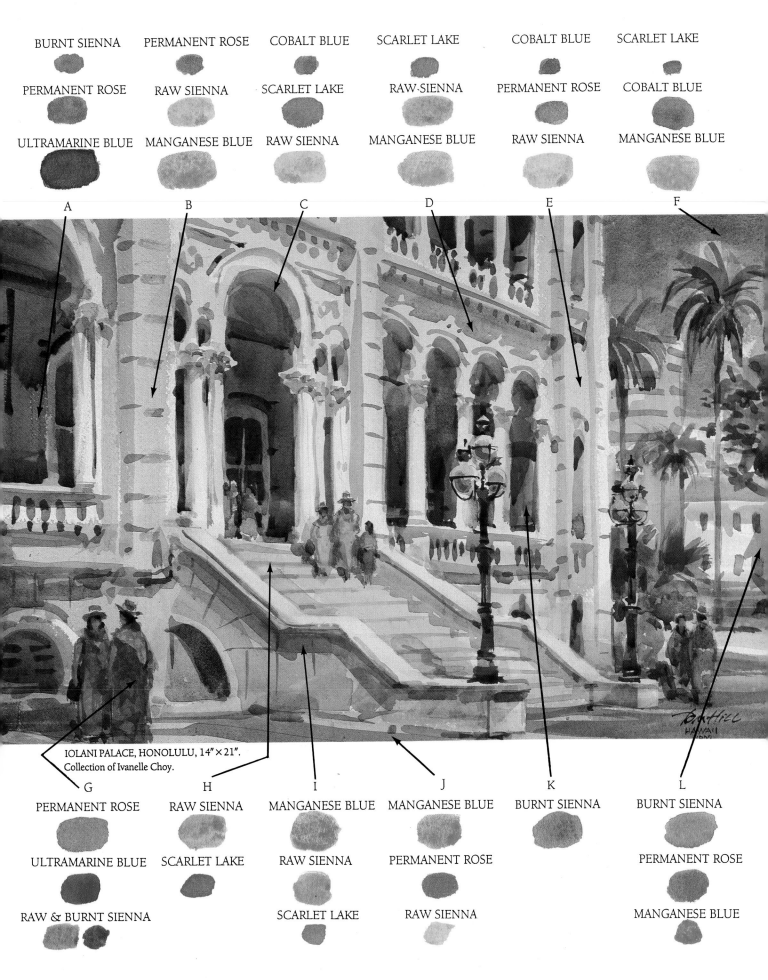

BURNT SIENNA
PERMANENT ROSE
ULTRAMARINE BLUE

A

PERMANENT ROSE
RAW SIENNA
MANGANESE BLUE

B

COBALT BLUE
SCARLET LAKE
RAW SIENNA

C

SCARLET LAKE
RAW SIENNA
MANGANESE BLUE

D

COBALT BLUE
PERMANENT ROSE
RAW SIENNA

E

SCARLET LAKE
COBALT BLUE
MANGANESE BLUE

F

IOLANI PALACE, HONOLULU, 14″ × 21″.
Collection of Ivanelle Choy.

G

PERMANENT ROSE
ULTRAMARINE BLUE
RAW & BURNT SIENNA

H

RAW SIENNA
SCARLET LAKE

I

MANGANESE BLUE
RAW SIENNA
SCARLET LAKE

J

MANGANESE BLUE
PERMANENT ROSE
RAW SIENNA

K

BURNT SIENNA

L

BURNT SIENNA
PERMANENT ROSE
MANGANESE BLUE

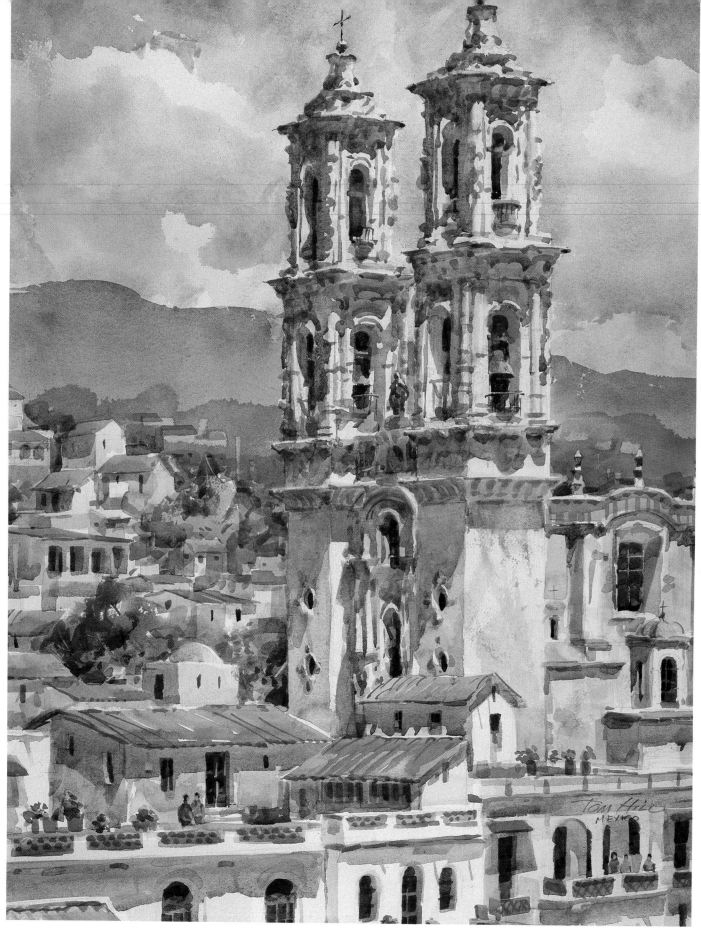

SUMMER MORNING, TAXCO (detail), 20″ × 16″.
The venerable old church at Taxco, Mexico, offers a wonderful subject — which clearly demonstrates the play of light and shadow, and all the color nuances involved — just what this chapter is about!

Chapter 7

COLOR IN LIGHT & SHADOW

I've heard it said that of all our senses, *sight* is our principal source of information. *Light* makes sight possible. Light's rays, as they fall across the world around us, create the colors and the light and shadow that help to define the shapes, forms and textures that we see.

In chapter 3 we talked about the spectrum of hues that are in white light and how they behave. Now, let's examine what actually happens when light falls across objects.

On the next few pages are photos I took of some basic shapes—in the form of boxes, cylinders, spheres and little toy houses. By placing them in direct sunlight and changing their backgrounds (their surroundings or "environment"), these photos and their accompanying illustrations reveal a lot about how light, color and shadow define what we're looking at.

SUNLIGHT'S ACTION

Since the sun is so much larger than the earth, the sun's rays can be considered parallel to each other. I think one of the easier ways to visualize the light rays of the sun is to think of them as streams of tiny rubber balls, unaffected by gravity, hurtling continuously in straight lines from the sun, and bouncing off whatever object they hit. The angle at which they hit determines the angle at which they bounce, and these angles are always equal. When the rays hit a flat surface at a right angle, they bounce directly back toward the light source, resulting in maximum light

reflection. When they hit a flat surface at an oblique angle, they bounce off at an equally oblique angle in the opposite direction, resulting in *less* light reflection. The more oblique the angle, the less light is reflected from the surface.

CREATION OF SHADOWS. When light rays are interrupted by an object, that object gains light and shadow sides, and casts a shadow of itself. Those sides most directly facing the light are lightest in value; sides, or areas, more obliquely hit by the light are lower in value. Sides completely blocked from the light are in shadow and their edges will determine the shape of the *cast* shadow. On the next page, the box illustrates all this very well. So do the cylinder and sphere, which also have a gradation of shadow, as their curved surfaces gradually reflect less and less light, going into the shadow side.

REFLECTED LIGHT. Of course, in most situations, there'll be other light rays—*reflected light rays*—bouncing off of nearby surfaces and into the shadow sides of the object *and* into its cast shadow. These reflected lights can be anywhere from obvious to very subtle and will reflect the *colors* of the objects from which they are bouncing.

Suppose you're painting a subject that's part in sunlight, part in shadow. The subject's color in sunlight isn't too difficult to determine, but how do you paint the change that happens to that color when it's in shadow? The photos on page 81 should help in understanding the way colors change from sunlight to shadow.

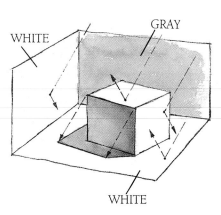

In the photo, the white box is in a "color neutral" setting: white or gray surroundings. In the illustration, the dashed-line arrows represent the sun's parallel light rays, how they bounce at equal angles and how they define the box's shadow. Notice, in the photo, the cast shadow is darker than the shadow side of the box. Also notice how the shadow on the box seems a bit darker just where its edges meet the lighted sides.

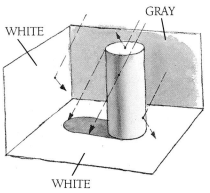

Here's the same neutral setting, which, in the photo, enables us to see just the value aspects of color. See how the light rays are gradually cut off by the curved shape of the cylinder, and, where they can no longer strike, we see a darker vertical area called a shadow "core." After that, the shadow gets lighter again, due to reflected light coming from the left.

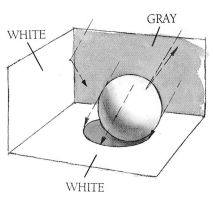

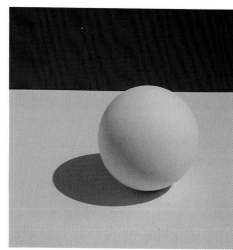

Again, a "color-neutral" setting. The sphere has a shadow "core," too, but because the sphere is continuously curving in all directions, its shadow core is crescent shaped, diminishing toward each end. Notice, in the photo, the cast shadow is darker than the shadow on the sphere itself, and especially dark directly under the sphere.

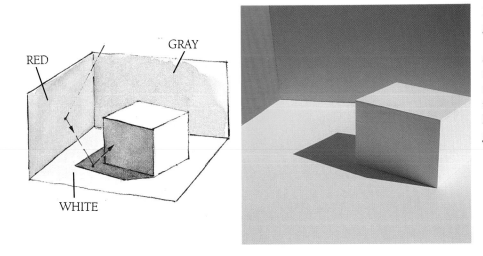

RED

GRAY

WHITE

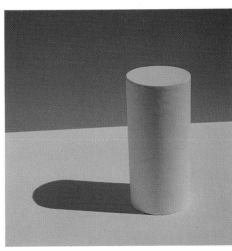

Here's the same white box, tabletop and gray background, but now there's a red "wall" to the left. In the photo you can see red light reflected into the shadows, tingeing them with a pink hue. Even the tabletop and the gray background are influenced toward red. The illustration helps explain the light's action in a more graphic way.

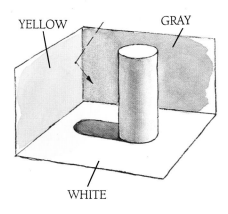

YELLOW

GRAY

WHITE

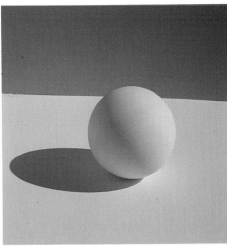

Now, the same setup as above, but with a yellow "wall" to the left of the cylinder. Reflected yellow light now permeates the whole scene, even tingeing the dark cast shadow with a hint of yellow. Try imagining that the cylinder is a silo, the yellow wall a yellow house, and you can quickly see the importance of color in reflective light and its application to your painting problems!

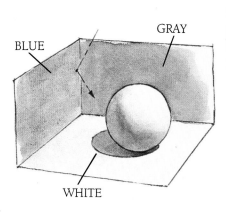

BLUE

GRAY

WHITE

The sphere in this photo is under the influence of the blue to its left, but this blue is a little less intense than the red and yellow shown above, so its effect is more subtle, though just as invasive. You could compare it to the blue "sky light" seen in nature, where the light from a blue sky, away from the sun, reflects onto shadow sides of objects in a landscape setting.

Color in Light & Shadow 79

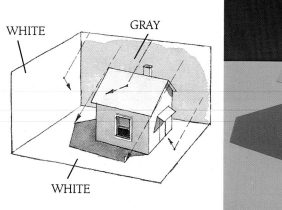

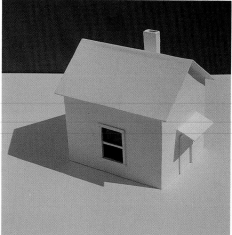

Light falling on this white house in a "color-neutral" setting, behaves exactly the same as it did on the white box — but there are more complexities to look for: the slanting roof reflects less light than the box's flat top; the more complex shape of the house casts a more complex (though logical) shadow. The illustration accentuates what happens.

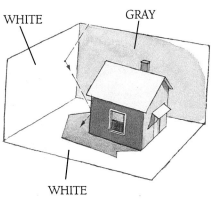

In this photo, you can see that the cast shadow is no longer darker than the shadow on the house, because the house's walls are now red — a darker value than white. The illustration shows how light rays do a double reflection, bouncing off the white wall to the left, then off the red wall at the back of the house and tingeing the cast shadow pink!

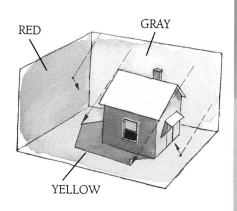

Now, a colored house in a colored setting, diagrammed by the illustration. Red from the left is reflected into the yellow "ground," turning the house's cast shadow orange. The same yellow reflects up into the shadow on the house itself, turning the red warmer and brighter. Even the neutral gray background is tinged by red (left) and yellow (right) in the photo.

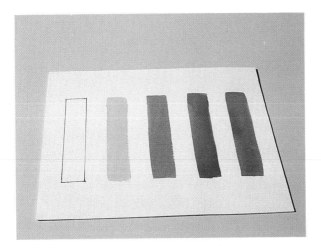

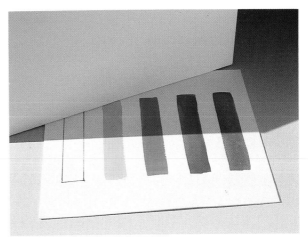

A color in sunlight looks different when it's in shadow. Although pigments aren't perfect and really can't exactly duplicate light, here's an experiment to help learn how to come fairly close to mixing and matching the colors you see in shadows. The photo above shows five 2 × 6-inch swatches in full sunlight. The white one is the paper itself, the others are new gamboge yellow, scarlet lake, ultramarine and thalo green, but they could be any colors you choose. Just think of them as colors on some object that's in a painting you're making.

Here I've cast a shadow over part of each color swatch—just as shadows might happen in a real painting situation. You can see how the colors in the shadow have changed: They're less intense in hue, darker in value, and any reflected light or color that's nearby will now be more apparent in shadow than it would be in direct sunlight. Assuming that it's fairly easy to paint the color that you see on the sunlit side, how would you mix your paint to duplicate the color you see on the shadow side?

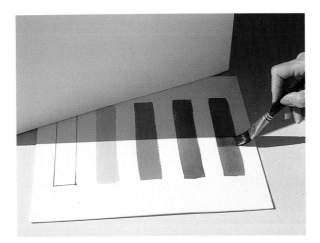

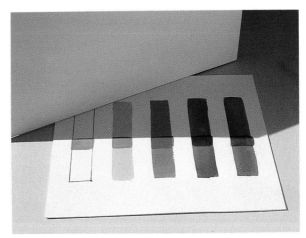

This photo shows thalo green's shadow color being matched with a glaze of paint over the thalo green color that's in the sunlight. Here's how it was done: to some additional thalo green on the palette, a little bit of thalo green's complement, red, was added (in this case, a dab of scarlet lake). Now the wash was less intense and darker in value. Because of the blue light that was being reflected in from a blue sky above, a tiny bit of cobalt blue was added. When this mix was painted next to the shadow color, as you can see, a good paint-color to actual-color match was achieved.

The same thinking was used to produce close color matches for the other colors: more of the original color, a little of its complement, then adding whatever reflected light color might be affecting the color in the shadow. To duplicate white's shadow color, a correct value of neutral gray was mixed and a little blue added to account for the reflected blue light from the sky. Try this approach with any paint color—some variation and modification may be needed to account for the individualities of different pigments—but you can always check your results for veracity by comparing them with the actual colors in sunlight and shadow.

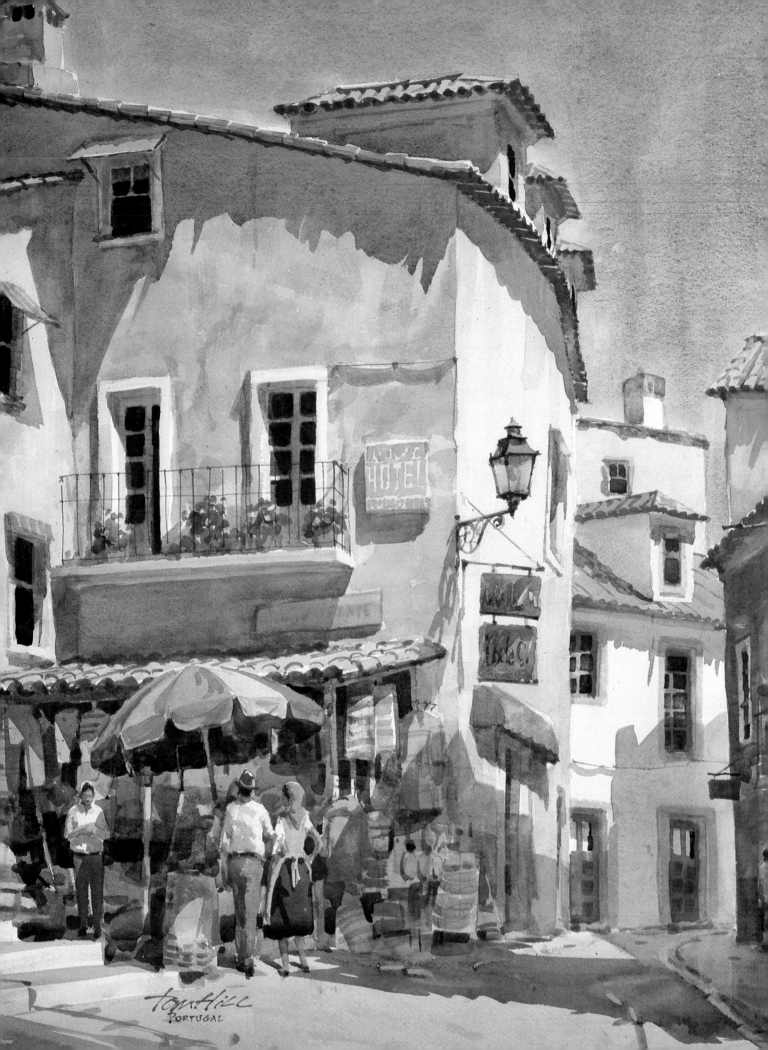

COLOR IN ACTION: TEN DEMONSTRATIONS

The final part of this book, it seems to me, should be about showing how all the color material we've been examining so far can be put to practical use. With that in mind, I've prepared ten demonstrations designed to amplify the preceding material by showing you how I've used it. I hope that you will find these examples helpful and interesting.

DEMONSTRATION 1:
Color in shadows and cast shadows

DO YOU THINK MOST OF US consciously pay any attention to shadows as we go through our daily routines? I doubt it. But, *subconsciously* we are aware of shadows, because shadows help define shapes and forms and thus enable us to better understand what we are seeing.

What happens to the *color* in light and shadow? In chapter 7 we discussed and diagrammed the interruption of light by various objects, creating shadows *on* those objects and the shadows that they *cast*. We also talked about how light bounces and re-bounces from one surface to another, not only carrying reflected light into shadows, but *color* as well.

Shadows, in nearly every case I can imagine, are affected by the light and the color that is reflected into them. It may be subtle—not even noticed consciously—but it's there! Color films, for all their remarkableness, just don't see the subtler colors that your eye can see—especially in shadows. Have you noticed how photos tend to show most shadows as black—or nearly black? If you're relying on photos to paint your color from, take it from me, you're not seeing what's really happening! Better to observe the real thing as it happens, if you possibly can.

I've painted two nearly identical paintings, which are shown on the following pages. One is principally to demonstrate what happens to light and color in the shadows that are *cast* by an object; the second shows what can happen to the light and color in the shadows that are *on* the object itself.

Also, I've shown the scene as light-valued, "high-keyed" and somewhat detailed, because this is the way the effect of reflected light and color in shadows is most obvious. The same things happen in a more somber scene, with lower values and colors that are darker or more neutralized—but the effects are more difficult to see.

ALFAMA DISTRICT, LISBON (detail), 20″×15″. Private collection.

This wall is getting a little less direct sunlight than the front of the building, so is slightly lower in value and has both warm and cool influences in it.

Cast shadow on this wall has cool from sky at its lower edge, warm from tile roof below, on its upper part.

SUNLIGHT'S DIRECTION

Cast shadow here gets less direct light than front of building, but picks up more cool from the sky.

Warm light reflected up from the roof and earth below.

Warm bounce light here, with little chance to catch any blue from the sky in this position.

This part of the wall is catching warm bounce light from the building at left.

Cast shadows from palms pick up warms from opposite wall but also cool from the sky, where the wall turns the corner.

This part of the wall is angled differently and is cooled by sky influence.

Cast shadow is warmed in parts by building reflections, cooled in other parts by the sky above.

Warm light bounced twice: first off building to the wall at right, then back into the cast shadow on building.

MORNING, OLD TOWN, GRANADA, 17″ × 13″
In this scene the sun is about halfway above us, over our right shoulder, and a bit in back of us. (Notice the arrow in the diagram above, indicating the light source.) The emphasis here is on showing what cast shadows do, especially as regards what happens to color.

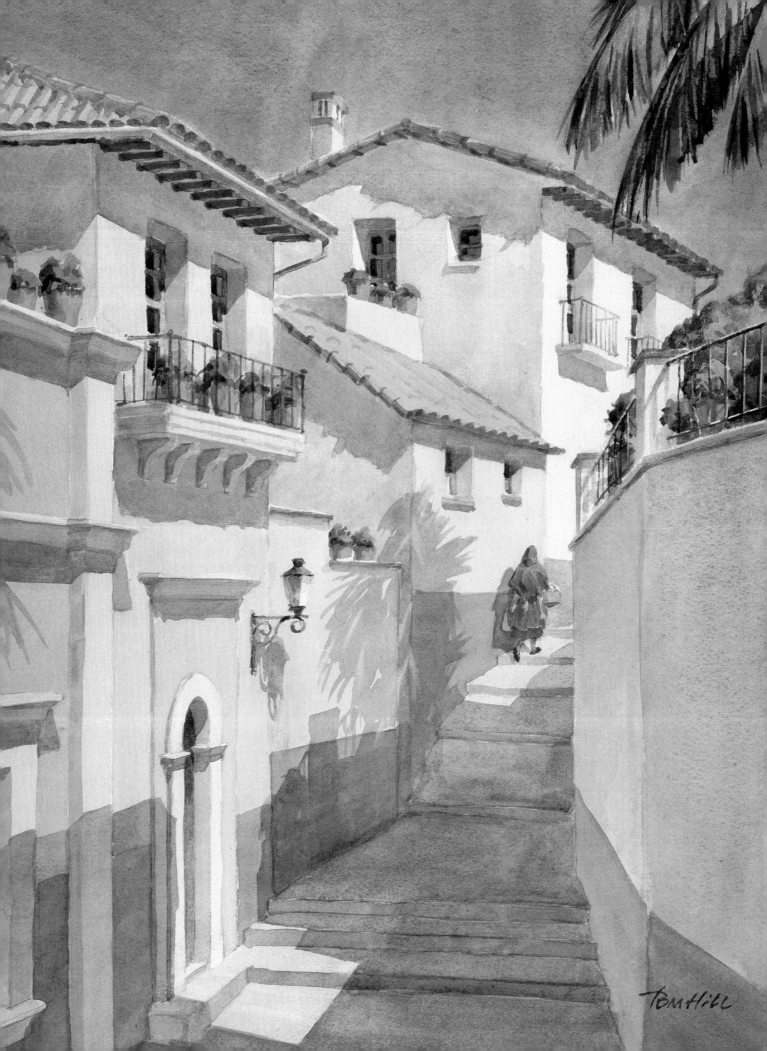

Tom Hill

SUNLIGHT'S
DIRECTION

Cast shadow here has warm from roof below, cool from sky above.

This wall is getting the most direct reflection, so is lightest in value.

Reflected light — warms from below, cools from above.

Subtle "upside-down" cast shadow, which is within the shadow on the subject itself!

Wall angle here allows some warm reflections from facing buildings.

The subject itself is in shadow, entirely lit by reflected light.

Fairly direct reflection of sun here, so lighter in value. Cast shadows of foliage pick reflection of cool from sky above, tinges of warm from buildings.

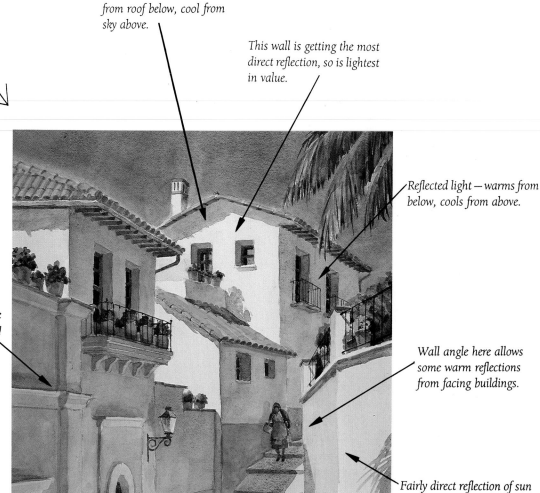

Cast shadow on street here is more under influence of cool from sky above.

Cast shadow on street here has some reflection of red from building at left.

AFTERNOON, OLD TOWN, GRANADA, 17″ × 13″
Here's the same scene as on the preceding pages, but this time we've moved the sun to a position halfway over our left shoulder, again a little in back of us. Now our emphasis is on examining what happens to color in the shadows that are on the subject.

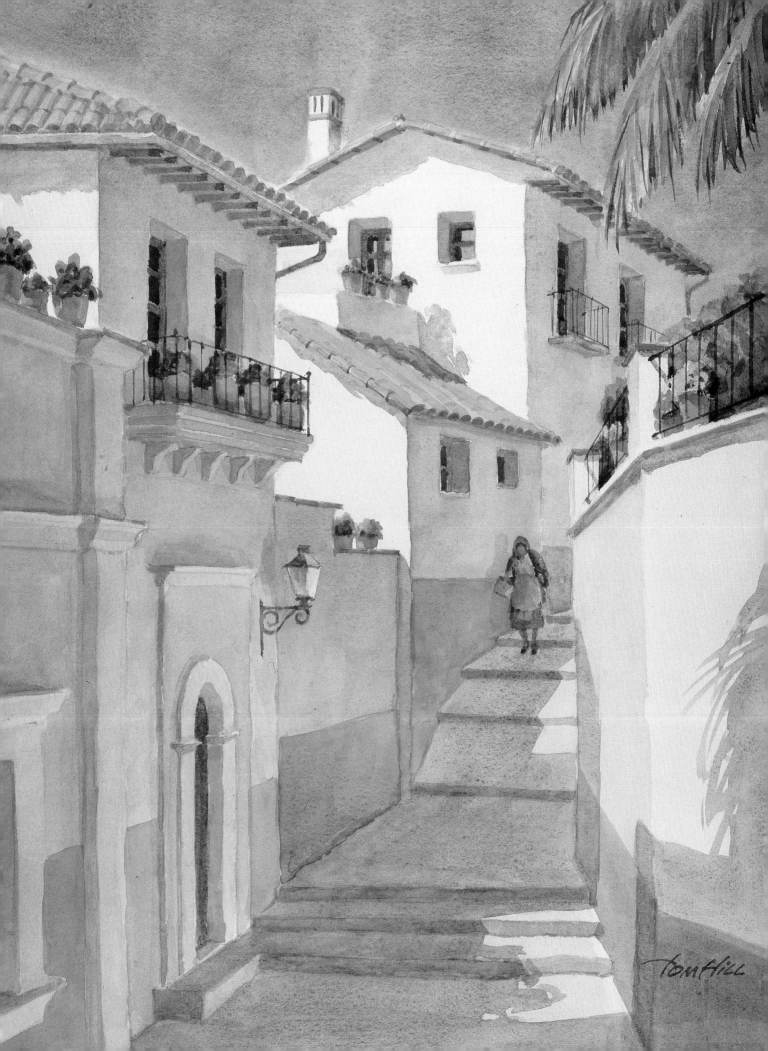

DEMONSTRATION 2:
Color in a white subject

YOU ARE ABOUT TO START a painting and your subject is white or mostly white. It's easy to see the *values* (the lights and darks) but these values aren't really neutral grays and whites. There's *color* in them, although it's often difficult to determine just *what* hues are there, for they can be quite subtle! How to handle it?

On a sunny day, a blue sky reflecting from the opposite direction of the sun, can influence shadows exposed to it, tinting them toward blue. White clouds can reflect into shadows, lightening their value, but not changing their hue. A nearby red barn, green trees, brightly colored clothes on a clothesline — all could add their reflected light and color into these areas. These effects are harder to see in some cases than in others, but they're there. If you look for them and understand them, you can paint with more confidence and authority!

So, when you're confronted with the problem of painting color in shadows on a white object (or any other color object, really) remember to:

1. Notice the environment around it. What object might influence the shadow by reflecting its particular hue? Can you use this color to help your painting?

2. Even if the color influence isn't too apparent, and may even look neutral to you, at least consider analyzing its color in terms of temperature — whether it's a warm or cool gray — and paint it accordingly.

3. Don't be afraid to simplify what you see and to act as an editor in the sense that you amplify or intensify the color a bit, if it will improve your painting.

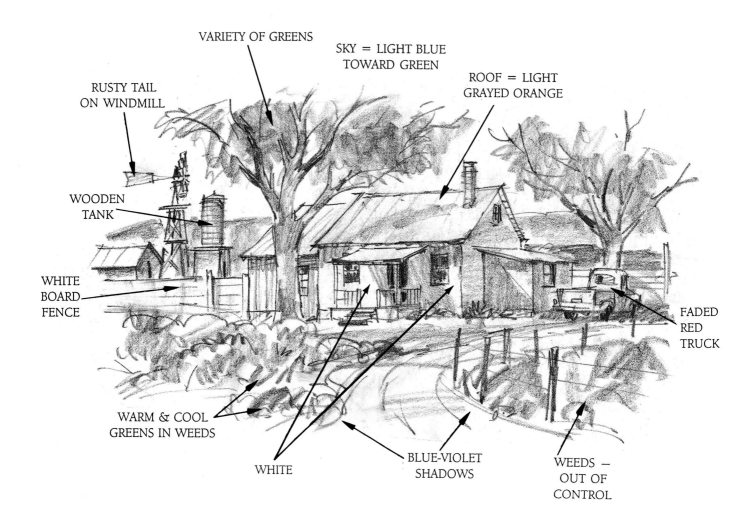

VARIETY OF GREENS

SKY = LIGHT BLUE
TOWARD GREEN

ROOF = LIGHT
GRAYED ORANGE

RUSTY TAIL
ON WINDMILL

WOODEN
TANK

WHITE
BOARD
FENCE

FADED
RED
TRUCK

WARM & COOL
GREENS IN WEEDS

WHITE

BLUE-VIOLET
SHADOWS

WEEDS —
OUT OF
CONTROL

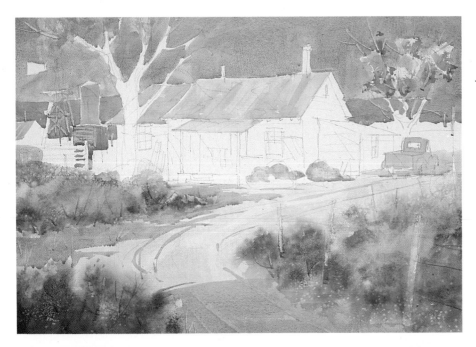

STEP 1. *Using my 1-inch and 1 ½-inch flat brushes, I washed in the sky with cobalt and manganese blue, cutting around the tree limbs. Next, I painted the foreground and weeds, working wet-in-wet. The warm and cool greens were "charged" with bits of raw and burnt sienna, manganese blue and permanent rose, and a little salt was sprinkled for texture. I "squeegeed" out the fence posts from the now damp wash, with a pocket knife, pulling away from the sharp edge. After this, I painted in the "local" color of the roofs, water tank, truck, etc. When dry, I brushed off the salt and painted the hills and cast shadows on the driveway, using cobalt and manganese blue, with a bit of permanent rose.*

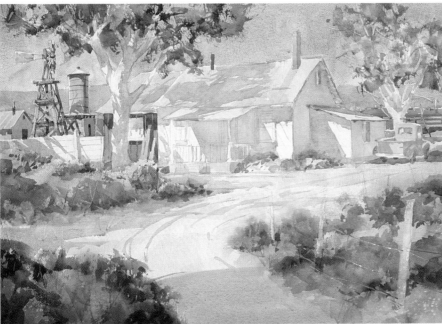

STEP 2. *I painted the windmill, chimney, corral area (in back of the truck). Then I added the shadows on the house, trees, out-buildings, etc. Most of these were done using appropriate warms and cools mixed from raw sienna, scarlet lake, permanent rose, cobalt and manganese blue (versions of yellow, red and blue when you stop to consider it!). I added more tree foliage, and weed shadows using mixed greens, made darker in value with additions of burnt sienna and alizarin crimson.*

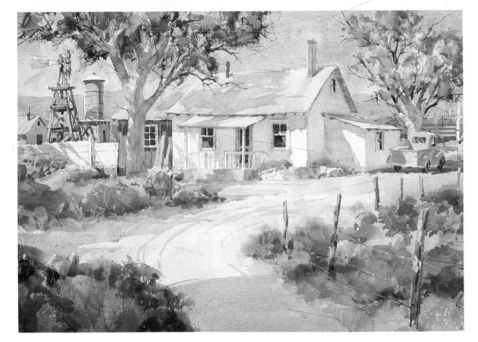

STEP 3. *Next, using a ½-inch flat and a no. 8 round brush, I added more tree limbs and twigs, plus warm darks to the windows, truck, windmill and foliage. These darks were made with different combinations of burnt sienna, alizarin crimson and ultramarine blue.*

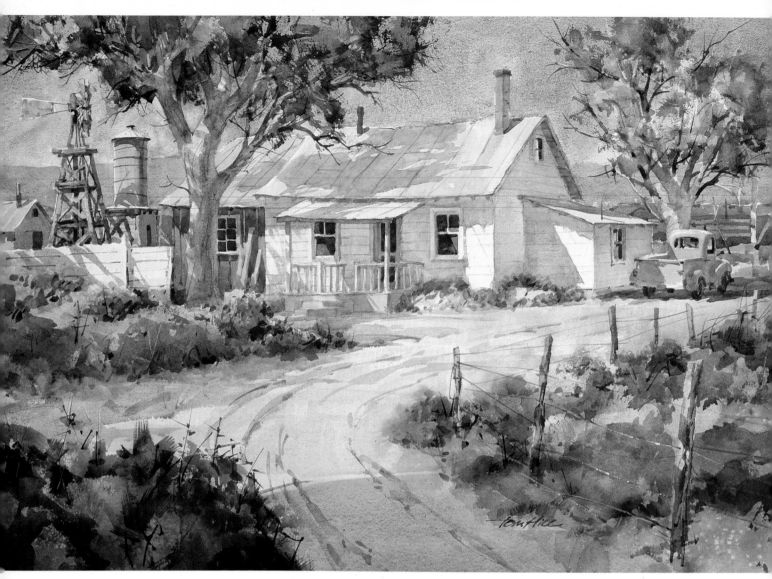

WEEDS ARE WINNING, 21" × 29". Private collection.

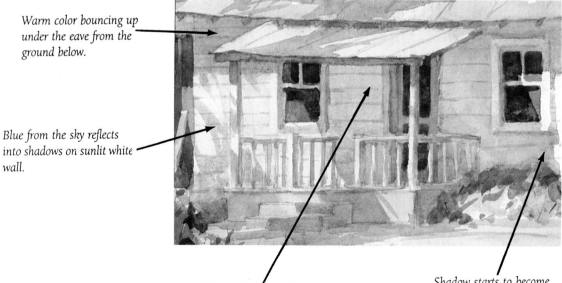

Warm color bouncing up under the eave from the ground below.

Blue from the sky reflects into shadows on sunlit white wall.

Warm colors, from the porch floor and the earth, bouncing up into the shadow cast by the porch roof.

Shadow starts to become cooler, due to blue influence from the sky above.

Some warm color bouncing into cast shadow under this eave.

Transition to a bluish cast as the upper part of this wall comes under the influence of blue sky above.

A somewhat darker blue cast shadow on the lean-to's roof, directly reflects the sky above.

Warm color bouncing up from sunlit ground below.

Cooler as sky color starts to invade cast shadow from roof overhanging.

As this wall recedes and gets farther from the red color of the truck, it gets slightly darker in value and color.

Warm color and lighter value here due to the bounce of light from the lean-to's side and the sunlit ground.

Almost a "hot" glow of warm pinks on this portion of the wall because of light bouncing off the red pickup truck.

Shadow side seems to be a darker value just where it meets brilliant sunlit side of the building.

A slight greening of the shadow on this part of the wall, because of the adjacent green foliage.

The farther this cast shadow of the roof gets from its source, the more the blue sky influences it.

STEP 4. (Above, left.) This painting was essentially finished by Step 3 — all that I did after that was to fine-tune it with details like: roof lines, clapboard lines, barbed wire, weed details, tree trunk lines and textures and more ruts in the driveway. In painting the demonstration of this white ranch house, I strived to show how things surrounding the house affect the hues and values found on the house and in its shadow (both the shadows on the sides of the house away from the sun and shadows of the tree, the roof, etc., that are cast onto the house). My color palette was simple: reds: scarlet lake and permanent rose; yellows: new gamboge and raw sienna; blues: cobalt, ultramarine and manganese. In addition, I used a small amount of Winsor green and burnt sienna.

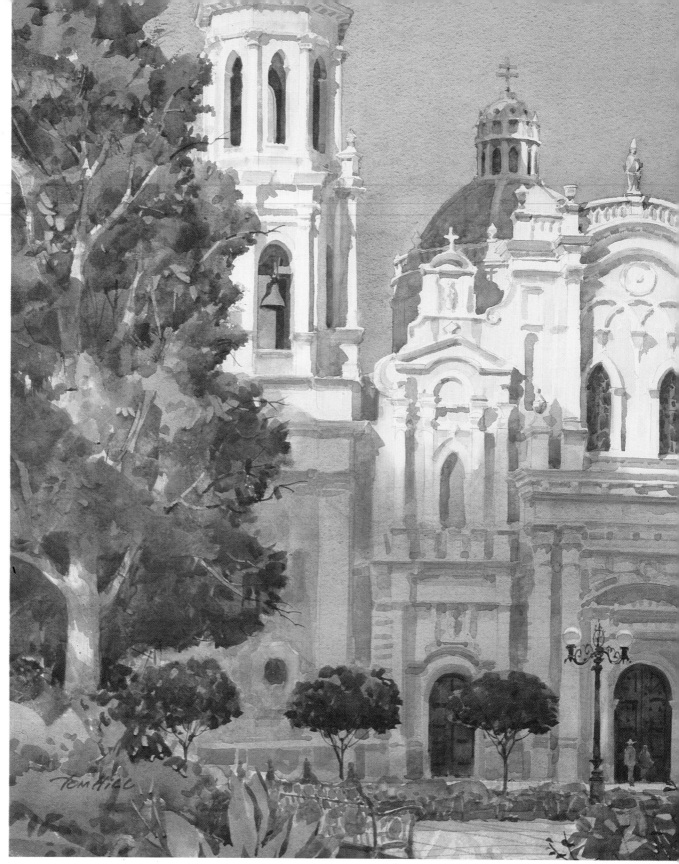

EARLY MORNING LIGHT, 25″ × 40″. Collection of Mr. & Mrs. Joe Dodson.

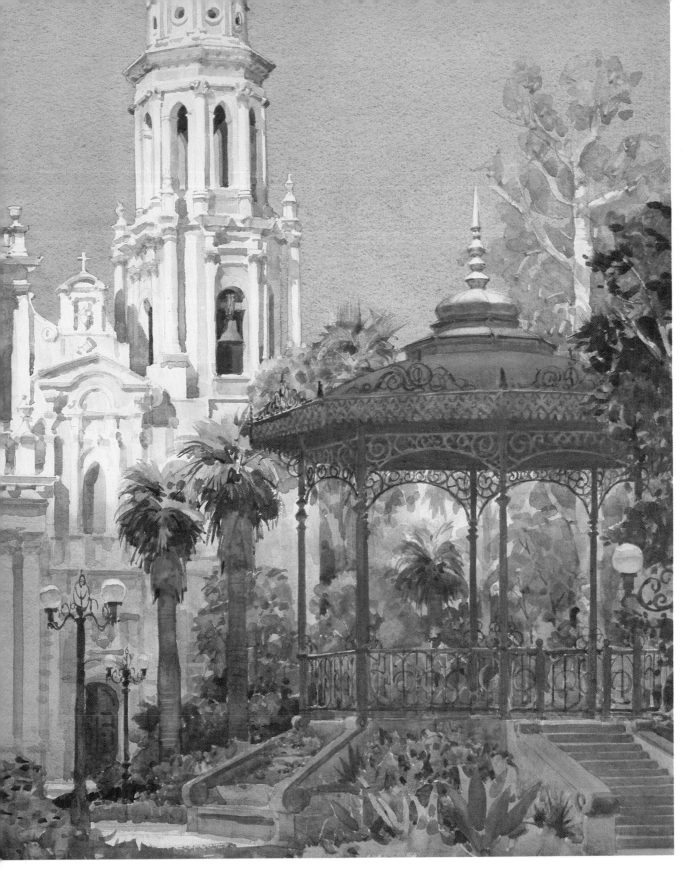

This painting is *about* a very brief moment when the rising sun's first reddish light combines with the blue of the sky to create a lovely blue-violet cast to the shadows below. Where the sunlight strikes the old Mexican church directly, complementary colors of yellow and orange appear in the shadows.

DEMONSTRATION 3:
Color in a colorful subject

WE TALKED ABOUT WHAT HAPPENS to colors on a white subject (the old Western ranch house, pages 88-91) and how best to capture their effects in paint. Now, let's do the same thing with a subject that is *not* white, but has a color of its own. This time, I'm painting an old stucco adobe surrounded by eucalyptus trees and prickly pear cactus—a subject typical of the old Southwest and fun to paint!

On the white ranch house most of the hues—especially in the shadows—were determined largely by what colors were being reflected into them by their surroundings. It's the same situation with this adobe, except that *now* the various hues being reflected are *themselves* modified by the pinkish-orange "local" color of the adobe itself.

Remember in chapter 3 we discussed graying a color by adding some of its opposite or complement to it? That's what I did here for the areas in shadow, *plus* adding whatever other hue was being reflected into it.

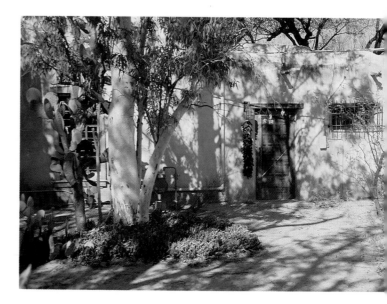

The photo at the right shows the subject. I've painted it on location several times before. Those efforts, plus photos and my pencil value-composition study (below) served as my reference for this demonstration. Please note that I felt free to move, simplify or eliminate elements; to change, intensify or neutralize colors from the way they were, if it would make a better painting. All the while, I strove to keep—or even increase—the effects that would convey my feelings about the scene.

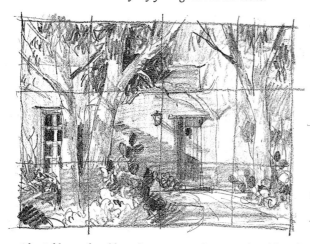

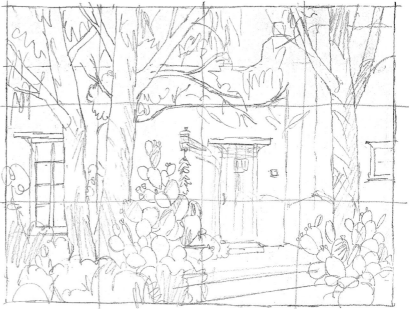

After I felt comfortable with my proposed picture plan (above), I drew the design onto my watercolor paper (right) using a light (2-B) pencil line that would erase easily later.

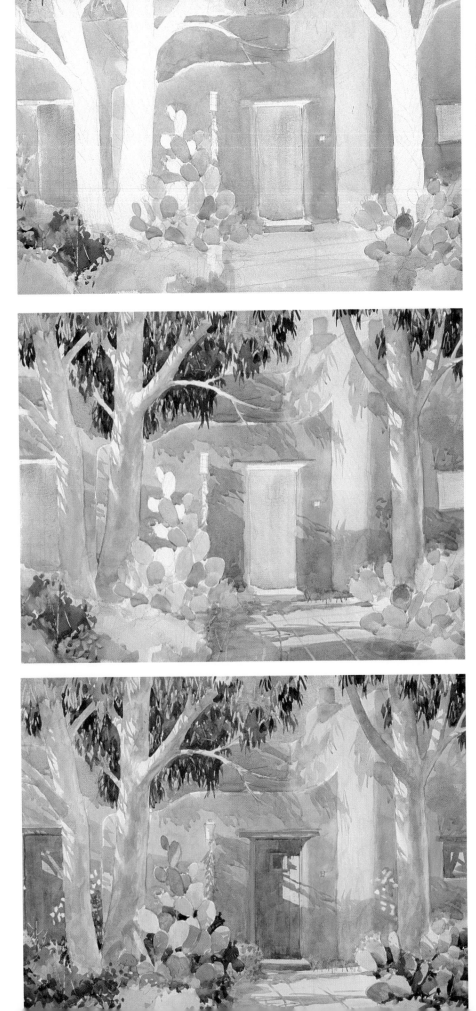

STEP 1. Using 1½-inch and 1-inch flat brushes, I washed in the large elements of the house, the door and windows, the sky and foreground. The sky was manganese and cobalt blue, the door and windows were manganese, plus a little raw sienna. I used combinations of scarlet lake, raw sienna and tiny amounts of manganese blue and permanent rose for the walls — increasing their intensity in places and lowering the overall value somewhat. I used a variety of greens, blues and violets in my underpainting of the foliage.

STEP 2. To account for the reflection of blue from the sky above, using a 1-inch flat brush, I painted the cast shadows on the walls and earth with a mix of manganese and cobalt blues — adding traces of permanent rose or burnt sienna here and there. Being transparent, these washes let the previously painted pinkish-orange color show through, giving a result that's very similar to what the actual shadow color was on the house itself! (See Demonstration 1.) I painted more eucalyptus leaves, adding "near" complements (burnt sienna and alizarin crimson) to the greens, to darken them and to account for the warms being subtly reflected into them from the nearby walls of the house.

STEP 3. Next, I painted the shadows on the door and windows, using manganese blue with raw sienna, as before, but a richer mix this time and bits of permanent rose with burnt sienna mingled here and there. I carried more darks to the cactus, painted the initial red on the hanging chilies and lifted out some little whites from the window and wall, to serve as yellow blossoms. (I did this by cutting small holes in masking tape, sticking it to the paper, wetting and blotting out the previously painted color.)

95

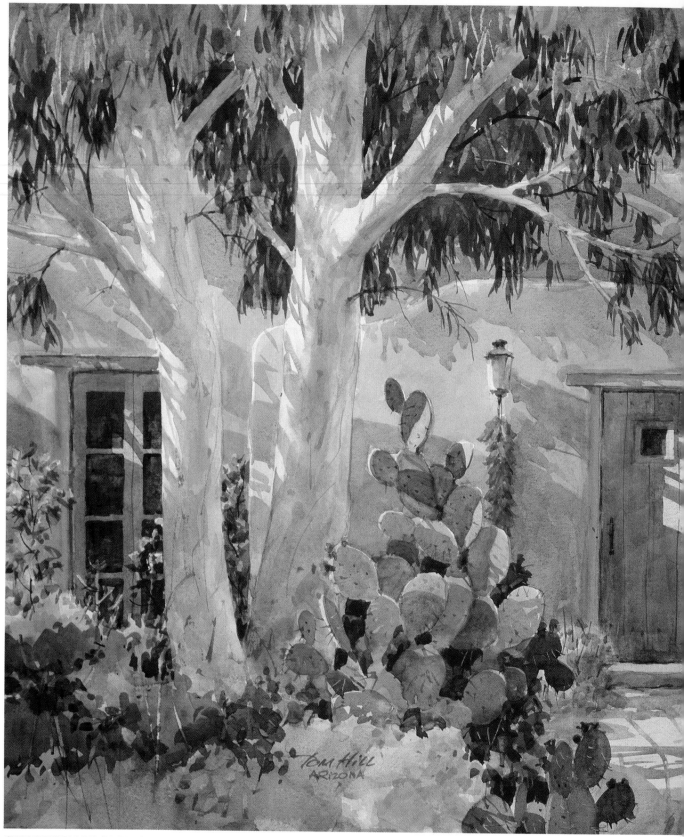

CHILIES DRYING ON AN OLD ADOBE WALL, 21″ × 29″. Collection
of Mr. and Mrs. Henry Harder.

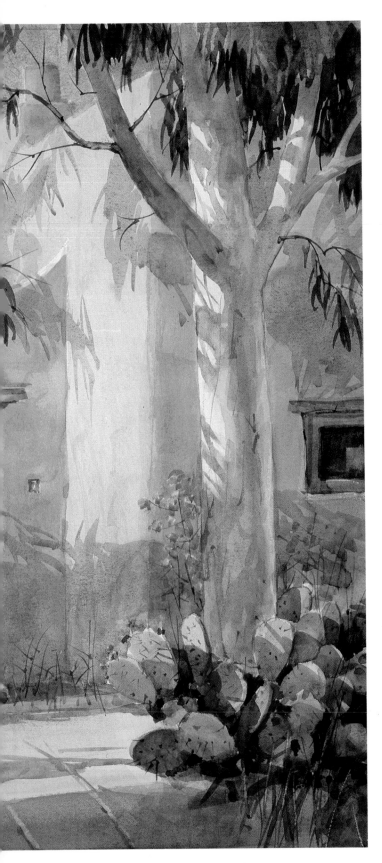

This detail shows warm hues from the wall and the earth, and cools from the sky and leaves reflecting into the shadows on the nearly white bark of the tree. Also notice the variety of greens present in the leaves: from light, cool blue-greens, to dark warm greens, verging almost into dark reds!

These cacti can have a great variety of hues in their pads. You can see how I played up the warms being reflected onto them and how I darkened and warmed the silhouetted pads.

STEP 4. All that was left to do from Step 3 was to fine-tune: details (not too many!) of twigs, bark, foreground shrubbery, mostly accomplished with a small no. 4 round sable watercolor brush. Last of all, I added a few, choice darks (windows, door, shrubbery) keeping them on the warm side.

My palette was simple: yellows: new gamboge, raw sienna; reds: scarlet lake, alizarin, permanent rose; blues: manganese, cobalt; plus burnt sienna, which is a grayed red-orange.

DEMONSTRATION 4:
Color in water

PURE WATER CAN BE CONSIDERED as colorless (though large volumes can acquire a faint bluish tinge). The colors we see in water are due almost entirely to three causes:

1. Minerals, vegetable matter, etc., coloring the water—much like our watercolor paints do.
2. Looking through water, we can see colors caused by objects in the water, or the bottom itself (if the water's shallow enough), or see a darker value, if the water's deep.
3. *Most* commonly, though, the colors we see in bodies of water are the result of reflections of things above the water.

Still water acts like a mirror and the angle that you look into it will reflect, upside-down, whatever the opposite and identical angle reveals. Wavelets on the water's surface create curving, multifaceted "mirrors." Looking at wavelets on a lake surrounded by trees and bluffs, you'd see fractured wavy-image "pieces" of them, all reflected and distorted by the continuously curving front, top and backside of each little wave, similar in effect to those "crazy mirrors" at a carnival. So, the colors of the trees, bluffs and sky would be the principal colors in the water. All this would be constantly changing. To interpret it in paint, you'd have to paint a little "moment in time." Very active water does the same things, but reflections become so myriad and complex, we have to look for the overall, broader color effects.

Also, the intensity of the hue of an object above water is almost always lower in its reflection in the water—so, that's how I painted them here. As I was looking slightly down on my subject, the reflections in the water revealed the undersides of objects above them— just as holding a mirror under an object shows the side of it you couldn't otherwise see from above!

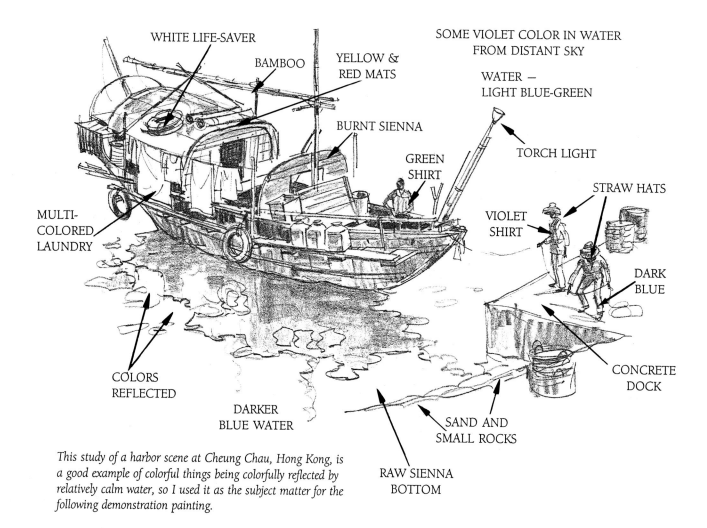

This study of a harbor scene at Cheung Chau, Hong Kong, is a good example of colorful things being colorfully reflected by relatively calm water, so I used it as the subject matter for the following demonstration painting.

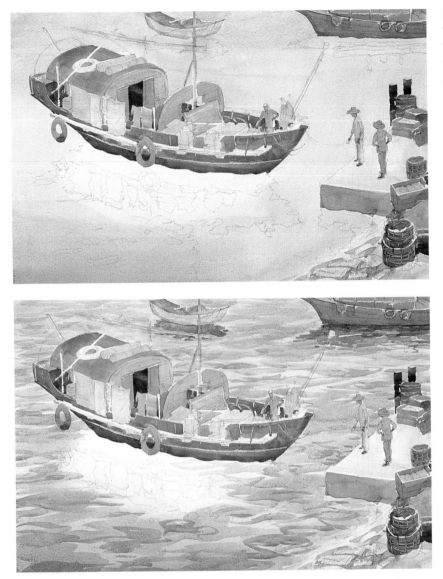

STEP 1. *After wetting the paper, except for where the boats and dock were, I worked wet-in-wet to paint all the water at once, using a light-valued mix of cobalt and manganese blues. I then charged a faint violet at the top (the distant sky reflection) and slightly darker blue at the bottom left where there was more overhead sky reflected — plus a little raw sienna at the lower right to indicate the sandy edge sloping down into deeper water. When this was dry, I painted the boats, dock, figures and paraphernalia, using mostly flat, hard-edged washes and scraping out some details while the paper was still damp.*

STEP 2. *Using a no. 12 round brush, I painted the "wiggly" wavelet shapes in two stages. First, a lighter blue-green, representing the sky reflections, then a blue toward violet, which represents looking through to the deeper water below the surface.*

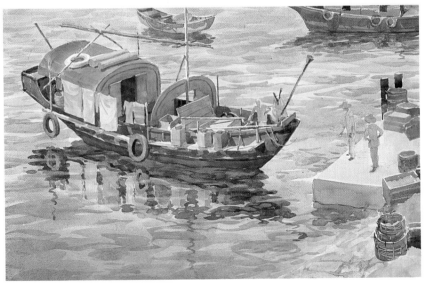

STEP 3. *Next, I painted more details on the boats: the laundry and gear, then the shadows on these objects, then the shadows cast by these objects. Next, the reflections of all this in the water. A good "rule" to keep in mind: generally, darker valued things above are reflected somewhat lighter in the water, whereas lighter ones above appear slightly darker below.*

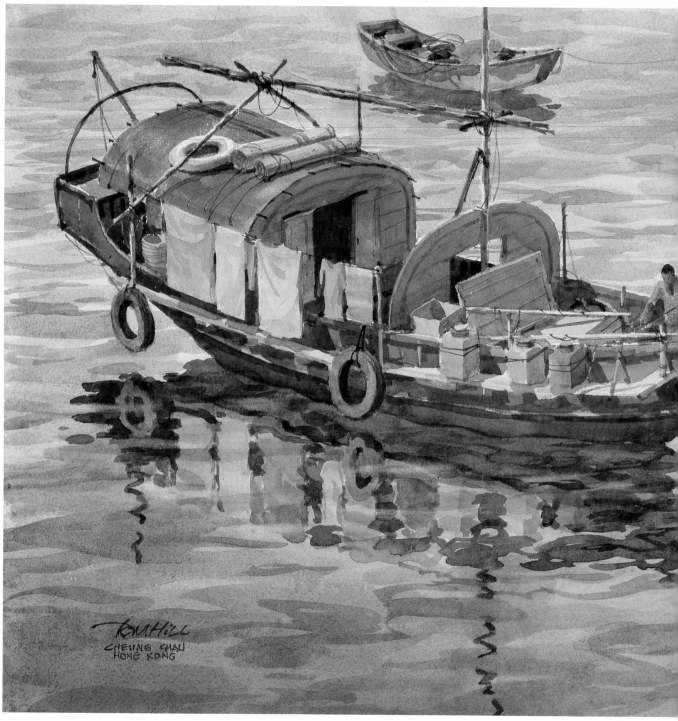

SAMPAN IN CHEUNG CHAU HARBOR, 13½″ × 21″. Private collection.

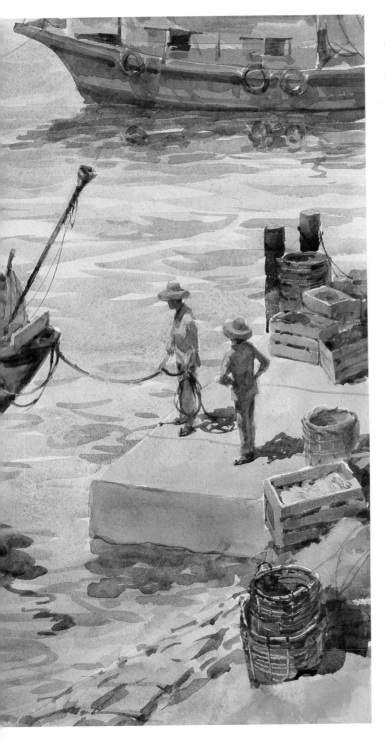

STEP 4. *As in the other demonstrations, you can see that the painting was basically finished by the end of the third step — all I did here was complete it by adding the smaller details and polishing shapes and color relations. I completed the figures mostly by just painting their shadow sides and then the shadows that they cast. After that, I worked on the contents of the baskets and crates; the rope and rigging were added, using a small round pointed brush — then the shadows on, and cast by, the bamboo poles and the mast — and that was it!*

These details show how I handled the color that was reflected in the water from the objects above — and how these upside-down images were distorted by the undulations of the surface of the water.

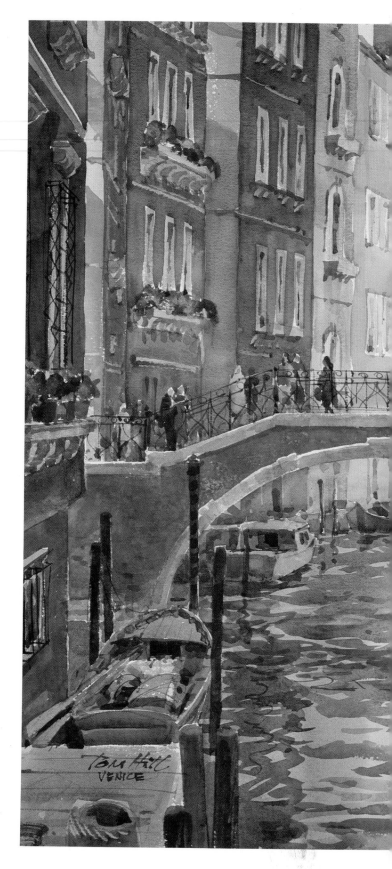

AFTERNOON, VENICE, 21" × 29". Private collection.
Some of the same painting problems I faced in the Cheung Chau Harbor demonstration were in this painting, too. The water, like a wavy mirror, presented distorted, upside-down images (mostly lower in intensity and value) of what was above. I simplified detail in favor of impression of the scene, keeping technique and color mixtures simple and direct.

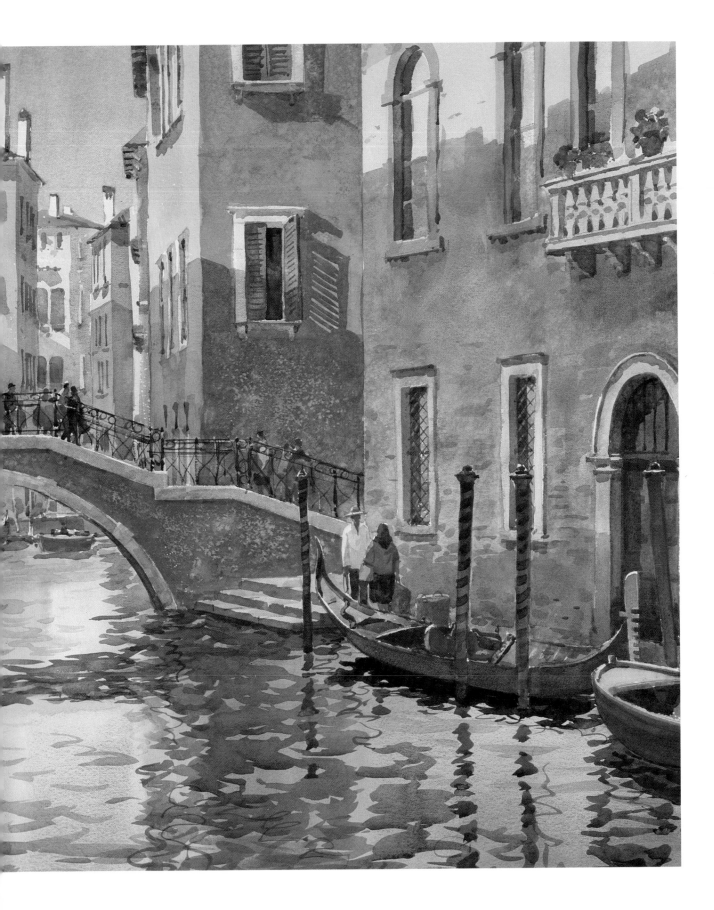

DEMONSTRATION 5:
Color in clouds and skies

IT SEEMS LIKE SOONER OR LATER every watercolorist will paint skies and clouds—probably sooner rather than later, for skies and clouds are a popular and frequently chosen subject for a painting. Now, what to do about the color (hue, value, intensity) involved in painting "skyscapes"? I think a lot of us carry around a first-reaction mental picture of *blue* skies and *white* clouds. In reality, though, almost any aspect of color—any hue, any value, any intensity—can be present in a skyscape; it all depends on the circumstances involved.

Skies can range from clear, with no clouds at all, to a solid cloud cover from horizon to horizon, or any combination in between. Cloudless skies can be very clear, somewhat hazy, even nearly *opaque* if there's enough moisture, dust, smoke, etc., in the atmosphere. Each of these situations has its own color possibilities.

When there are clouds present, they can offer the viewer a bewildering array of shapes, sizes, edges and types, with a great variety of color possibilities. We've all heard cloud names like cumulus, stratus, cirrus (and even altocumulus, cirrostratus, nimbostratus, etc.) and common names like cotton ball, buttermilk and mare's tail—but what's important to artists is not so much the exact name of the cloud, but its shape, texture and color.

Basically there are two types to be aware of: cumulus, which tend to form puffy "clumps," rise vertically, and are somewhat separated from each other; and stratus—which are not so thick vertically, are more horizontally layered, and are often connected, sometimes covering the entire sky!

To show some of this pictorially, I've painted a few little skyscape examples, along with descriptive captions, which might be useful to you in your thinking about the subject. Of course, given the endless variations and combinations that are possible in nature's skies, these paintings will only scratch the surface! It still comes down to carefully observing nature, then working from that infallible source of information that will never let you down!

Here are some aspects of skies and clouds to look for and use in your paintings:

- A given sky can gradate from warm to cool in hue, from light to dark in value, and this can occur horizontally, diagonally or vertically.
- Sky and cloud colors can vary with the time of day (or night) and change rather quickly—especially during sunrise or sunset.
- Cloud's edges can range from soft (even almost indiscernible) to rather crisp and well defined.
- Clouds conform to the laws of perspective—appearing larger when close to us, smaller and closer together when farther away.
- Clouds can reflect the colors of things above, below and to their sides, including each other.
- Clouds cast shadows—on the ground and, at times, on each other.
- Skies and clouds—their colors and shapes—can be a most useful part of constructing a painting's design and composition—and contribute greatly to its mood or story.

An early morning sky just before the sun appears. The overhead dome of sky is blue that's slightly toward green (manganese and cobalt blues), which lightens as it descends, with a touch of violet (permanent rose) to the left, heading toward yellow to the right (Winsor or lemon yellow). Nothing on the ground has any direct sunlight yet, so I've kept it darker in value and mostly on the cool side.

Here's a noon sky—the sun about overhead. Now the blue is nearly a "true" blue at the top (I used cobalt), gradually getting lighter in value and a touch greener as it gets toward the horizon (a little Winsor or lemon yellow). The hills in the background and the buildings in front of them are in direct overhead sunlight, with shadows pointing downward.

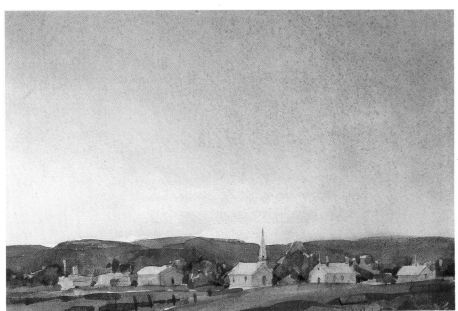

An early evening sky. The sun has just set to the left, while the sky to the right is darkening. The sky's color (ultramarine and cobalt blues) gets lighter as it descends, with a hint of warm red to the left, violet to the right, near the horizon. There's no direct sunlight now, so everything is lit by the remaining reflected light from the sky.

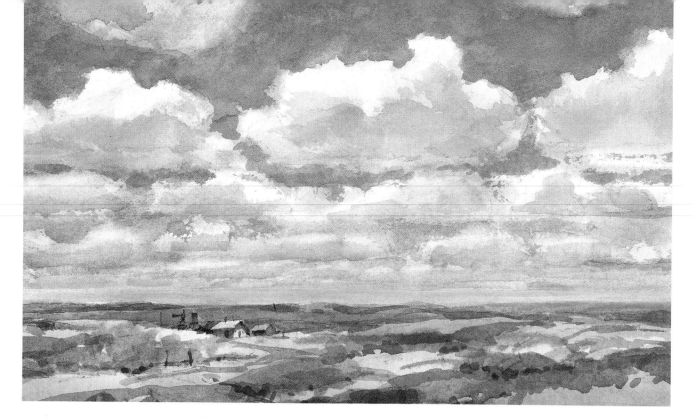

Summer afternoon on the plains. Groups of puffy cumulus clouds float at the same altitude. With their flattened bottoms and the appearance of growing smaller and closer together in the distance, they offer a feeling of perspective. Warm hues, reflected to their undersides from the earth, are noticeable, while the shadows they cast on the ground are toward a cool hue, because of the light reflected from the blue sky.

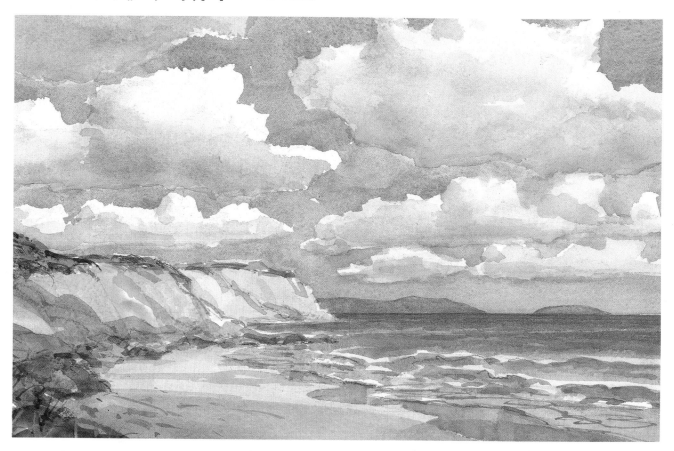

Here's another sky and cloud situation, painted to show how reflected light can affect the color of clouds. Sunlight, bouncing up off the ocean, gives a cool, bluish cast to the bottoms of the clouds on the right—while the clouds to the left are getting warm hues reflected from the land below them.

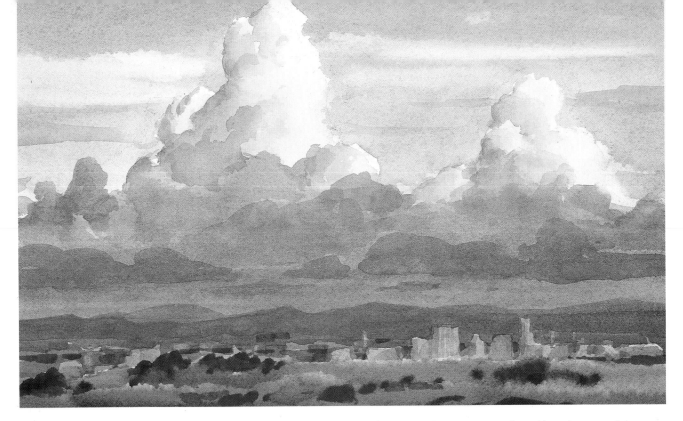

In this evening setting, the sun no longer lights the earth below, but, for a few moments, still lights the tops of the towering thunderheads and the even higher bands of cirrus clouds behind them. The longer red light waves, best able to penetrate the greater volume of atmosphere, tint the cloud tops with pink and pale pink-orange, while below, all the hues are cooler.

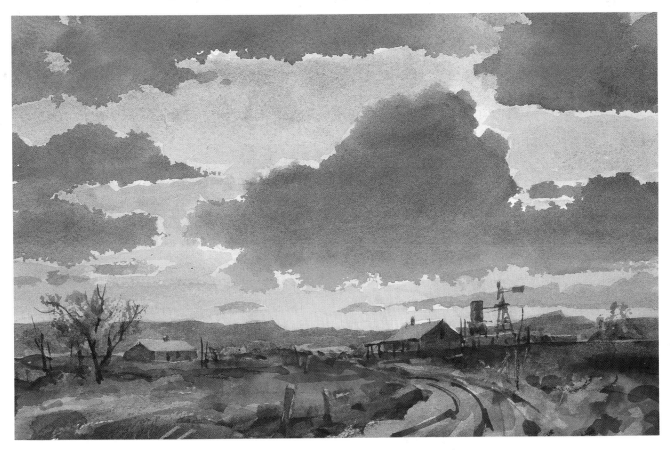

Here, we're facing west, where the sun has already set, the opposite view from the painting above. Only indirect light from the sky lights the scene, and this is dominated by the longer red light waves. Clouds, silhouetted against the lightest part of this sky, can assume some of the darkest and warmest hues possible and, if they're high enough, can acquire a silver lining from the sun which is now out of our view.

DEMONSTRATION 6:
Painting the greens in nature

ARTISTS OFTEN OVERLOOK THE POSSIBILITIES and potential that are available to them in painting greens, and instead, settle for just a few "easy" ones. To the casual observer, the greens of nature—whether in forest, farm, desert or mountain—can give an impression of sameness. Closer observation, however, especially to the "seeing" eye, reveals a multitude of greens—everything from light to dark, bright to dull, warm to cool!

The Arizona desert may seem an unlikely place to find a variety of greens in a landscape, but, as this demonstration painting shows, the greens are there in abundance, and even more so on a spring morning, following an evening of rain showers.

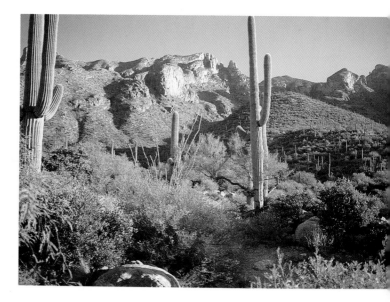

Here's a photo I took that gives some idea of the Arizona desert. Though color film doesn't discern colors as well as your eyes, the picture hints at the many greens. The native saguaro cactus can be huge—reaching more than thirty feet in height. The trees are mesquite and palo verde ("green stick").

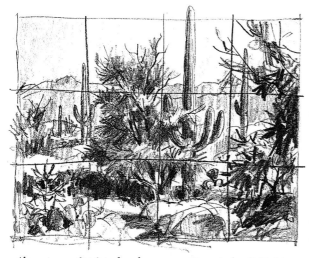

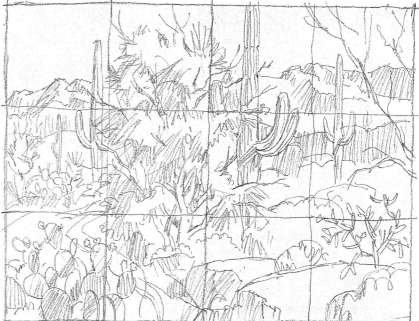

Above is my 6 × 8-inch value-composition study, divided into sections. Using the same divisions at a larger scale, I transferred this design onto my 18 × 24-inch watercolor paper (right), using a light pencil line.

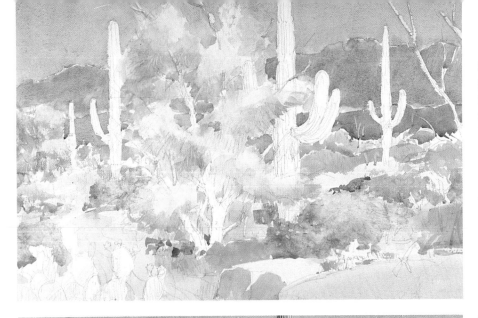

STEP 1. On stretched, 140-lb. Arches cold-pressed paper, using my 1-inch and 1½-inch flat brushes, I washed in a cobalt-manganese sky, painting around the foliage. Then darkening this same color mixture and adding permanent rose, I painted the mountains. Next, I painted the yellow-greens of the trees and shrubs, then added blue-greens, darker greens, pinks and violets to the middle and foreground, plus light cool and warm washes to the rocks and ground areas.

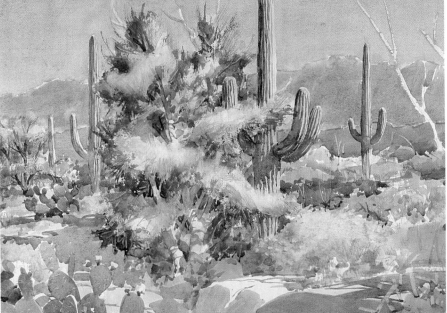

STEP 2. Next, I painted more warm and cool greens, to help define the shapes of the foliage. With clean water, I wet, softened, and lifted out some of the color from the upper foliage of the palo verde tree. After this, I painted the accordion-like pleats of the giant saguaro cactus, rendering the lights and darks, the warms and cools. Then I added the multi-hued shapes of the prickly pear cactus and the darker blue-violet shadows in the foreground.

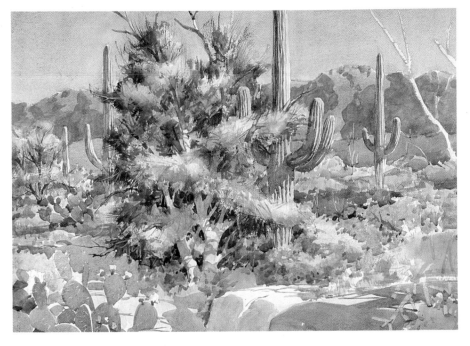

STEP 3. At this point, I painted the shadows on the mountains in the background, again using the same cobalt/manganese/permanent rose mixture, but making it a darker value by using more pigment. The way these shadow shapes are delineated is what tells the viewer the character of the mountains. Next, I added more detail to the branches of the palo verde tree.

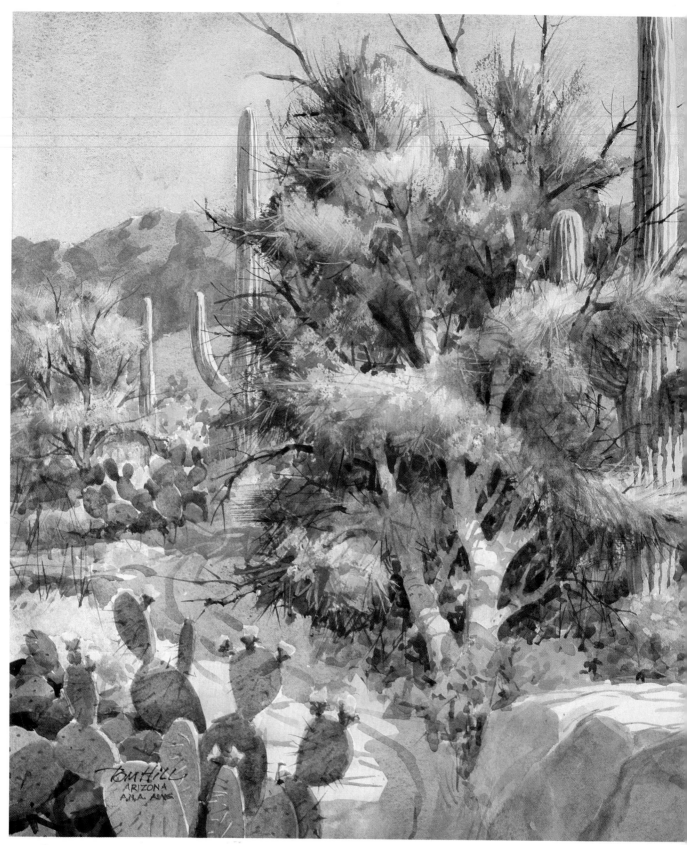

SPRING MORNING, SAGUARO COUNTRY, 18″ × 24″. Collection of
Kirk and Elizabeth Gibson.

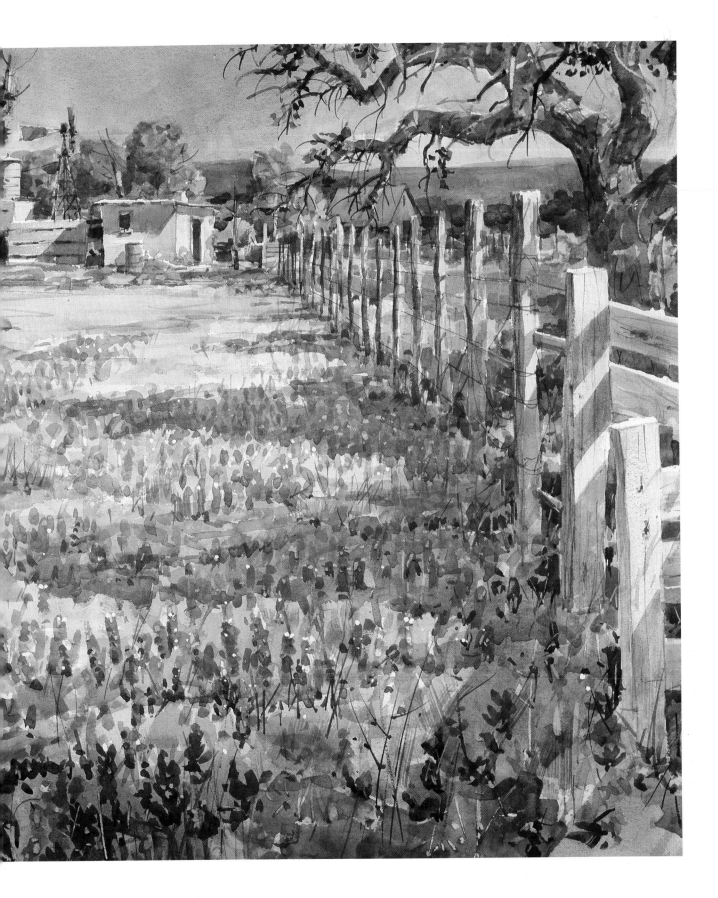

DEMONSTRATION 7:
Intensifying a color's brilliance

PIGMENT COLORS, BEING REFLECTIVE, HAVE LIMITS. Even the most brilliant fall short of the color intensity of direct light. However, when a color needs even *more* brilliance, it's possible to increase its intensity by using "color contrast." Color contrast means a color can appear lighter or darker, warmer or cooler, grayer or more brilliant, just by its color surroundings. As no color exists in isolation in a painting, color contrast, properly used or not, is everywhere in a painting. (Refer to chapter 5,

pages 58-63.) In painting *Glancing Sunlight, Oaxaca*, details of which are shown on these two pages, I tried to capture the brilliant colors of a Mexican market by using color contrasts, especially by placing intense complements in juxtaposition throughout the painting, to help amplify the feeling of brilliant sunshine falling across a colorful scene. Some of these color contrasts are pointed out in the two details shown here, while the entire painting is reproduced on the next two pages.

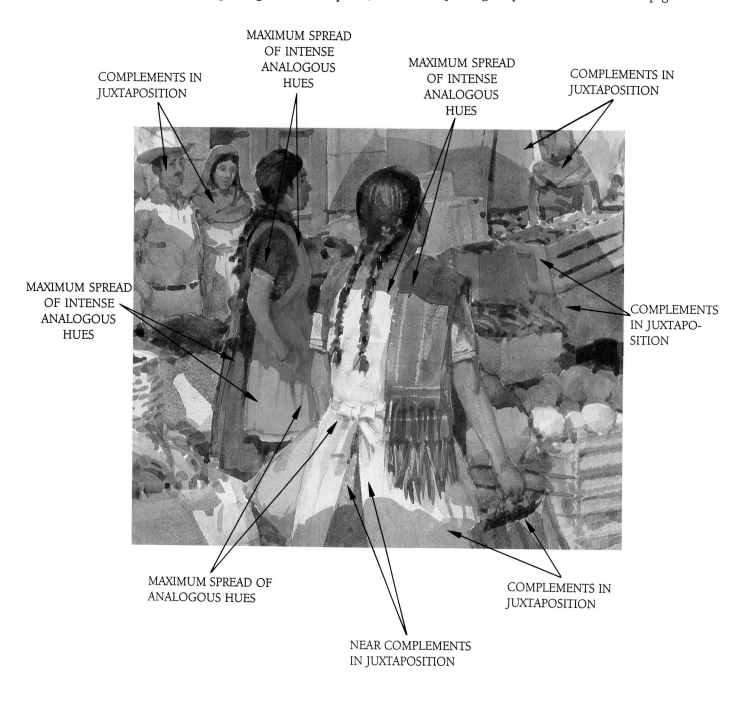

COMPLEMENTS IN JUXTAPOSITION

MAXIMUM SPREAD OF INTENSE ANALOGOUS HUES

MAXIMUM SPREAD OF INTENSE ANALOGOUS HUES

COMPLEMENTS IN JUXTAPOSITION

MAXIMUM SPREAD OF INTENSE ANALOGOUS HUES

COMPLEMENTS IN JUXTAPO-SITION

MAXIMUM SPREAD OF ANALOGOUS HUES

COMPLEMENTS IN JUXTAPOSITION

NEAR COMPLEMENTS IN JUXTAPOSITION

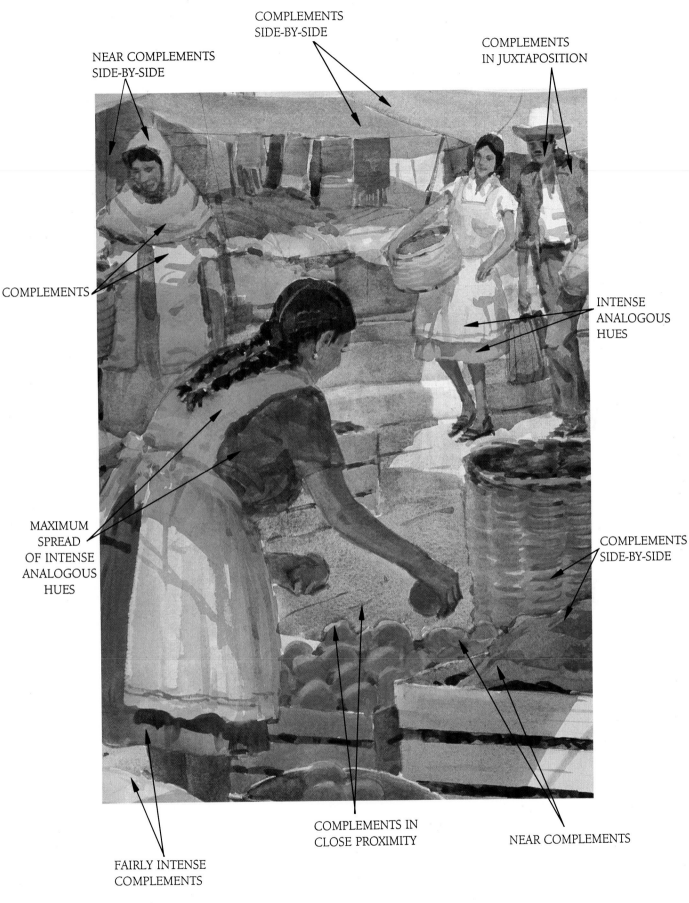

NEAR COMPLEMENTS
SIDE-BY-SIDE

COMPLEMENTS
SIDE-BY-SIDE

COMPLEMENTS
IN JUXTAPOSITION

COMPLEMENTS

INTENSE
ANALOGOUS
HUES

MAXIMUM
SPREAD
OF INTENSE
ANALOGOUS
HUES

COMPLEMENTS
SIDE-BY-SIDE

COMPLEMENTS IN
CLOSE PROXIMITY

NEAR COMPLEMENTS

FAIRLY INTENSE
COMPLEMENTS

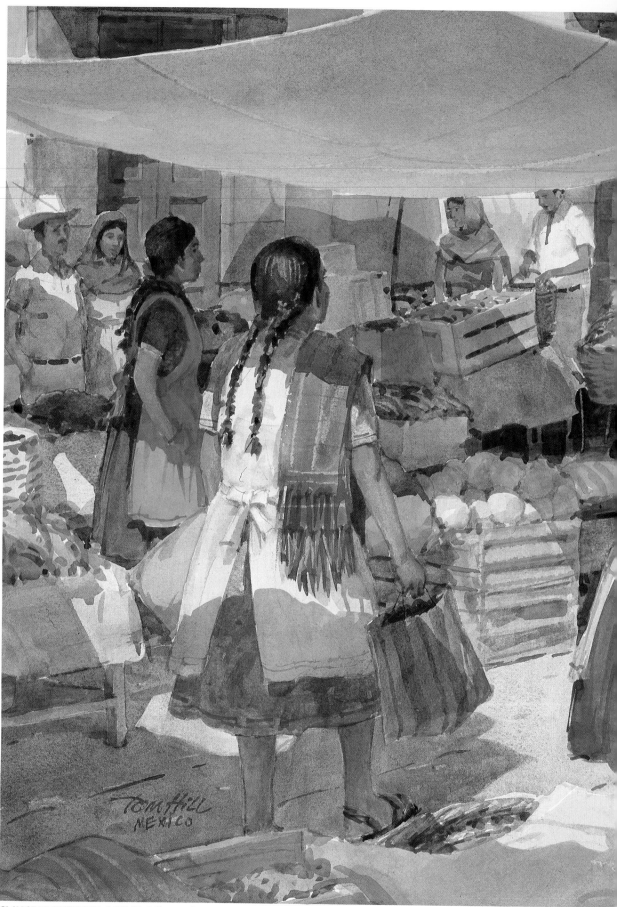

GLANCING SUNLIGHT, OAXACA, 21″ × 28½″. Private collection.

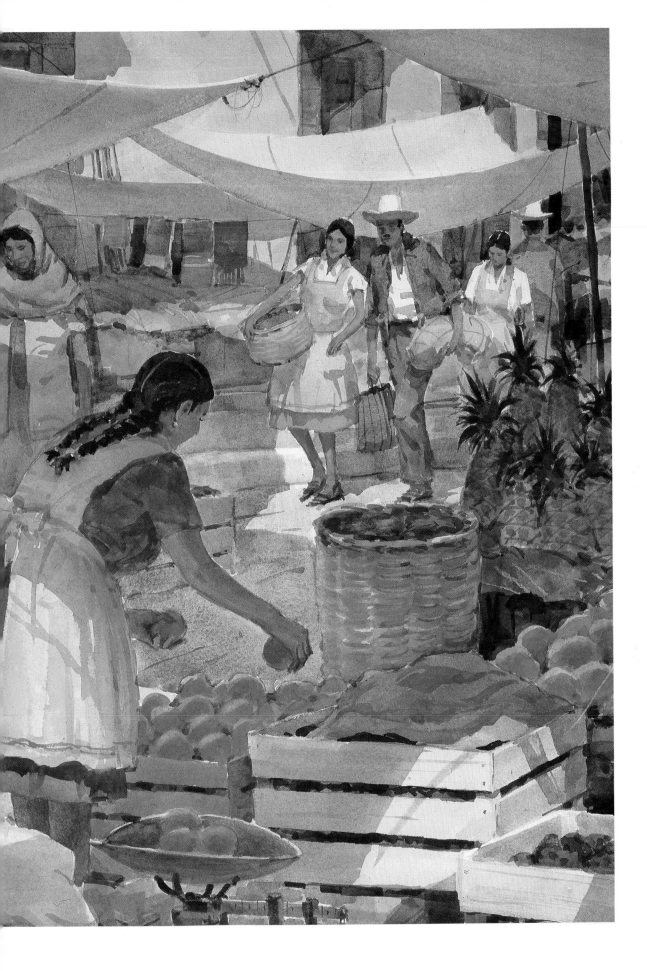

ABERDEEN SHIP REPAIR, HONG KONG, 21″ × 29″. Collection of the artist.

The dominant colors in this painting, red-oranges and blue-greens, produce an effect almost as if the painting had been done with a two-color complementary palette, each color enhancing the other's brilliance. Notice the ship's upper cabin surrounded by blue sky. Of course, subtler yellows and violets are there, lending their support to the final result.

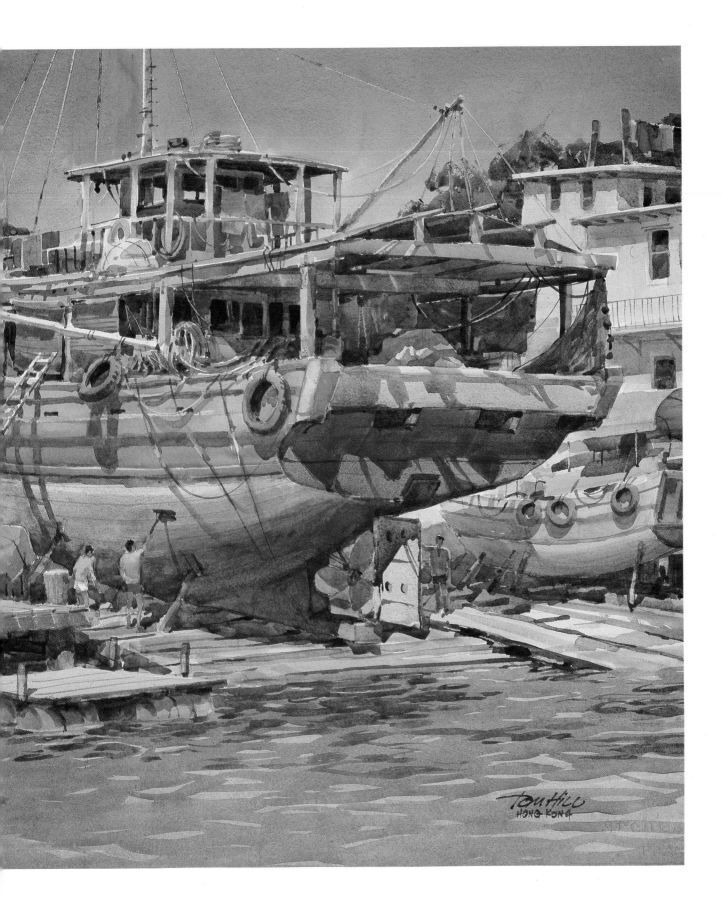

DEMONSTRATION 8:
Painting grays that aren't muddy

WHEN YOU THINK OF A COLOR, chances are you envision a brilliant version of it: a *red* red, a *blue* blue. Actually, "everyday" colors around us are somewhat neutralized—only occasionally very intense in hue, like a bright blossom against the grayer green leaves. So, it's important to understand how to gray colors and use them properly in our paintings, too, for they're a part of nature's way with color.

A recent painting trip to Guaymas, Mexico, offered me an opportunity to see some marvelous grayed colors in action. This colorful old town sits beside a convoluted bay on the Gulf of California and is home port to a large fishing fleet and all the attendant paraphernalia that goes with it. The photo of me starting a painting only hints at the exciting array of subject matter that was available.

A late afternoon sun bathed the sky and dry desert hills with a lovely warm grayed-violet. As I painted, the light was diminishing, colors becoming more neutralized—but still clear, clean and almost *vibrant* in a low-key way. How to capture those wonderful grays without getting "muddy" colors? Mixing clean grays is not complicated or mysterious—it's fairly easy to get what you want in hue and value, usually with a simple mixture.

In chapter 5 we talked about mixing grays (pages 55-58) and how any color can be grayed by mixing its complement with it—the more you add, the more it's neutralized. Using a "near" complement will "tilt" your result toward warmer or cooler, depending on which side of the direct complement you use. For example, to mix a grayed red, use green. To tilt it toward *cooler*, mix it with a blue-green; toward *warmer*, use a yellow-green. Paint pigments *do* have their idiosyncrasies, so experimenting and practicing with different pigment versions of the same hue will help you get the results you want.

Starting a watercolor at Guaymas.

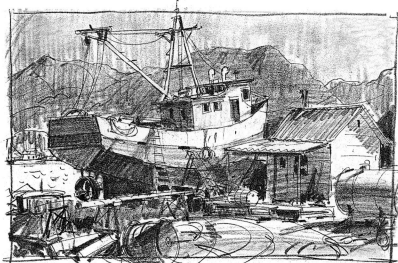

(Left.) *On-location pencil study of the painting subject.* (Above.) *I followed my pencil study to make this value/composition painting plan.*

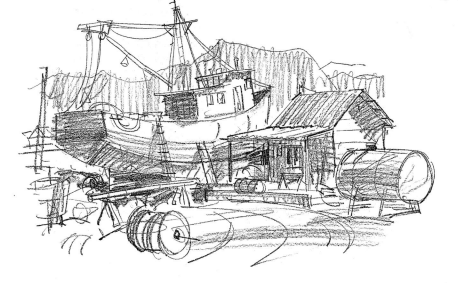

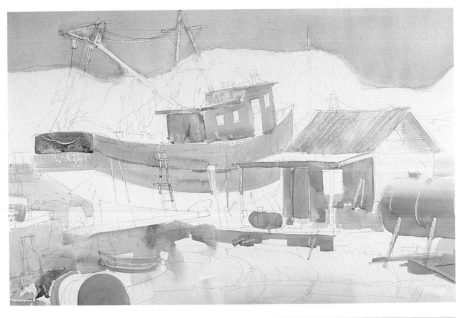

STEP 1. *On Arches 140-lb., cold-pressed paper and using a 1½-inch flat brush, I started by painting the larger, lighter-value shapes, switching to a 1-inch flat brush for the smaller ones. All these hues were grayed some, mostly by using the color's complement (or near complement), adding a third hue if needed for the right effect.*

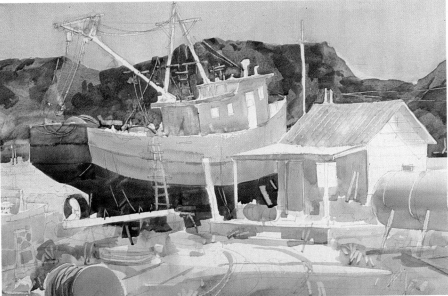

STEP 2. *I painted the mountain with a grayed red-violet, adding the shadows as it was drying. I cut around the boat and shack shapes with my brush, rather than masking them out. Next, I added the dark, lower portion of the boat, painted the gear and junk in the foreground, as well as the long shadow across the roadway.*

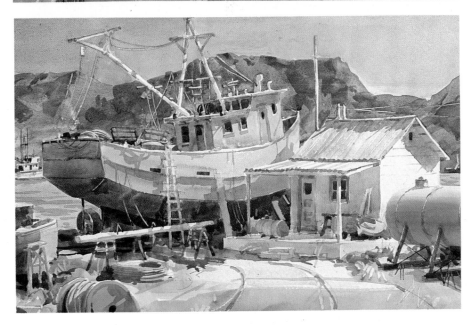

STEP 3. *I glazed the sky darker to the left, then painted more definition to the shapes, mostly by adding the shadows. For darker shadows, I added more of the hue itself, plus its complement. Next, brighter oranges on the doors and windows of the shack and on the large tank in the foreground, a bright blue-green on the boat's trim, doors and windows, and a brighter violet on the tarpaulin on the porch.*

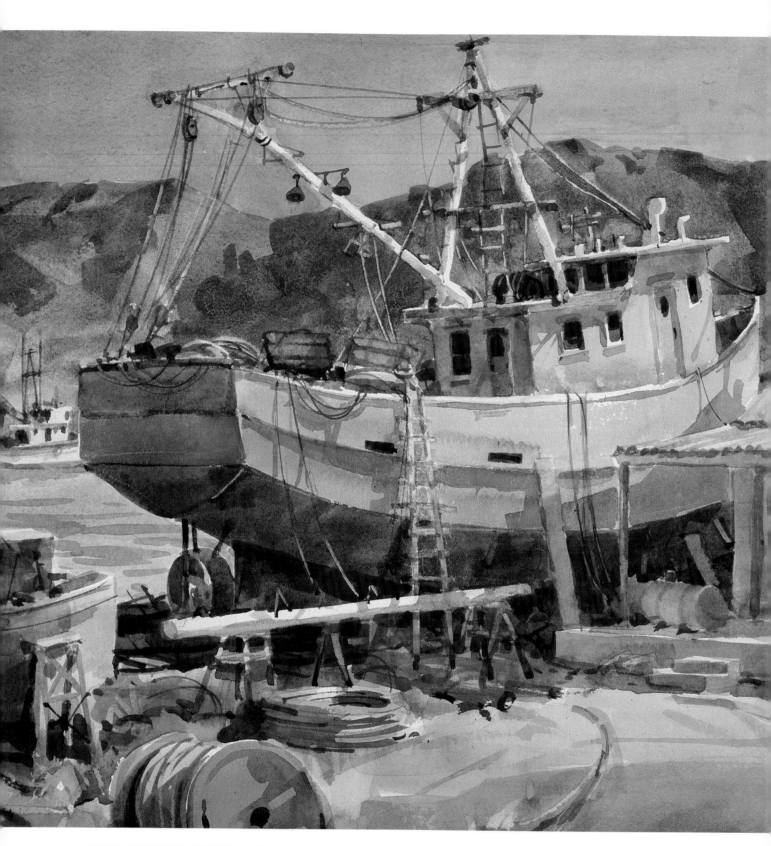

SHRIMP BOAT REPAIR, GUAYMAS, 13½″ × 21″ . Private collection.
*Now, to finish the painting, I added final details and checked
to see that all elements worked together and were complete. The*
simple paint mixtures used to gray the colors, plus a few bright
hues and rich darks are what keep the painting clear, clean and
not muddy looking.

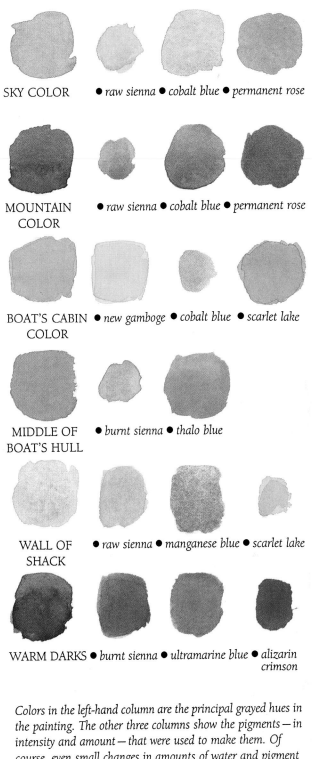

SKY COLOR • *raw sienna* • *cobalt blue* • *permanent rose*

MOUNTAIN COLOR • *raw sienna* • *cobalt blue* • *permanent rose*

BOAT'S CABIN COLOR • *new gamboge* • *cobalt blue* • *scarlet lake*

MIDDLE OF BOAT'S HULL • *burnt sienna* • *thalo blue*

WALL OF SHACK • *raw sienna* • *manganese blue* • *scarlet lake*

WARM DARKS • *burnt sienna* • *ultramarine blue* • *alizarin crimson*

Colors in the left-hand column are the principal grayed hues in the painting. The other three columns show the pigments — in intensity and amount — that were used to make them. Of course, even small changes in amounts of water and pigment would produce different results. My suggestion is to gray your own combinations — and practice. (Note that most of the combinations above are versions of red, yellow and blue!)

DEMONSTRATION 9:
Using color to create distance

PICTURE YOURSELF LOOKING OUT over mountain ranges into the far distance. The farthest mountains look cooler in hue, lighter in value, while those closest to you appear warmer and darker, even though they're the same mountains! The brown earth and warm green trees where you stand look faded and cooler far away. Warm yellow flowers at your feet seem to "wash" away to neutral in the distance. Of course, an object far away will look smaller than the same object close up — that's basic perspective — but what we're talking about here is a sort of perspective created by *color* shifts — in fact, this phenomenon is referred to as "color" or "atmospheric perspective."

All this occurs because the vast sea of air that we live in really isn't invisible. Blue light waves refract in the air more than the other spectral hues (giving us blue skies), creating a blue tinge to our atmosphere — especially where we're looking out through it for miles and miles. Add to this the fact that even the clearest air has *some* particulate suspended in it — dust, moisture, pollen, even smog — and it's easy to understand how color perspective occurs.

We can apply all of this to help us make better paintings — especially landscapes where distance is involved. The simple thing to remember is that warm, dark colors seem to come toward us; cool, light colors seem to retreat.

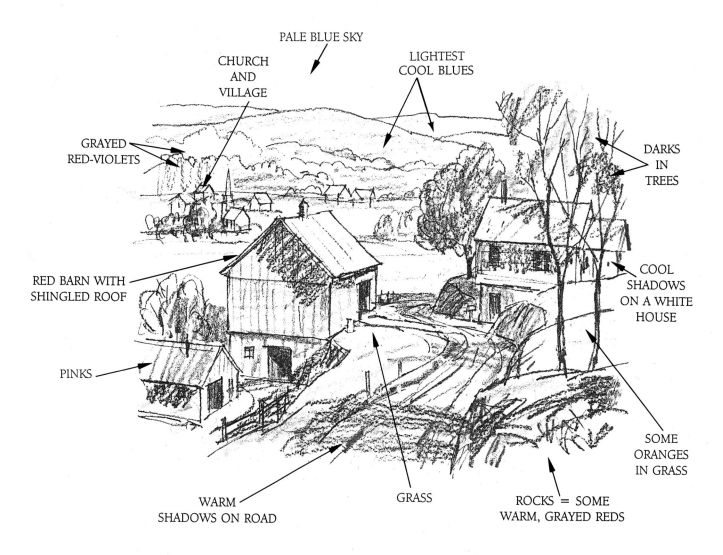

STEP 1. *Pencil sketch of the scene, with reference notes for later use.*

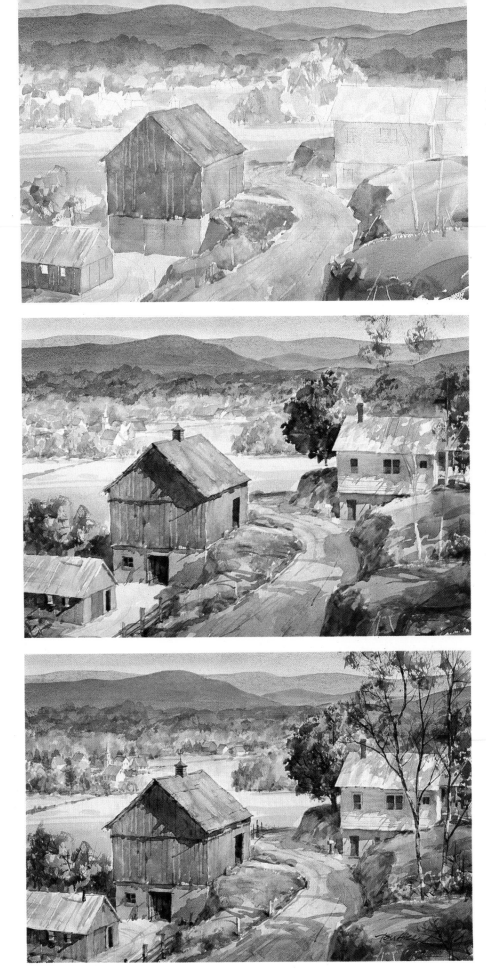

STEP 2. *After penciling my design on the paper, I wash in distant sky, lighter yellow-greens of middle ground, and lighter values in the foreground. Next, the mountains, starting with those most distant and lightest in value. Then the distant trees, basic colors and shapes of the barn, outbuilding, house, and foreground grass and rocks, knifing out tree trunks and fence posts while the paint is damp.*

STEP 3. *I add a shadow side to the most distant trees, the trees by the house and barn. Then I paint the cast shadows on the buildings, road, rocks and grass. Now, some darks for the window and door openings.*

STEP 4. *The painting is basically finished, but needs final details. I add a few to help define the village and its area. Then I paint details and darks in the roofs, sides, windows, etc., of all the buildings. Finally, I add trunks, limbs, twigs and detail to the trees, shrubs and fence posts.*

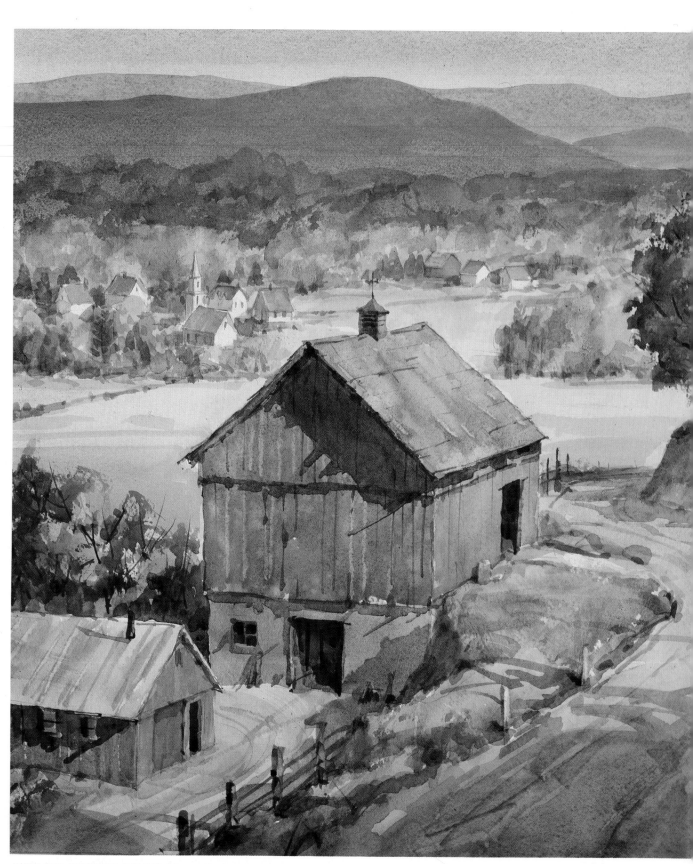

EARLY FALL, VERMONT, 14″ × 19″. Private collection.
Here are the colors I used in painting Early Fall, Vermont:
Yellows: Winsor and new gamboge. Reds: scarlet lake, perma- *nent rose, alizarin crimson. Blues: manganese, cobalt, ultrama-* *rine. Other: burnt sienna.*

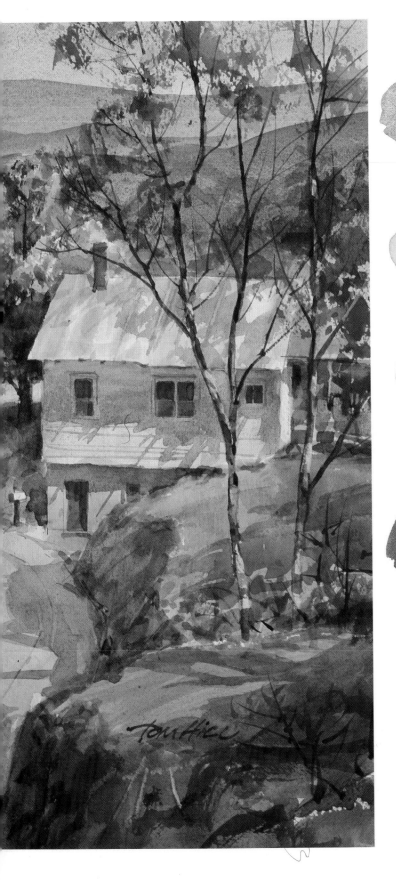

BACKGROUND

- A tint of manganese blue
- Cobalt blue with a bit of permanent rose
- Manganese blue and permanent rose

MIDDLEGROUND

- A tint of scarlet lake mixed with new gamboge
- A tint of Winsor yellow mixed with a very small amount of cobalt blue
- A light-value mix of cobalt blue, new gamboge, and a touch of manganese blue

FOREGROUND

- Orange mixed from scarlet lake, new gamboge, with a bit of burnt sienna
- Rich mix of scarlet lake, permanent rose and bits of cobalt and burnt sienna
- An even richer mix of permanent rose, burnt sienna, and ultramarine blue
- Green mixed with new gamboge, manganese blue, and tiny amounts of scarlet lake

I've painted some swatches of the principal hues and their values that were used in the painting and placed them beside their most-used areas in the painting. This painting—like most landscapes—can be divided into three planes: foreground (barns, road, house, nearby trees); middleground (meadow in the valley, village and trees near it); background (distant trees and hills beyond). Notice that the yellows, oranges, reds and greens in the middleground are all lighter in value, cooler in hue, less detailed than those in the foreground. In the background, yellows and oranges have all but disappeared, leaving just grayed blue-green and blue-violet shapes.

DEMONSTRATION 10:
Redesigning your subject's color

IF YOU UNDERSTAND HOW to get the hue, value and intensity of a given color that you want to put in your painting, but the painting subject doesn't have that color—why not redesign your painting to include the colors you want—especially if doing so will make the painting "say" what you want it to say? We were in Hong Kong with a busy schedule and no painting equipment—all I could do to record information was to make some quick notes, drawings and snap a few color photos. Later, in my studio, I felt the photos lacked the color excitement of the scene—so I "redesigned" the colors of my painting to come closer to the vivid memory I wanted to portray.

These photos give you an idea of the character of this part of Hong Kong, its crowded clutter and bustle, but seem a little dark and not as colorful as I'd remembered it. I always "vote" in favor of the painting, so I set about to redesign not only the composition toward a better solution, but to rearrange, add and redesign the color so that the result might be closer to what I wanted my painting to say, which was: "Here's a slice of Hong Kong: a busy, crowded, colorful and almost overwhelming place!"

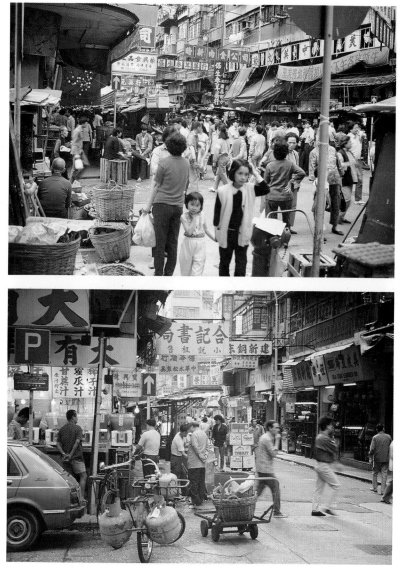

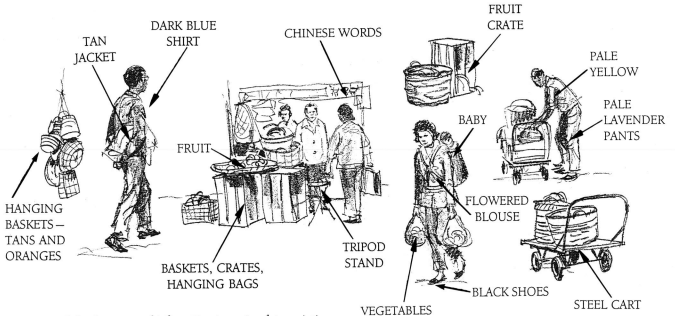

TAN JACKET

DARK BLUE SHIRT

CHINESE WORDS

FRUIT CRATE

PALE YELLOW

PALE LAVENDER PANTS

HANGING BASKETS — TANS AND ORANGES

FRUIT

BASKETS, CRATES, HANGING BAGS

TRIPOD STAND

BABY

FLOWERED BLOUSE

VEGETABLES

BLACK SHOES

STEEL CART

Pencil sketches to record information to use in a later painting.

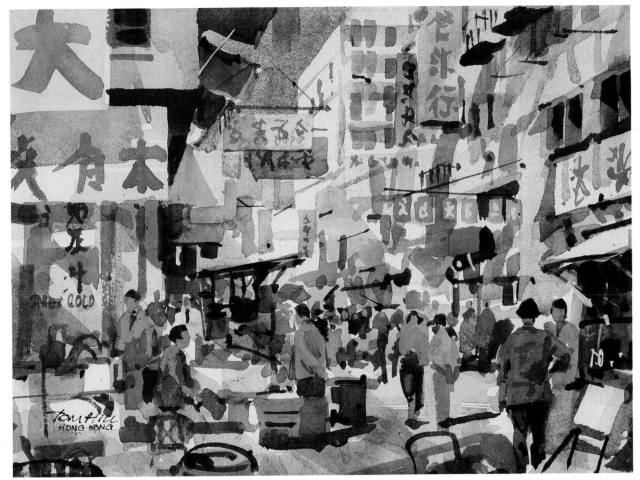

Small color study for use in final painting, 7″ × 9″

As the Hong Kong scene is a complex one, I decided to carry my painting preparations further than a black-and-white value/composition study. I painted this little (7 × 9-inch) full-color study, which helped a lot in the painting of the final picture shown on the following pages.

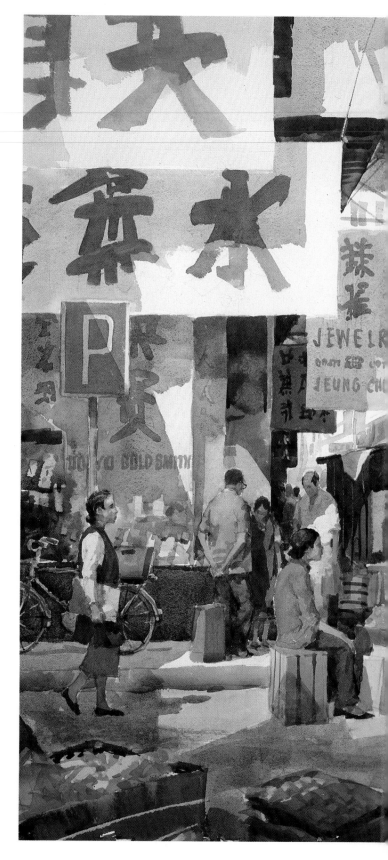

YAU MA TEI DISTRICT, KOWLOON, HONG KONG, 21" × 29". Private collection.

As you can see, I've rearranged many of the painting's elements as compared with those in the photos — and I've even changed and redesigned shapes, shadows and colors from the small color-study painting. All of this in favor of the goal I had for this painting: to have you feel the same visual excitement that I did that day in Hong Kong!

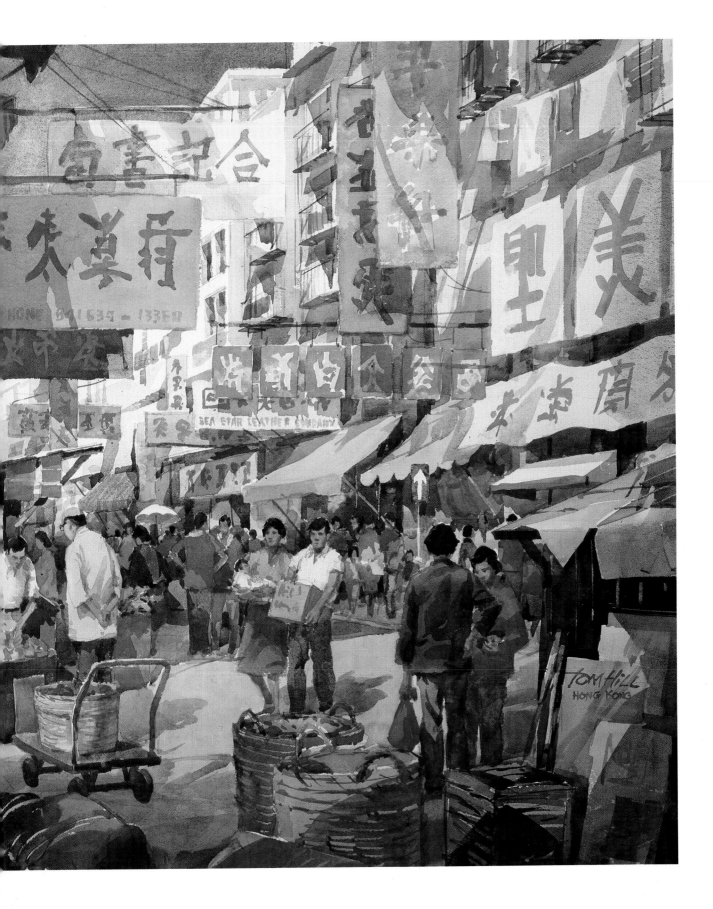

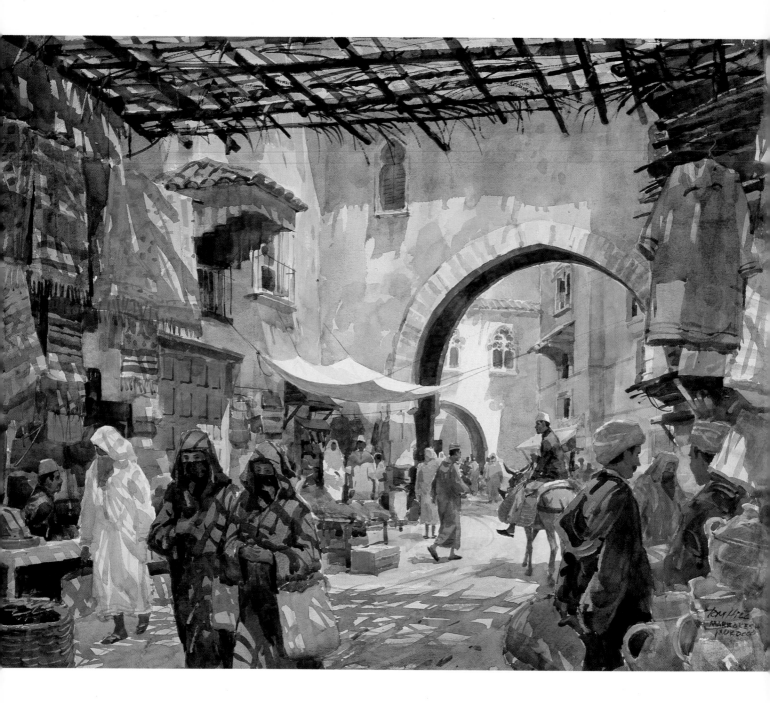

Conclusion

When I first began painting, I didn't consider color in any special way — it seemed to be just another aspect of the painting process. At that time, in my teens, I was more concerned with learning to draw and making my drawing accurate and convincing to others. This was good, of course, as solid drawing is really the beginning of everything in representational painting.

I didn't know a cool blue from a warm one, probably didn't realize that burnt sienna, for example, was really a grayed red-orange, and was only vaguely aware that some paints were just brighter and clearer versions of others. Relating spectral colors of light to colors of pigment in any practical way just didn't occur to me. The aspect of color that concerned me most in those days was value — the darks-to-lights — while hue and intensity, as well as what color actually is and how it really works, went rather unnoticed.

Gradually, though, through ever-continuing experience in painting and life, the idea that the right use of color could elevate my work into whole new dimensions began to dawn on me, and my interest in color and light started to grow — as it still does — stronger than ever, to this day.

Of course, there's more to the subject of color than is included in this book, but my hope is that what *is* in it will open new doors of understanding for you — maybe enable you to profit from all my struggles to understand and possibly leap-frog ahead in your concepts and use of color in your painting!

INDEX

A

Aberdeen Ship Repair, Hong Kong, 118-119
Adriatic Morning, 38-39
Advancing color, 29
Afternoon, Old Town, Granada, (demonstration), 86-87
Afternoon, Venice, (demonstration), 102-103
Alfama District, Lisbon, (detail), 82
Alhambra, Late Afternoon, The, 32
Alizarin crimson, 35, 72
 glazing grid, 43
 graying, 56, 57
 staining, 47
 tinting, 48
 transparency test, 44-45
 tube color, 40-41
Analogous color palette, 68, 73
 with complement, 69, 73
Angles of light, 77
Applications, paint, 12, 14-15
Atmospheric color, 29

B

Basic painting guidelines, 15
Blending color, 11
Board, watercolor, 3
Bristle hair brushes, 4
Brush(es), 3
 materials, 4
 styles, 3
Brushwork, 12, 13
Burnt sienna, 35
 glazing grid, 43
 graying, 57
 staining, 47
 tinting, 48
 transparency test, 44-45
 tube color, 40-41
Burnt umber, 35, 66, 67
 transparency test, 44-45
 tube color, 40-41

C

Cadmium lemon, 34
 staining, 47
 tinting, 48
 transparency test, 44-45
 tube color, 40-41
Cadmium orange, 35
 glazing grid, 43
 transparency test, 44-45
 tube color, 40-41
Cadmium red/light, medium, deep, 35
 transparency test, 44-45
 tube color, 40-41
Cadmium scarlet, 35
 glazing grid, 43
 staining, 47

tinting, 48
transparency test, 44-45
tube color, 40-41
Cadmium yellow/pale, medium, deep, 34
 glazing grid, 43
 graying, 56
 staining, 47
 tinting, 48
 transparency test, 44-45
 tube color, 40-41
Cerulean blue, 36
 transparency test, 44-45
 tube color, 40-41
Charging color, 11, 53-55
Chilies Drying on an Old Adobe Wall, (demonstration), 94-97
Chroma, 28
Cleanliness, 42
Clouds, painting, (demonstration), 104-107
Cobalt blue, 36
 graying, 56, 57
 staining, 47
 tinting, 48
 transparency test, 44-45
 tube color, 40-41
Cobalt violet, 36
 transparency test, 44-45
 tube color, 40-41
Color (See also individual color names)
 advancing, 29
 atmospheric, 29
 blending, 11
 charging, 11, 53-55
 chart, 33-37
 colorful subject, in a, (demonstration), 94-97
 contrast, 58
 defined, 23-25
 distance, creating with, (demonstration), 124-127
 environment, 62-63, 88
 experiments, 42-48
 graying, 29, 31, 55-60
 intensifying, 58-61; (demonstration), 114-119
 local, 29
 matching chart, 61
 mixing, 51-55
 modifying, 60
 names, 33
 opacity, 42, 44-45
 primary, secondary, tertiary, 25
 redesigning, (demonstration), 128-131
 relationships, 25
 retreating, 29
 settings, 78-81
 shadows' effect on, 78-81; (demonstration), 83-87
 "student," 5

swatches, 33
systems, 31
temperature, 29
terms, 26-31
thumbnail, 20
transparency, 42, 44-45
water, in, (demonstration), 98-103
white subject, in a, (demonstration), 88-93
Color wheel, 25-26
 grayed, 30
 simple, 27
 tertiary, 27
 tube colors on, 40-41
Complementary palette, 67, 73, 118
Complements, 25
 graying, 58
Composition study, 16-17, 94, 108, 120
Control, 9

D

Davy's gray, 37
 transparency test, 44-45
 tube color, 40-41
Distance, creating with color, (demonstration), 124-127
Drawing board, 3

E

Early Fall, Vermont, (demonstration), 124-127
Early Morning Light, 92-93
Easel, 3, 5-6
Environment, color, 62-63, 88
Equipment
 essential, 3
 miscellaneous, 3, 7
Evita and Pancho, 8

F

Flat brushes, 3
 brushwork with, 12, 13
Flat wash, 9-10
Full-color palette, 74-75
Full-color study, 129

G

Glancing Sunlight, Oaxaca, (demonstration), 116-117
Glazing, 11-12
 experiment, 42-43
 grid, 43
Graded wash, 9, 10
Graying (a color), 29, 31
 blues, 55
 chart, 56-57
 greens, 55
 oranges, 55

reds, 55
violets, 55
yellows, 55
Grays
 intensifying, 58, 60
 nonmuddy, (demonstration), 120-123
Greens, painting in nature,
 (demonstration), 108-113
Guidelines, basic painting, 15

H

Hooker's green dark, 37
 transparency test, 44-45
 tube color, 40-41
Hue, 26, 28

I

"If you want a color to look . . . /Paint
 next to it . . . " chart, 60
India ink, 42
Indian red, 70
Indirect wet-in-wet, 11-12
Intensity, 26, 28
 increasing, 58-61; (demonstration),
 114-119
Iolani Palace, Honolulu, 74-75
Ivory black, 37
 transparency test, 44-45
 tube color, 40-41

L

Lamp black, 37
 transparency test, 44-45
 tube color, 40-41
Layered wet-in-wet, 11-12
Lemon yellow Barium, 34
 transparency test, 44-45
 tube color, 40-41
Lemon yellow Hansa, 34
 transparency test, 44-45
 tube color, 40-41
Lift-outs, 14
Light, 3, 7, 23, 77
 "direct" or "additive," 25
 "reflective" or "subtractive," 25
 sunlight, 77
Lisbon Street, 20, 21
Local color, 29
Low Tide, Empalme, 64

M

Manganese blue, 36
 staining, 47
 tinting, 48
 transparency test, 44-45
 tube color, 40-41
Matching color chart, 61
Materials, 3-7 (*See also* equipment)

Mixing, colors, 51
 chart, 52
 greens, chart, 59
 more than two, 51, 53
 two, 51
 while painting, 53, 54
Modifying color, 60
Monochromatic palette, 66, 73
Morning, Old Town, Granada,
 (demonstration), 84-85
Mud, 42

N

Nearly Forgotten, Almost Gone, 49
New gamboge, 34, 71, 72
 graying, 56, 57
 staining, 47
 tinting, 48
 transparency test, 44-45
 tube color, 40-41

O

Opacity, color, 42, 44-45
Opposite colors, 25
Oxhair brushes, 4

P

Paint(ing), 3
 applications, 12, 14-15
 considerations, 5
 development of a, 18-19
 guidelines, basic, 15
 indoors, 5-6
 out-of-doors, 6
 standing to, 6
Palette, 5
 analogous, 68, 73
 color, 65-75
 complementary, 67, 73, 118
 full-color, 74-75
 "John Pike," 5
 monochromatic, 66, 73
 six color, 72
 three color, 70, 71, 73
Paper, 3
 considerations, 4
 stretching, 4-5
Payne's gray, 37, 70
 transparency test, 44-45
 tube color, 40-41
Pencils, 19
Permanent rose, 35
 graying, 56
 staining, 47
 tinting, 48
 transparency test, 44-45
 tube color, 40-41
Photographs, 18
Primary colors, 25

R

Raw sienna, 34, 70
 staining, 47
 tinting, 48
 transparency test, 44-45
 tube color, 40-41
Raw umber, 34
 transparency test, 44-45
 tube color, 40-41
Reflected light, 23-25, 77
Retreating color, 29
Reverses, 14
Rocky Point Drydock, 22
Round brushes, 3
 brushwork with, 12, 13

S

Sable brushes, 4
Salt, 15
Sampan in Cheung Chau Harbor,
 (demonstration), 98-101
Saturation, 28
Scarlet lake, 35, 71, 72
 graying, 56, 57
 staining, 47
 tinting, 48
 transparency test, 44-45
 tube color, 40-41
Scraping, 14
Secondary colors, 25
Settings, 78-81
Shade, 29
Shadow(s), 77
 core, 78
 effect on color, 78-81;
 (demonstration), 83-87
Shrimp Boat Repair, Guaymas,
 (demonstration), 120-123
Simultaneous contrast, 62
Six color palette, 72
Sketches, 19, 124, 129
Skies, painting, (demonstration),
 104-107
Solar spectrum, 23, 24
Spatter, 12, 15
Sponges, 12, 14
Spring Morning, Saguaro Country,
 (demonstration), 108-111
Squeegeeing, 14
Staining strength, 46, 47, 51
Stamping, 15
"Student" colors, 5
Studio, 7
Summer Morning, Taxco, (detail), 76
Sunlight, 77
Synthetic hair brushes, 4

T

Taboret, 3, 6
Tarahumara Basket Weavers, 50

Temperature, 29
Terre verte, 37
 transparency test, 44-45
 tube color, 40-41
Tertiary colors, 25
Thalo blue, 36, 72 (*See also* Winsor blue)
 glazing grid, 43
 graying, 57
 staining, 47
 tinting, 48
 transparency test, 44-45
 tube color, 40-41
Thalo green, 37
 glazing grid, 43
 graying, 56
 staining, 47
 tinting, 48
 transparency test, 44-45
 tube color, 40-41
Thalo red, 35
 transparency test, 44-45
 tube color, 40-41
Three color palette
 high-key, 71, 73
 low-key, 70, 73
Thumbnail
 color, 20
 studies, 19
Tint(ing), 20
 strength, 46, 48
Tone, 29
Tools (*See* equipment, materials)
Transferring designs, 20, 94, 108
Transparency, color, 42
 test, 44-45
Tripod as easel, 6

U
Ultramarine (French) blue, 36, 67, 72
 glazing grid, 43
 graying, 56, 57
 staining, 47
 tinting, 48
 transparency test, 44-45
 tube color, 40-41

V
Value, 10, 26, 28, 58, 66, 88 (*See also*
 composition study)
Viridian green, 37
 graying, 56
 transparency test, 44-45
 tube color, 40-41

W
Wash techniques, 9-12
Water, color in, 98-103
Weeds Are Winning, (demonstration),
 88-91

Western Spring, 112-113
Wet-in-wet wash, 10-11, 53-55
Winsor blue, 36 (*See also* Thalo blue)
 transparency test, 44-45
 tube color, 40-41
Winsor green, 37
 transparency test, 44-45
 tube color, 40-41
Winsor red, 35
 transparency test, 44-45
 tube color, 40-41
Winsor violet, 36
 graying, 56
 staining, 47
 tinting, 48
 transparency test, 44-45
 tube color, 40-41
Winsor yellow, 34, 72
 glazing grid, 43
 graying, 56
 staining, 47
 tinting, 48
 transparency test, 44-45
 tube color, 40-41

Y
Yau Ma Tei District, Kowloon, Hong Kong,
 130-131
Yellow ochre, 34
 glazing grid, 43
 transparency test, 44-45
 tube color, 40-41